Immediacy

or,

The Style of Too Late Capitalism

Anna Kornbluh

VERSO

London • New York

First published by Verso 2023
© Anna Kornbluh 2023

1 3 5 7 9 10 8 6 4 2

Verso
UK: 6 Meard Street, London W1F 0EG
US: 388 Atlantic Avenue, Brooklyn, NY 11217
versobooks.com

Verso is the imprint of New Left Books

ISBN-13: 978-1-80429-134-4
ISBN-13: 978-1-80429-135-1 (UK EBK)
ISBN-13: 978-1-83929-136-8 (US EBK)

British Library Cataloguing in Publication Data
A catalogue record for this book is available from the British Library

Library of Congress Cataloging-in-Publication Data

Names: Kornbluh, Anna, author.
Title: Immediacy, or The style of too late capitalism / Anna Kornbluh.
Other titles: Style of too late capitalism.
Description: London ; New York : Verso, 2024. | Includes bibliographical
 references and index.
Identifiers: LCCN 2023025353 (print) | LCCN 2023025354 (ebook) | ISBN
 9781804291344 (trade paperback) | ISBN 9781804291368 (ebook)
Subjects: LCSH: Arts—Philosophy. | Arts—Economic aspects. |
 Arts—Political aspects. | Capitalism.
Classification: LCC BH39 .K6375 2024 (print) | LCC BH39 (ebook) | DDC
 700.1—dc23/eng/20230814
LC record available at https://lccn.loc.gov/2023025353
LC ebook record available at https://lccn.loc.gov/2023025354

FSC
www.fsc.org
MIX
Paper | Supporting
responsible forestry
FSC® C171272

Typeset in Sabon by Biblichor Ltd, Scotland
Printed and bound by CPI Group (UK) Ltd, Croydon CR0 4YY

Contents

Immediacy itself is essentially mediated.
—G. W. F. Hegel, *Lectures on the Philosophy of Religion*

Acknowledgments

This book eked itself out amid the long, lonely pandemic. As it tries to underline, mediations are connective collectivizers, and ideas are social things. Contending with the stylized negation of mediation while abiding social isolation was nearly intolerable. In the absence of missed classrooms, missed hallway chats, missed conferences, missed happy hours, and missed family, a few steadfast interlocutors sustained sociality enough to carry the project—and me. Immeasurable, heart-bursting gratitude to the vivifying hilarious geniuses Seth Brodsky, Jude Stewart, Sianne Ngai, Hans Thomalla, Zach Tavlin, Adam Kotsko, and Chris Breu. The stellar researchers Justin Raden and Rithika Ramamurthy provided indispensable assistance, atop their service as deeply adored, deeply admired friends. Comrades Todd McGowan, Hilary Neroni, Russ Sbriglia, Lakshmi Padmanabhan, Jodi Dean, Nathan Gorelick, Alex Galloway, Kate Marshall, Liz Anker, Caroline Levine, Emily Steinlight, Audrey Wasser, Rob Lehman, Leah Feldman, Benjamin Morgan, Zach Samalin, Michael Gallope, Eleanor Courtemanche, Ted Underwood, Robert Tally, Gabriel Hankins, Matt Seybold, Chris Newfield, Rebecca Colesworthy, Mark McGurl, Nico Baumbach, Leigh Claire La Berge, Daniel Hoffman-Schwartz, Nathan Wolff, and Nathan Hensley offered brilliance and ballast. Audiences who welcomed this thesis when in-person conversation reopened vastly deepened it; thanks to the English and comparative literature departments, humanities centers, and film/media working groups of Boston College, Vanderbilt, UNC, U Minnesota, Stanford, Penn State,

Carnegie Mellon, Northwestern, Providence College, Boston U, Columbia U, Cornell, and UC Davis. The UIC Institute for the Humanities awarded a research fellowship at the luckiest time, and Mark Canuel, Linda Vavra, and the fellow fellows were bolstering. Cherished UIC colleagues kept the institution running and the conversations warm; thank you abundantly, Nasser Mufti, Pete Coviello, Helen Jun, Aaron Krall, Nicholas Brown, Jennifer Ashton, Walter Benn Michaels, Madhu Dubey, Paul Preissner, Stephen Engelmann, and Lisa Freeman. The working groups Comparative Theory and InterCcECT, along with the virtual groups #wellngai and #mannicmondays, were constant inspiration. The staff of and anonymous reviewers for Verso Books were wonderfully guiding; Sebastian Budgen edited my very first published journal article over twenty years ago, so circling up to him now for a book is total career zenith. Josh Rutner, indexer extraordinaire, read the book better than anyone. Nothing would be possible without institutions like Chicago Public Schools and the UIC United Faculty. Nothing would be joyous without friends like Liesl Olson, John McGuire, Ariel Kalil, Karl Felbinger, Julie Orlemanski, Kim O'Neil, Isabel Bethke, Corbin Hiday, Nina Dubin, Matthew Jesse Jackson, Carrie Sandler, Ben Roberts, Lia Markey, and Richard Schwartz. Greg Kornbluh makes the best jokes. Andrea and John Kornbluh make the best life. To the all-time crew for fun and puns, adventure and affection: Mira Blue and Ezra, thank you thank you.

Although publishing supply chains deliver this argument to readers in a shape that by now could just as well be utterly otherwise, what good contour still holds is owing to the frames and embrace of these many partners and guilds. If constructing the category of immediacy style ever so slightly helps process the dominant repudiation of representation and disintegration of mediation, maybe it will have been worthy of them.

A version of "Imaginary" appeared in *Portable Gray* 2:2 (2022). Notions of and some lines from "Antitheory" were first tested in "It's Complicated," *nonsite.org* 35 (2021), "Prospective Criticism: On Private and Public Things," *Textual Practice* 37:2 (2023), and "In Defense of Feminist Abstraction," *Diacritics* 49:2 (Winter 2021).

Introduction

In contemporary cultural aesthetics, there is something going on with mediation. The social activity of representation is slackening, loosing presence too much with us. Medium dissolves, extremes effulge, exposure streams.

But it's best to begin in the middle.

Standing at the edge of your mat, bring your arms out to the sides and up to the sky, joining your palms above your head, then relax your shoulders and lift your gaze to the sun. Its blazing rays swirl, thick brushstrokes animated, seventy-five high-definition projectors scaling wall to wall, floor to ceiling, 500,000 cubic feet of psychedelic wallpaper pinned to crescendos of digitally synthesized pop. "Inhale," the yogi quietly croons into your earpiece: intake the piped aroma of lavender gardens at Arles, inhabit the moment, Instagram it to be sure, #ImmersiveVanGogh.

Sunrise exercise is the ultimate American maximization of the nontraditional art experiences raging in Europe for the past several years, fusing whole-body whole-mind entertainment with the insatiable pursuit of wellness, reality and virtual reality, art and theater, phantasmagoria and yoga, the spectator ingested by the spectacle.[1] Here is one of history's most accessible artists, whose

1 To understand the relative novelty of this medium swirl, the analysis of the contrasting distinction of medium by Anna Schechtman can help: "In the second half of the twentieth century, as popular, industrial, and mass culture increasingly informed the concept of art in the name of 'media,' the American museumgoer's experience of art became focused on the ostensibly distinguishable aesthetic

art no longer suffices to create an effect. Van Gogh's quotidian images, utmost color saturation, and mental distress are not enough to generate an adequate sensory encounter; sweat and endorphins must pump that regular spectating into multimedia, multitasking Vinyasa flow. In this flexible hypersensory coordination, the bounds of medium unfold: the work of art becomes indistinguishable from its installation and the corporeality of its spectators, while the aesthetic experience stretches toward total engagement, mixing miasmic emanation, everything simultaneously without rest or distinction.[2] Painting, panting, impressionism, immersion, gallery, studio: exhale. It is all art; there is no art.

The vanGoghga, let's call it, blends physical exertion and aesthetic reception, interpellating a subject of utter sensation whose discipline attunes cultural consumption and corporeal optimization. In this limbering, it instantiates the embodied bent of the more haute contemporary artworld's movements of "socially engaged art" and "relational aesthetics." For the spectator to use their body to produce an "experience" logically augments both the remodeling of the gallery into a social space providing food, dentistry, or therapy, and the hulling of artforms down to affective transfer. A signature work: large empty square room, gray walls, and gray polished concrete floors, two unvarnished wooden chairs, one woman seated.[3] Via a performance that is also an installation that is foremost an encounter, the artist Marina Abramović offers her mere presence, ten hours a day, most days a week, for three

experiences of discrete mediums." Anna Schechtman, "The Medium Concept," *Representations* 150:1 (May 2020), 67.

2 Boris Groys differentiates installation from exhibition in "Art and Money," *e-flux* 24 (April 2011), e-flux.com. For Groys, the inclination to installation, and the broader injunction to circulation beyond objectification—to art experiences rather than artworks, to propagating information about art beyond exclusive encounters with art, to happening rather than contemplation—are basically positive developments. He associates circulability not only with democratic access but also with a "revolutionary" "acceleration of the world of flow" and to a metaphysically more honest "synchroniz(ing) with the flow of time." *In the Flow* (London: Verso, 2016).

3 Miranda Siegel, "Water Definitely Not Included," *New York Magazine*, May 2010, nymag.com.

months, a custom bedpan insuring against absence.[4] Testimonials from spectators enthuse "a transforming experience—it's luminous, it's uplifting, it has many layers, but it always comes back to being present."[5] *The Artist Is Present* realizes its title exactly, and presence overflows the constraints of modality, medium, even venue. Presence itself is the work; relational aesthetics do not produce a contoured or commodified object so much as a happening that defies representation: medium redacted, charisma magnetizes.

One low, one high, immersive unmuseums and social practice art meet in this immensity of presence that excises medium, an enterprise that also underlies the artworld's most notorious hot trend: nonfungible tokens. NFTs are digital items like an image or sound clip, laden with indivisible metadata certifying the authenticity of cryptocurrency transactions. The computational energy for the certifications ("mining") has reached around 143 annualized terawatt-hours—more than the entire country of Argentina. Not all of this planetary arson masquerades as art, but the art NFT's astronomical market growth ($200 million in just the month of March 2021, compared to $250 million in all of 2020) includes a recent record-setting art auction at Christie's: $69 million for a group of images called *Everydays*—the third most expensive sale ever of a work by a living artist (Beeple).[6] Crucially,

4 "I understood that . . . I could make art with everything . . . this was the beginning of my performance art. And the first time I put my body in front of [an] audience, I understood: this is my media." "Marina Abramović: Early Years," moma. org. For theorization of other such artworld projects, see Claire Bishop, *Artificial Hells: Participatory Art and the Politics of Spectatorship* (London: Verso, 2012).

5 "The Artist Is Present," *MoMA Learning*, moma.org. For more on presence in contemporary art, see Hito Steyerl, *Duty Free Art: Art in the Age of Planetary Civil War* (London: Verso, 2017): "The idea of presence invokes the promise of unmediated communication, the glow of uninhibited existence, a seemingly unalienated experience and authentic encounter between humans. It implies that not only the artist but everyone else is present too, whatever that means and whatever it is good for. Presence stands for allegedly real discussion, exchange, communication, the happening, the event, liveness, the real thing—you get the idea" (22).

6 Sales data provided by the market tracker nonfungible.com and reported in Andrew R. Chow, "NFTs Are Shaking Up the Art World—But They Could Change So Much More," *Time*, March 22, 2021, time.com.

what was sold was not the "work" of art (since, as the Christie's listing proclaims, the owner of the NFT "does not bear exclusive rights to view, access, or reproduce" the item; the works are not securely archived, nor does the owner hold a legal title) but only the metadata encoded in it—an unforgeable authentication of provenance itself, owning ownership. Through this encoding, objects that freely circulate are endowed with a nonreplicable element of scarcity: the unique entry in the blockchain ledger, compiled through the paradoxically anarchic fiat of networked computing. Whether or not NFTs will become regulated in the future, in this moment the euphoria they incite hinges upon the deinstitutional character and the singularity of the ledger entries. Art that is bought and sold already consolidates the experience of aesthetic value with the asset function of capital value—not merely "money on the wall," as Andy Warhol once put it, but "inflation hedging," as the Deloitte consulting firm now holds it.[7] NFTs perform by contrast a liquidating: scrapping money as the medium of value (replacing institutionally authenticated value with unique transparent encoding by decentralized actors) while also stripping the dimension of aesthetic value from art.[8] In this reduction of sensory experience or beauty and this deflation of asset or currency into irreducible expression, art NFTs squeeze the abstraction "value" into a new unique expressive indivisibility:

no abstract equivalent—only concrete discrete metadata;
no central bank—only dispersed servers;
no aesthetic property—only unreplicable code.

Prolific splainers in the recent art and business press have not yet ciphered the allure of this distributed concretude, but juxtaposed with full-body-pose-impressionism and the social practice of

7 Deloitte, "Seeing the Bigger Picture: Arts, Collectibles and Wealth Management," 2014, www2.deloitte.com.

8 Ben Davis, "I Looked Through All 5,000 Images in Beeple's $69 Million Magnum Opus. What I Found Isn't So Pretty," *Artnet*, March 17, 2020, news.artnet.com.

charismatic presence, art NFTs bespeak a bourgeoning cultural compulsion: to have done with mediation.

In the eminent tradition of aesthetic theory, "mediation" means the *active process of relating*—making sense and making meaning by inlaying into medium; making middles that merge extremes; making available in language and image and rhythm the super-valent abstractions otherwise unavailable to our sensuous perception—like "justice" or "value." Now, this middling falters. Yoga in the strobe lights, bedpan chair-sits, and metadata liberated from financial reserve institutions: these three incongruous vertices of contemporary aesthetics together illustrate that art is drooping. The medium is the missing. Conventionally, art takes up a discernable medium and takes creative distance from ordinary communication or banal functionality, making an appeal to the senses that reroutes common sense. A painting isn't an efficient way to send a message or achieve a goal, but beholding its inefficient indirection can stimulate thought. In the current climate, though, art renounces its own project of mediation. Directness and literalism are the techniques; immersiveness and surety are the effects. If we forward-fold, we incorporate van Gogh; if we meet her gaze, we incarnate Abramović; if we buy Beeple, we invest securely. Short-circuiting allusion, a pressure throbs: get it.

There's no accounting for taste, but what accounts for these recent consistent pressures against mediation? The beginning of an answer lies in the commonality between these art trends and the dynamics of twenty-first-century capitalist production and circulation. For it turns out that this urge to cut out the middle-man does not upraise art so much as merge it with a sweeping spate of other social and commercial activities, from gig labor to self-publishing to e-brokerage. The big business of "disinter-mediation" accompanies the aesthetic happenings we're observing: flexibility and fluidity, emanation and connectivity, directness and instantaneity are economic premiums as much as they are artistic ones. And it is this confluence that coheres a cultural style: "immediacy."

immediacy

Immediacy crushes mediation. It is what it is. Self-identity without representation, ferment with "no words." The prefix "im-" connotes that negation—in the middle without intermediary, #NoFilter—as well as a prepositionality: the inness or onness of immersion, intensity, and identity. An estate of direct presence, always on, continuous, abundant, sui generis. Immediacy's pulsing effulgence purveys itself as spontaneous and free, pure vibe. Let it flow, let it flow! But in this imperative lies a grind.

Immediacy, or, The Style of Too Late Capitalism presents immediacy as a master category for making sense of twenty-first-century cultural production. Immediacy rules art as well as economics, politics as much as intimacy. It's at the art auction, in the boardroom, in the lingo, on the brain. Exacerbating this hegemony, immediacy animates even contemporary critical theory that now sidles too close to its objects, embracing rather than disarticulating dominant logics. Labeling this everythingness is a gesture toward reestablishing theoretical distance, though initially grasping the problem is tricky—a list-y, circuitous, roving vibeology.

The colloquial connotation of immediacy as "urgency" underlines the temporal dimension of this style, a hurry-hurry that compresses time into a tingling present.[9] Spatially, immediacy encloses while delivering everything close: the world at your fingertips; "Let's go places." The flexible psychology surfing

9 Time-space compression is constitutive of postmodernity in David Harvey's account, and similarly, liquidity is constitutive of modernity for Zygmunt Bauman. See David Harvey, *The Condition of Postmodernity: An Enquiry into the Origins of Cultural Change* (Malden, MA: Blackwell, 1990), and Zygmunt Bauman, *Liquid Modernity* (Cambridge, UK: Polity, 2000). Lauren Berlant, in *Cruel Optimism* (Durham, NC: Duke University Press, 2011) describes the historical sense of the present as "affectively . . . immanence, emanation, atmosphere, emergence" (6). Immediacy's temporality might thus be understood as this presence without future.

these urgencies and proximities is self-possessed and transparent: "Speak your truth!" "Live your best life!" "You do you!"—the auto-actualization of human capital. Immanentist theology congeals this realm of ken in an unholy mix of instantaneity and eternity, presence identical to itself, the moment refreshed, Buddha at the gas pump on the mindfulness plane of continuity. Individuated epistemology ("Do your own research!") ensues from alternative facts, horseshoe both-sidesism, faux news, and personal-pan propaganda. Ideological variants of immediacy include virulent opinionism, cults of charisma, nihilist absolutism, and ecstatic anarchy. Its politics eschew organizations and institutions in favor of organic horizontalism, aleatory uprisings, and local autonomy; its adherents refuse vehicles of power while enthusing the omnipresence of power, and rhapsodize the immutability of domination, exonerating inertia. And underlying all these compressions and expressivities is the economy of hurry and harry, same-day shipping and on-demand services, where the ease of one-click buying covers up a human hamster wheel, and innovative circulation pulls off a just-in-time deflection from the multi-decade crisis in capitalist production.

Immediacy is out there everywhere: the basis of economic value, the regulative ideal for behavior, the topos of politics, the spirit of the age—so, if the category works, other indications should flash to mind now. In the following pages, we'll track many manifestations and analyze economic and technological determinations, while according special consideration to aesthetic compositions, those strata of culture where mediation usually shows itself—like art, literature, or TV. Think of how the vanGoghga negates medium by decomposing the frame of the painting in chase of overdrawn affectivity. Similarly, contemporary literature repudiates representation itself, dismantling narration, character, plot, and the smoke of myth in favor of simply manifesting viscerally affecting stuff. Fiction makes me nauseous, the writer Karl Ove Knausgaard avers on the page, and reams of twenty-first-century writers incubate this malaise, in

unalloyed unbosoming via radiant voice. In televisual production, massive platforms drown in content whose immanentized cinematography and genre fluidity formally anticipate the cascade of the stream: I'm watching you watch me, the TV protagonist Fleabag avows directly into the camera. Like "socially engaged" art, such bids for unboundedness pit themselves against the artifices of mediation, breezing in as lustrous manifestation. Though they appear as singular sensations, these arts serialize a cultural cloth in which ardor surges, acuteness pounds, and medium melts, exscinding the strictures of representation.

Immediacy's propensity to quiver with extremities minimizes art's capacity to imaginatively break with the merely given. And this demission now compromises cultural theory too. In the history of philosophy, in work from Aristotle, Hegel, Marx, Lukács, Adorno, Raymond Williams, Stuart Hall, and others, "mediation" evokes the social process of making representation, connections, and meaning—which often reveals that the merely evident or intransitively existent does not already make sense. Immediacy style short-circuits and preempts this social process, swelling with self-identical thisness. Its reign in culture has evaded critical analysis because of its obvious appeal, but also because cultural theorists have succumbed to its intoxications. Across a wide variety of disciplines, theorists propagate the style in both form and content, denouncing abstraction while enthusing concretudes, writing in conspicuously "postcritical" modes like acafandom and autotheory to extol entanglement, the body, and tautological haecceity. Eating the real with a spoon.

style

A matrix of contemporary meaning, immediacy booms in pop ontology and quotidian epistemology, in official wisdom and *Oprah* magazine, in low art and high theory. To call this great general sway a "style" is to underline its obscured particularity:

immediacy swallows everything, but it is still discrete. Its peculiar insistence that mediation recede makes that special manner harder to perceive; immediacy style ferries the paradox of anti-style.

From the Latin for pencil or pillar, "style" denotes marks, the lineating that brings a thing into being. While colloquialisms oppose style to substance, it is tricky to actually disentangle the two, since style simultaneously augurs "semblances, referring to how things generally seem, look, or appear" and vests essences, what is definitional for such "things."[10] At once appearance and essence, style also straddles purpose and purposelessness: even though in fashion the de rigueur adjective for style is "effortless," style often precisely indicates deliberateness, exertion, and target beyond the haphazard. And, as a classification of a certain place, person, period, or proclivity, style provides a heuristic for history; a style category grasps specificity stamped in time.

As small as how a novelist uses verbs (Henry James famously likes to nominalize them) or as diffuse as the rituals that comprise a zeitgeist (pandemic-era mask refusal as mass enactment of our nonsociety), style marks the features of an event, era, text, or form as having been made. It thus indexes work: effort was expended to configure a *what* in this particular *how*. It could have been different. Style also indexes constraint: we make art, but not in conditions of our choosing.[11] Exertions within limits, style finally connotes nothing other, critic Michael Dango argues, than "action": neither the affective expectations of genre nor the structuring affordances of form, but an ongoing adaptation or

10 Sianne Ngai, *Our Aesthetic Categories: Zany, Cute, Interesting* (Cambridge, MA: Harvard University Press, 2012), 29.

11 Leonard Meyer explores style as defined by the set of constraints within which a choice can be made. *Style and Music: Theory, History, and Ideology* (Chicago, IL: University of Chicago Press, 1997). Karl Marx writes: "Men make their own history, but they do not make it as they please; they do not make it under self-selected circumstances, but under circumstances existing already, given and transmitted from the past." *The Eighteenth Brumaire of Louis Bonaparte* (1869 [1852]), chap. 1, trans. Saul K. Padover, available at marxists.org.

accommodation, "how we continue to move around in the world . . . we cannot not act; we are always doing something."[12] "Style" is a theoretical name for the particular way busy people do things all day, the flavor of living and imagining in an osmotic present. That things as they are simply continue euphemizes what Theodor Adorno and Max Horkheimer pinpoint, in their monumental study of "the culture industry," as "style's secret: obedience to the social hierarchy."[13] Style is not just this maintenance of hegemony though; as Adorno and Horkheimer also argue, it stashes a "promise" to disclose the general truths of its context and convoke general subjects.[14] Through this promise, through the imprint of its efforts and constraints, style outreaches what might appear as the merely aesthetic or idiosyncratically individual and, rather, piques social and collective dynamics— like how work is organized, how creativity is exercised, how value is assigned. For these and other reasons, the analysis of style frequently intrigues critics and scholars of politics and the political.[15]

Style individuates, but culture is common and "ordinary"— the shape, purposes, and meanings, Raymond Williams formulated, that every society expresses.[16] "Cultural style" is therefore something of an oxymoron, what is particularly general. Moreover, style bespeaks unity, while culture is admittedly heterogeneous, which led Fredric Jameson to prefer a term like

12 Michael Dango, "Not Form, Not Genre, but Style: On Literary Categories," *Textual Practice* 36:4 (2022), 501–17.

13 Max Horkheimer and Theodor W. Adorno, *Dialectic of Enlightenment: Philosophical Fragments*, trans. Edmund Jephcott (Stanford, CA: Stanford University Press, 2002), 103.

14 "In every work of art, style is a promise. In being absorbed through style into the dominant form of universality, into the current musical, pictorial, or verbal idiom, what is expressed seeks to be reconciled with the idea of the true universal. This promise of the work of art to create truth by impressing its unique contours on the socially transmitted forms is as necessary as it is hypocritical." Ibid., 103.

15 For more on this intrigue in the Marxist tradition especially, see Daniel Hartley, *The Politics of Style: Towards a Marxist Poetics* (Boston: Brill, 2017).

16 Raymond Williams, "Culture Is Ordinary," in *Resources of Hope: Culture, Democracy, Socialism* (London: Verso, 1989), 3–19.

"cultural dominant": what characterizes a culture is more likely a hegemony rather than a unity.[17] This question of dominance calibrates the scale at which a cultural style can reveal itself, a degree of remove that risks beclouding particular instances. Arguing for the commonality between streaming aesthetics, literary fiction, contemporary art, and digital platforms surely underplays some differences. Notwithstanding all of these difficulties in the analysis of style, the wager that it is possible to identify and theorize cultural style pays off in the revealing ways overarching generalities can texturize particularities. As poetry scholar Jeff Dolven puts it, "Style holds things together, things and people, schools and movements and periods. It makes us see wholes where we might be bewildered by parts. But it makes us see parts, too."[18] "Immediacy" names a unifying logic that should also aid us in interpreting separate instances; if we want to understand what is going on with mediation, what is up with immersive art or cringe TV or antifictionality, it helps to theorize their categorical commonalities.

The paradox of immediacy is a cultural style that imagines itself unstyled. As such, it nixes many regular frames for interpretation. In the habitual "substance versus style" contrast, for example, ordinary information conveyance detaches from extraordinary bedazzling: "style is understood as emphasis (expressive, affective, or aesthetic) added to the information conveyed. Language expresses and style stresses."[19] In immediacy, though, the express/stress difference falls away; to express is to stress. Similarly, if style often pins historical context, immediacy's temporality of instantaneity resists tether. Where stylization palpates the seams of its own appearance, immediacy's metaphysics of presence chafes against representation. And wherever

17 Fredric Jameson, *Postmodernism; or, The Cultural Logic of Late Capitalism* (Durham, NC: Duke University Press, 1991), 4.

18 Jeff Dolven, *Senses of Style: Poetry before Interpretation* (Chicago: University of Chicago Press, 2017), 1.

19 Michael Riffaterre, "Criteria for Style Analysis," *WORD* 15:1 (1959), 155.

art slants, immediacy pools, in medium dissolve and ad-lib unformedness. The critic's task is to orient amid all this swirl— to situate immediacy's priorities of immersion, intensity, and instantaneity within the grid of values that define the twenty-first century.

too late capitalism

What makes those values distinct? *Immediacy, or, The Style of Too Late Capitalism* grapples with how the present diverges from the past: something is different, even though much is also the same. "Late capitalism" has been a Marxist term of art for this different sameness for more than a century, used to describe everything from post–Great War market integration to postwar prosperity to 1970s stagflation to millennial leverage busts, but it is perhaps most famously associated with Fredric Jameson's now forty-year-old argument for postmodernism as the logic of cultural production in the 1980s and '90s.[20] Critics increasingly agree that postmodernism no longer furnishes the logic of the contemporary.[21] Does any such thing as a cultural dominant

20 See Werner Sombart, *Der moderne Kapitalismus* (Berlin: Duncker & Humblot, 1902); Theodor Adorno, "Late Capitalism or Industrial Society" (1968), available at marxists.org; Ernest Mandel, *Late Capitalism* (London: Verso, 1972); Jürgen Habermas, "What Does a Crisis Mean Today? Legitimation Problems in Late Capitalism," *Social Research* 40:4 (Winter 1973), 643–67; Jameson, *Postmodernism*. For some genealogy, see Peter Osborne, "The Postconceptual Condition; or, The Cultural Logic of High Capitalism Today," in *The Postconceptual Condition* (London: Verso, 2018).

21 See Andrew Hoberek, "After Postmodernism," *Twentieth Century Literature* 53:3 (Fall 2007), 233–47; Jeffrey Nealon, *Post-Postmodernism; or, The Cultural Logic of Just-in-Time Capitalism* (Stanford, CA: Stanford University Press, 2012); Mitchum Huehls, *After Critique: Twenty-First-Century Fiction in a Neoliberal Age* (Oxford: Oxford University Press, 2016); and Lee Konstantinou, "Four Faces of Postirony," in *Metamodernism: Historicity, Affect, and Depth after Postmodernism*, ed. Robin van den Akker, Alison Gibbons, and Timotheus Vermeulen (London: Rowan & Littlefield, 2017), 87–102. For a different approach, see Nathan Brown's argument that stylistic differences, however evident, do not bespeak economic differences, since modernity abides as long as we remain in the

come after? Periodization in too-short bursts belongs to mainstream historicization as well as to the very rhythm of instantaneity culture with which this book is out of step. But, even so, the gamble here is that immediacy comprehensively unifies contemporary culture, and that its capitalist substrate takes definite form. It's still capitalism after all these years. Only now, the economic dynamics of the 1970s that were first registered in postmodernism have been compounded by those of the turn of the millennium (audited below in "Circulation"), and they modulate themselves in today's cultural aesthetics differently. "Too Late Capitalism" titles that difference: a contradictory moment where the overmuchness of lateness arrests itself. Future-eclipsed, present-immanentized, "Step on it!" immediacy.

After postmodernism's skepticism and irony, immediacy's authentications and engrossments now plat realness. Where postmodernism revels in mediation—intertextuality, irony, the meta—immediacy negates mediation to effect flow and indistinction. Where postmodernism aesthetically activates pastiche, a "blank," playful "heterogeneity without a norm," immediacy precipitates blur, a demediated meld that lacks the contours to array heterogeneity.[22] Where postmodernism aesthetically and epistemically embraces the surface and eschews depth, immediacy mires itself in profundities of corporeality, affect, and polarized extremity. Where postmodern affect undergoes "waning"—a dilution of modernist ferocity like anomie and alienation into "free-floating" flatness—immediacy's affects wax rapt and veritable.[23] Where postmodernism inscribes "a crisis of historicity," immediacy encodes a crisis of futurity, a beclouded nonhorizon.[24]

capitalist mode of production: Nathan Brown, "Postmodernity, Not Yet: Towards a New Periodization," *Radical Philosophy* 2:1 (February 2018), n.p.

22 Jameson, *Postmodernism*, 17.

23 Ibid., 10–11, 15–16.

24 Fredric Jameson, "Postmodernism, or the Cultural Logic of Late Capitalism," *New Left Review* I/146 (July/August 1984), 69.

Blur, immersion, presence: too late is no longer merely late. The material corollary of this stylized time is the inevitable environmental ruin wreaked by undead zombie capitalism. It is too late. Ecocide has already taken place. Lethal deluges, catastrophic droughts, and heat death are already baked into our future. The earth is hotter now than at any moment in the last 125,000 years. No matter what happens tomorrow, sea levels will rise six to twelve inches over the next two decades. Two billion people worldwide are currently living on land that will soon be either uninhabitably hot or well underwater, or both. There is no going back. Already in 1988, the first United Nations Framework Convention on Climate Change compiled enough terrifying data to compel virtually every country on earth to recognize the severity of climate change, commit to mitigating greenhouse gases, and do so in accordance with a principle of "common but differentiated responsibilities and respective capabilities," acknowledging wealth, power, and contributory inequities; thirty years later little action has ensued.[25] A small number of hyperconsuming billionaires, their oligarchic plutocratic enablers, and syndicates of lumpen McShoppers have irreparably degraded the planet, ergo billions of people will be displaced and killed. The world's wealthiest 10 percent are responsible for 50 percent of carbon emissions, which have skyrocketed in direct proportion to our undeniable knowledge of their catastrophic effects. Scorching temperatures and rising waters aren't the only effects; along with biodiversity collapse there is also the horrific reality that concentrated carbon dioxide levels compromise cognition, diminishing the human brain's ability to think strategically, react patiently, or read theory books for the hell of it. In the near future, we will be hot and imperiled and stupid. It is too late.

The ideology of immediacy holds a kernel of truth: we are fastened to appalling circumstances from which we cannot take distance, neither contemplative nor agential, every single thing a

25 "History of the IPCC," Intergovernmental Panel on Climate Change, ipcc.ch.

catastrophe riveting our attention. The very narrow window is slamming shut, and for many it has already been nailed. The country whose economic might and imperial extraction have fueled global carbonization staggers from domestic delegitimation, corruption, fascism, and utter abandon of the elementary offices of government—and many other governments follow in its suit. The crucible of ideas perpetuating this political order, the world-class research university, sometimes fostered its elucidative critique, along with humanistic flourishing, civic literacy, and paths to dignified labor and upward mobility—but now finds itself stripped for parts. Murdered earth, failed states, and razed institutions are structural context for the ongoing categorization, racialization, and expulsion of human beings. Countless abjects persist in a class of surplus population: outside any regular wage relation, cut off from institutions unless held captive by them. Twelve million people in the United States alone were officially classified by the Bureau of Labor Statistics as "unemployed" prior to the pandemic, a distressing throng that nonetheless omits the 2.3 million people (of 10 million worldwide) incarcerated. Near-future dislodgement will irreparably enlarge this caste. The mediating function of the state and social institutions has dissipated into only corporate welfare, and the industry of securitization enforcing this depredation has exploded.

Expulsion, immiseration, incarceration, crisis: these are the quicksand grounds of immediacy. The more dehumanizing our world becomes, the more gross the failures of human society, the more splintered the efforts at collective transformation—the more tightly immediacy cinches. The material irrefutability of catastrophic ecocide, the historical outmodedness of this irrational and immiserating capitalism, the epidemic of depression and anxiety, declining life expectancy, domestic abuse, mass violence, mass incarceration, and the group-differentiated vulnerability to all these terrors (to slightly bend Ruth Wilson Gilmore's definition of racism)—these deformities tar existing sociability, begetting atomistic absorption and evanescent egress

as its only alternatives.[26] When the mediations of society miscarry so systematically, it begins to look as if mediation itself is to blame.

Crushing lateness and routinized abjection increasingly limit imaginative departures from reality. The petrodepression hellscape is quashing creativity; the novelist and critic Amitav Ghosh's observation of literary narrative that "the climate crisis is also a crisis of the imagination" might be extrapolated to encompass aesthetic inspiration as such. Immediacy's abdication of art evinces this crisis. Artistic mediation—representation in excess of messaging, creativity in excess of use, giving sensuous form to the unexpressed—has always been a fundamental human activity. The oldest archeological evidence of artwork, an ochre crayon drawing of seven lines, dates from 70,000 years ago. When *Homo erectus* was capable of speech but not yet writing, before humans began ritual burial of dead or to create clothing from animal hides, before what is now called "behavioral modernity," there was already abstract mediation—underlining that art is not epiphenomenal to life.[27] Immediacy's evacuation of mediation eclipses this essential dimension of human being—an extinguishing hard not to interpret as a response to the imminent threat of human extinction. Climate collapse, war, the wanton degradation condemning us to heat death, swelling waters, and diminished cognition hardly need allegories—but the contemporary undoing of mediation surely provides one. The expressivist intensities of collapsed representation—a claim to be more real than made up, a dissolve of the bounds of medium into experience, an emission of inner selves without boundary—comprise

26 "Racism, specifically, is the state-sanctioned or extralegal production and exploitation of group-differentiated vulnerability to premature death." Ruth Wilson Gilmore, *Golden Gulag: Prisons, Surplus, Crisis, and Opposition in Globalizing California* (Berkeley: University of California Press, 2007), 28.

27 Nicholas St. Fleur, "Oldest Known Drawing by Human Hands Discovered in South African Cave," *New York Times*, September 12, 2018, nytimes.com. Abstract painting is 70,000 years old; figurative paintings have been discovered in both Europe and Asia as old as 40,000 years.

delugent subsidences that put mediation into duress and under erasure. Urgency; extremity; no future, only presence. Party before the lights come up.

Shit is very bad. The umbrella tradition of post-Adorno critique to which this book belongs has often confronted a terrible world only to find in popular culture the weapons of mass distraction. "Amusement in late capitalism is the prolongation of work"; sure, toil is tedious—but doesn't this rom-com delight?[28] Escapism and diversion on the big screen enable exploitation and discrimination in the daily grind, even as they also preview a freedom from active work. But the mode and genres of immediacy now suggest a different function for favored entertainment: not evasive delusion *about* but deeper enthrallment *in* the spectacle of mass abjection, an enveloping total sensory engagement with too-real social distortion. Faddish genres like cringe and edgy sci-fi practice exposure and extremity, magnetizing us infrangibly to the brutalizations of the known world. If past crises like global war or nuclear annihilation yielded mediums and media shaped by fracture and fragmentation, rupture and disorientation, the metastasizing crises of the twenty-first century seem to beget something else: total absorption, the loss of mediation itself. In this way does immediacy offer itself in response to raging omnicrisis while taking too much of its logic from the flames.

Of course, omnicrisis devours us. Of course, immediate interventions and immediate solutions simply match the violent sordidness and political extremism attending the wholesale destruction of the habitable earth. Of course, flow portends balmy reprieve from the desert of alienation, a utopian mirage in immediacy style. However, a core argument of this book is that immediatism is a reaction to crisis that fails the bar of strategy, a reflex that is ultimately crisis-continuous. A working out of

28 Theodor Adorno and Max Horkheimer, *The Culture Industry*, trans. J. M. Bernstein (London: Routledge, 2001), 7.

species death that is also a covering over, immediacy presses to be interpreted as a symptom, an unavowable but irrepressible truth routed through forms of expression or stylization that at once avoid and announce it. In this ambivalent structure, immediacy style alludes to a desire for mediation while also ideologically enjoining us to enjoy our devastation. Amid crisis, alienation, and stratification, immediacy feels right: urgent, engaging, homogenizing. But this is pharmakon: remedy and poison in one. Working through rather than working out would involve cognizing that it doesn't have to be this way. It is too late at the same time as it is not too late.

Patience, distance, circumnavigation, imaginative distortion, and prolonged attention are resources and mitigants for disastrous mechanization—and they are forsworn by urgency, however well meant. Applicative reason reduces critical thinking and creative exploration to profit maximization, problem solving, and vocational training—and then we worsen those reductions in demanding topical, transparent art. Calculative and extractive regimes seek value at the surface—and we condone that value regime when we mistake confession and self-expression as tactics against the predations of privatization. The world's proliferating abasements continually render immediacy more seductive and continually inflate its apparent purchase, obscuring immediacy's own role in immiseration. Immediacy impedes the public, conceptual, and reasoned mediations that are essential to limiting the devastations of deinstitutionalized society, privatization, and ecocide, and crucial for imagining different frames of value, meaning, representation, and collectivity.

Too-lateness as a condition for climate affect and cultural style heats up the present, but, were we to dialecticize our relation to time, this extremity could ordain action rather than resignation. Every past deed of oligarchic malfeasance now come to light, every terror come home, every threshold exceeded nevertheless admits the possibility of more amelioration. Too-lateness pegs the hopelessness that contrasts the hopefulness pinged in

"late" capitalism's anticipation of an end. And yet, hopelessness is not self-identically fatalist; a kind of radical hopelessness that dares refuse the old promissory and progressive logics of capitalist growth could open political horizons. Such openings need not be novel: old forms, outmoded institutions, and residual constructs still have more to offer. Diagnosing too-lateness as it materializes in the style of immediacy shouldn't be an invitation to melancholy so much as an incitement to collaboration: it's not too late—things can still be less worse.

the book medium

The organization of this book undertakes the work of articulating connections and causes, remediating immediacy by moving from context and general phenomena to specific mediums: writing, moving images, critical paradigms. For context of what is historically and technologically specific about immediacy, chapter 1, "Circulation," analyzes the contraction of global productivity over the multidecade era now recognized by Marxist theorists and establishment economists as "secular stagnation" to interpret the emphasis on speed and flow in the microelectronic and logistical revolutions as intensification of the circulation (but not production) of value. Chapter 2, "Imaginary," probes the subjective sides of networking technology through a focus on the circulation of images, with a theoretical assist from psychoanalysis and its concepts of the imaginary, symbolic, and real, outlining a materialist explanation for what is misdiagnosed as a raging narcissism epidemic. Chapter 3, "Writing," pursues the destruction of fictionality and dismantling of representation in multiple modalities of literature that center individual experience, private perspective, and personal voice, studying a dramatic mutation in the history of the novel as well as casualization in university labor and the publishing industry. Chapter 4, "Video," argues that the technological and economic processes of

streaming are now materializing in stylistic features of moving-image arts like front-facing camera, universe sprawl, spectacular sadism, and eternal looping. Finally, chapter 5, "Antitheory," exposes how, in both content and form, contemporary critical study propagates immediacy rather interpreting it, propounding flatness, entanglement, nihilism, and indistinction, all against the function of criticism to make a cut. These various media of immediacy style do not range all its amplitude (with luck, readers will find inspiration to further analysis, of music or fashion or more), but they do sound out the dystopian syncing in present cultural production.

As this preliminary discussion suggests, understanding immediacy as style involves aesthetic description, historical periodization, an inquiry into causality, and a flirtation with the encyclopedic. These are operations of analysis that fulfill theory's task to attain a meta-reflection on the production of ideas, including theoretical ideas. Traditionally, theory has been able to take a push toward this mediating function from art itself. Art constitutively thwarts immediacy, urgency, and utility; its most direct use rests in this indirection—but today's immediatist art aspires to void itself, and theory has been following in its wake. Recalling a different vocation for both art and theory requires esteeming mediation at the outset. Adorno writes: "By the affront to needs, by the inherent tendency of art to cast different lights on the familiar, artworks correspond to the objective need for a transformation of consciousness that could become a transformation of reality."[29] Jameson ramifies this task of art into the task of dialectical theory:

> It must not cease to practice this essentially negative hermeneutic function (which Marxism is virtually the only current critical method to assume today), but must also seek through

29 Theodor Adorno, *Aesthetic Theory*, trans. Robert Hullot-Kentor (Minneapolis: University of Minnesota Press, 1997), 243.

and beyond this demonstration of the instrumental function of a given cultural object, to project its simultaneously Utopian power.[30]

Like art itself, critical theory defamiliarizes and reconceptualizes in order to build. In refracting the pressing need to address social calamities into the multidimensional need to reconstitute the social, mediations wield their own formedness—their qualities as artistic detour, their aspects of theoretical abstraction—toward forming, reforming, transforming. Artforms and theory alike demand the slow and uncertain work of making sense, countering immediacy with mediation.

Even in the present straits, this capacity for mediation spurs art and theory forms that continue to create impersonality against privatization, objectivity against subjectivity, speculation against phenomenality, formalization against formlessness. Beyond the diagnostic gestures of the book's descriptive effort, the conclusion studies constructive alternatives, highlighting examples from cultural history, the minor contemporary, and theoretical traditions through which generative mediation abides. A cranky puncturing of beloved commodities is no fun, but fun bubbles in lingering with countercultural projects that withstand the imperative for immediacy. Some works still revel in figuration, abstraction, and the antiphenomenal marvel of fiction. And mediate forms are not just relics of the past, old novels and outmoded art, Jane Austen's novels or Eugène Atget's stills—though those prove wonderful too. Mediations remain residual and spring emergent, peripheral but powerful, waiting at the margins of contemporary aesthetics, in forms that activate older modes of representation or that confabulate new mediacies, like Colson Whitehead's third-person novels or Edward Burtynsky's impersonal photography. In concluding by showcasing these

30 Fredric Jameson, *The Political Unconscious: Narrative as a Socially Symbolic Act* (Ithaca, NY: Cornell University Press, 1981), 291.

alternatives, and the lessons and strategies we may glean from them, *Immediacy* strives to achieve critique's promise for affirmative synthesis.

Generative works critically depart from the ideology of the contemporary, holding open a portal for other departures. The many macroeconomic and psychic and intellectual determinants of immediacy want us to stay—in the moment, in the midst, in the wound. The more our crises imperil careful metabolization or disinterested study, the fewer institutional and social opportunities for interpretative learning, the greater the exigency of tactics and strategy sundered from visions and projects, the worse the fate of mediation. These binds render all the more precious those group practices with the capacity to orient broader efforts for mediation and social transformation. We creative types can generate dialectical images and poems and novels and art that precipitate new passages from the mesmeric imaginary to the sticky symbolic. We teachers have a special opening—our classrooms can be clinics of mediacy where we thicken the symbolic, estrange language, closely read, uncover unknowns, slow down, value impersonality, construct objectivity. We activists working to collectively confront the unevenly distributed catastrophe of our extinction thanks to capitalogenic climate crisis can challenge the immediatist tendencies of enisled localism and spontaneous anarchism, revalorizing the mediating function of forms like the party, the union, the state. We theorists especially owe our colleagues the engagement in real disagreement about the limits of so many paradigms of concretude, expressivism, and nihilism, carrying out our work instead as speculative synthesis and capacitating abstraction.

Writing a book makes little intervention in the extensive and entrenched material conditions and ideological formations of too late capitalism. But the aim of these words is to formulate new concepts that remediate immediacy. Such an aim is still possible thanks to remnants of prior cultural constructions—tenure and research fellowships and academic presses and the

institution of theory—and to the enduring capacities of language and other collective forms to collocate relations. In these pages, the work of categorizing and synthesis inlays the ubiquitous phenomenon of immediacy style into the medium of theory. Across this study, we will break with the merely apparent and the self-evidently important, estranging the new norms. Arguments for the historical roots and economic causes of style will interrupt immediacy's presentist immanence. Prolonged attention, belabored descriptions, and counterintuitive pattern recognition will, one hopes, withdraw from immersiveness. Checking the individuated "I" complex of the private contemporary will motivate the convocation of a "we," a mediated subject of collectivity that urges flourishing. And counterintuitive tropes or nerdy prose will surprise immediacy with a style makeover.

All of these strategies of theory will fall short of cultural transformation. Words are but tiny stoppers against the tide of immediacy. In the extremity of too late capitalism, distance evaporates, thought ebbs, intensity gulps. Whatever. Like the meme says: get in, loser.

Circulation

Immediacy is deluge without staunch, a stylized flood of intense immanence in cultural aesthetics that eerily conforms to contemporary conditions of oil swells and aquatic surges. Water out of place is already defining the twenty-first century, and fluid-motion conflicts will only increase. Eighty-four percent of North America's fresh water sits in the Great Lakes. At the mouth of the largest, Superior (also the world's largest), protestors have been mobilizing for years to obstruct construction of a pipeline ferrying crude across the watershed under the management of a company with a disastrous track record of spilling millions of gallons of oil into the lakes. Anishinaabe lands are violated by the project; people of the White Earth, Red Lake, and Mille Lacs nations have all sued; the governor of Michigan has revoked the company's permits. While these routine legal measures do little to stem the tide, activists are mobilizing. A dexterous coalition of Indigenous and environmental protestors in Palisade, Minnesota, blocks the movement of heavy-duty equipment—for the sake of precluding the stream of oil, for the sake of protecting the flow of water, for the sake of the living beings who need it to survive. Sites of such protest are multiplying in the twenty-first century, as elders like Louise Erdrich and scholars like Jeff Insko, Charmaine Chua, and Joshua Clover all note.[1] Masses of bodies

1 Louise Erdrich, "Not Just Another Pipeline," *New York Times*, December 8, 2020, nytimes.com; Jeffrey Insko, "How to Dream beyond Oil," *Public Books*, July 12, 2021, publicbooks.org; Charmaine Chua, "Logistics, Capitalist Circulation, Choke-points," *The Disorder of Things* (blog), September 9, 2014, thedisorderofthings.com;

align to disrupt the flow of oil, goods, and traffic, from Midwest pipelines to New York's High Line, shipping ports to airports. This salience of blockades in contemporary political struggle reveals the indispensability of "flow" for the current order of things.

Fluid, smooth, fast circulation, whether of oil or information, fuels contemporary capitalism's extremization of its eternal systematic pretext: things are produced for the purpose of being exchanged; money supersedes its role as mediator of exchange to become its end point; the means of circulation become the end of circulation; as economic geographer David Harvey observes, "when circulation stops, value disappears and the whole system comes tumbling down."[2] The price for this velocity in the present is outrageous destruction: pipeline leaks, atmospheric carbonization, planetary arson. And, in turn, these elemental calamities betide immediacy as cultural style. Flow as essential value for this aesthetic swells from flow as essential value for the twenty-first-century economy. This premium on circulation is historically distinct, and the story of its coursing importance is a juicy one.

secular stagnation

Not only radical Marxists, but also run-of-the-mill business and political leaders understand crises as endemic to this mode of production: where there is capitalism, there is instability. Capitalism's drive to maximize surplus value comes into conflict with workers' capacity, with competing social values, and with political frames like the nation or the state. The project of indefinite wealth accumulation is unstable and, therefore, prone to moments of political disruption, financial correction, or material

Joshua Clover, *Riot, Strike, Riot: The New Era of Uprisings* (London: Verso, 2016).

2 David Harvey, *A Companion to Marx's Capital: The Complete Edition* (London: Verso, 2018), 14.

obstacle. The Dutch tulip bubble, South Sea bubble, major stock market crashes every decade of the nineteenth century, the great depression, 1970s stagflation, the dot-com bust, and the global meltdown of 2008 are but a few of these crisis points. Volatility lurks: workers may unionize. Consumer confidence may lag. Sovereign tools like interest-rate reductions may be exhausted. Hurricanes may disrupt oil rigs. Floods may wreck supply chains. So high is the likelihood these difficulties will occur at regular intervals that they are subject to predictive analytics and become their own source of wealth accumulation, via commodities like "reinsurance" (through which insurers purchase and sell insurance on their own risk). Some theorists even argue that crisis poses less a threat to profit-making than a tool for it: creative destruction and shock doctrine are like controlled burns on the plains; when something goes wrong, entrepreneurs can sell new solutions.[3] Crisis is officially ordinary, simply entailed in the everyday machinations of capitalism; "flow" floats as a figure of noncrisis: the equilibrium of the market, the uninterrupted intercourse of the many, the optimality of exchange.

Even though crisis has been conventionalized for centuries, present macroeconomic conditions show unusual stress—which sparks immediacy as a novel cultural style. Economists, historians, Marxist theorists, and even former treasury secretary Larry Summers all now concede that a serious crisis grips: capitalist growth began to lag irreversibly in the 1970s, although it took until the late 1990s for this lag to be acknowledged as a long-term trend. Amid the political tumult of the disastrous Vietnam War—which delegitimated the US in spite of its ongoing primacy as the world's largest economy and issuer of the world's premier currency, while escalating political struggles over imperialism that dramatically disrupted the global oil supply—the G7 economies (US, UK, Canada, Japan, Germany, France, Italy) all

3 See Naomi Klein, *The Shock Doctrine: The Rise of Disaster Capitalism* (New York: Picador, 2007).

experienced marked ends to the postwar boom. Fifty years later, these declines show no signs of reversing. Objective indicators of decline on the labor side include unemployment, wage stagnation, and diminishing benefits (or responsibilization of workers, rather than companies or governments, for their own health care and retirement);[4] indicators on the capital side include the decreasing rate of founding new firms, decreasing daily number of New York Stock Exchange transactions, corporate stock buybacks, slow rate of computer-chip and equipment improvements, and, most importantly, the deeply slackening rate of business investment.[5] Firms and governments have responded to these factors by attempting to intensify the process of capitalist production: with attacks on unions, ruthless efficiency standards, expansion of temporary labor and benefit-less subcontracting, as well as large-scale outsourcing of industry and increases in automation. Nevertheless, some of these very strategies were already contributing to the aforementioned declines (globalization of manufacturing meant plateauing world-market consumer demand; fewer wage gains and worker protections meant declining domestic consumer demand), and as a result, successes there have been minimal.[6]

Marxian theory predicts this minimal return from labor compression as a "law" of the capitalist system, free fallin':

4 The concept of "responsibilization" (vesting individuals with social responsibilities formerly held by the state or institutions) is developed in Wendy Brown, *Undoing the Demos* (Princeton, NJ: Princeton University Press, 2015).

5 These factors are identified by Gordon in his analysis of stagnation since the '70s and post-'90s. He shows that the microelectronics revolution had limited impact from 1990 to 2004 and is not likely to be repeated. Robert J. Gordon, *The Rise and Fall of American Growth: The US Standard of Living Since the Civil War* (Princeton, NJ: Princeton University Press, 2016). For more on the decreasing rate of founding new firms and declining overall number of firms and of their employees, see Gerald F. Davis, *The Vanishing American Corporation: Navigating the Hazards of the New Economy* (Oakland, CA: Berrett-Koehler, 2016).

6 For insightful studies of automation in conjunction with the declining rate of profit and expulsion from the wage relation, see Jason E. Smith, *Smart Machines and Service Work: Automation in an Age of Stagnation* (London: Reaktion Books, 2020), and Aaron Benanav, *Automation and the Future of Work* (London: Verso, 2020).

workers are the main source of surplus value; over time capital-ism needs fewer workers, while its drive for ever-increasing accumulation of surplus value remains unslaked; the smaller the proportion of labor ("organic composition of capital"), the smaller capital's profitability, since exploited labor is the well of profit. Capital accumulation requires not just the extraction of surplus value but the conversion of surplus value back into capital in order to generate yet more surplus value. When that investment in production does not take place, when the system's propensity for efficiency over time absorbs fewer workers, and when workers fight against further extraction (in struggles over the working day, social reproduction, and destruction of natural resources), a limit arises beyond which surplus cannot be accumulated. This world-market, saturated-consumption, auto-mated-production, expelled-population scenario is what Marx referred to in part III of *Capital*, volume 3, as "the law of the tendency of the rate of profit to fall."[7]

While theorists debate this law in the abstract, the concrete situation of secular stagnation is well-acknowledged empirical reality. Capitalist production has been contracting. A compensa-tory expansion of *circulation* is underway.

Both production and circulation are essential to capitalism: as Marx puts it, "Circulation is just as necessary as is production itself."[8] Production is the "hidden abode" of value, the often-invisible employment relation in which labor receives a wage in exchange for pouring its power into the making of commodities; circulation is the *unhidden, manifest* abode of value, the exchange sphere where "an immense collection of commodities" emanates value. Within this more manifest realm of circulation, capitalism tends toward obviating the mediating function of money: where, at first, commodities and money meet with money serving as a

7 Karl Marx, *Capital: A Critique of Political Economy*, vol. 3, trans. David Fernbach (New York: Penguin, 1981), 316.

8 Karl Marx, *Capital: A Critique of Political Economy*, vol. 2, trans. David Fernbach (New York: Penguin, 1993), 205.

mediator to facilitate the exchange of commodities (C–M–C), ultimately money wants to transcend this mediation and become an end in itself—not just M–C–M but self-valorizing value, "the unmediated extremes M–M'."[9] Marx presents this disintermediation as capitalism's central drive:

> The simple circulation of commodities—selling in order to buy—is a means to a final goal which lies outside circulation, namely the appropriation of use-values, the satisfaction of needs. As against this, the circulation of money as capital is an end in itself, for the valorization of value takes place only within this constantly renewed movement. The movement of capital is therefore limitless.[10]

Circulation qua immediatized infinite flow is thus always integral, no less essential than production.

This interdependence of production and circulation orients Marx's foundational insight that "value" is an abstraction that can only be concretized retroactively.[11] Attention to this actualization of abstraction distinguishes Marxism from a flat-footed labor theory of value à la classical economist David Ricardo since it is, rather, a systematic theory of value as a cardinal abstraction realized in concrete practices of both production and circulation. Labor makes things useful, while exchange and its hypostasis in the concept of value and the medium of money is the activity that generates value *qua value*. This is why, for Marx, value as such only becomes the ruling idea in a society of widespread commoditization. Barter economies have concepts of "need" and of "use," while commodity economies, where production is undertaken for

9 Karl Marx, *Capital: A Critique of Political Economy*, vol. 1, trans. Ben Fowkes (New York: Penguin, 1990), 267.

10 Ibid., 253.

11 For more on value theory, see Neil Larsen et al., eds., *Marxism and the Critique of Value* (New York: MCM', 2014), and Michael Heinrich, *An Introduction to the Three Volumes of Marx's Capital* (New York: Monthly Review Press, 2012).

the purpose of exchange and accumulation, have concepts of "value."

The valorization process has two prongs, but they do not always function equally. This asymmetry can be systemic: if production slackens, circulation intensifies, which involves closing the time lags, geographic gaps, and information chasms of exchange.[12] It can take place on a geospatial axis, striating and terraforming. (Chinese factories use raw materials from Chile or Congo to foothold global production, while the US operates world financial exchanges and hegemonic infomedia companies to stronghold circulation.) It can also advance on a temporal-historical axis, with periods of production intensivity succeeded by periods of circulation intensivity. Among the many revelations in the research of the economist Giovanni Arrighi is that the interconnection of production and circulation accommodates a relative dominance of one or the other process at different historical moments.[13] Seventeenth-century mercantilism is his prime example of circulation dominance, but nineteenth-century financialization is another, and twenty-first century speculative privatization is shaping up to be yet another. Just in time.[14]

The twenty-first-century concentration on circulation, with its premium on flow, conditions immediacy as cultural style that immanentizes presence, eclipses relay, and negates mediation. While capacity hypothetically exists for cultural aesthetics to resist rather than insist upon this logic, our moment overwhelmingly

12 Harvey, *Condition of Postmodernity*, 150–6; see also Harvey's *A Brief History of Neoliberalism* (Oxford: Oxford University Press, 2005).

13 See Giovanni Arrighi, *The Long Twentieth Century: Money, Power and the Origins of Our Times* (London: Verso, 1994).

14 In underscoring this relative dominance, Joshua Clover has characterized circulation phases as suborning a unique kind of political struggle: where production phases experience strikes, circulation phases experience riots, which are disruptive presencings often taking place at strategic points of transit (intersections, highways, airports, and shipping ports), as well as at places of commerce (retail districts, megastores, city centers). Circulation is fundamentally movement; political disruptions of it are often stoppages, blockades. Flow versus jam. See Clover, *Riot, Strike, Riot*.

leans into circulatory flow. Already in the 1980s, Fredric Jameson and David Harvey understood postmodernism as issuing from space-time compression (bringing the places and zones of the globe in more proximate contact through communications technology and transportation).[15] Turn-of-the-millennium observers underscored the consummation of this compression: "the world is flat," laminated by a "culture of speed."[16] Speed is, of course, the preeminent colloquial connotation of "immediacy," and flatness is the dimension of smooth flow. Now there remain to be elaborated other notions of immediacy, enacted in the protracted intensification of circulation: doing away with go-betweens and intercessions, promoting perpetual motion, streaming emanative exchange.

circulation, inc.

Paramount for these immediatizations are late-twentieth-century technological, epistemological, and political developments, such as advanced information systems (including mainframe and eventually networked computers, telecommunications, and global shipping logistics). Circulation signifies circular movement: metabolic flow and fluid motion, urban traffic, news and newspapers, ideas and gossip. While these many connotations have been activated over the long arc of modernity, they are

15 Harvey, *Condition of Postmodernity*. "Efficiency of spatial organization and movement is therefore an important issue for all capitalists. The time of production together with the time of circulation of exchange make up the concept of the turnover time of capital. This too is an extremely important magnitude" (229).

16 See Thomas Friedman, *The World Is Flat: A Brief History of the Twenty-First Century* (New York: Farrar, Straus & Giroux, 2005); John Tomlinson, *The Culture of Speed: The Coming of Immediacy* (London: SAGE, 2007); Paul Virilio, *Speed and Politics* (Los Angeles: Semiotext(e), 2007); Judy Wajcman, *Pressed for Time: The Acceleration of Life in Digital Capitalism* (Chicago: University of Chicago Press, 2015); Hartmut Rosa, *Social Acceleration: A New Theory of Modernity*, trans. Jonathan Trejo-Mathys (New York: Columbia University Press, 2013).

uniquely at stake in contemporary social and economic trans-
formations.[17] Moreover, the economy has been circulation-forward
for several decades, but the totalization of these dynamics in
cultural aesthetics has taken some time.

Let's take a little tour through some of the information and
communication-technology innovations instrumental for circula-
tion from the 1960s onward. The rise of the mainframe computer
mechanized accounting, while copy machines changed record
keeping, secretarial labor, and legal proceedings. Credit cards
(invented in 1950) and automated teller machines (1969) com-
pressed banking, enabling transactions without cash or branch,
while universal product codes and scanners revolutionized retail
by 1980. All of these enhancements sped up elementary consumer
activities and elementary work of information management and
exchange tracking.

One vivid index of this fluid speed is the revolutionary com-
pression of exchange engineered by "just in time" logistics.
Developed in the 1970s by Toyota and widely adopted by the
1990s, JIT bears the surreal tagline "Make value flow."[18] Seam-
less integrated circulation even streamlines production: "lean
manufacturing" configures commodity supply chains to traffic
components rapidly and thereby provide final goods expressly,
while data-trimmed inventories eliminate costs of warehousing,
and fast shipping fulfills demands instantly. In a feedback loop,
point-of-sale data enable retailers to dictate what and when man-
ufacturers produce. As theorist Jasper Bernes summarizes, JIT is

17 For another argument about the importance of circulation to aesthetic style
and cultural production—one that centers circulation systems like the printing
press and information bureaucracies from the late eighteenth to mid-nineteenth
centuries—see Sianne Ngai's chapter "Merely Interesting" in *Our Aesthetic
Categories: Zany, Cute, Interesting* (Cambridge, MA: Harvard University Press,
2015).

18 MIT Operations professors and efficiency experts James Womack and
Daniel Jones composed a treatise, "Lean Thinking: Banish Waste and Create
Wealth in Your Corporation," *Journal of the Operational Research Society* 48
(1996), 10.

the active power to coordinate and choreograph, the power to conjoin and split flows; to speed up and slow down; to change the type of commodity produced and its origin and destination point; and finally to collect and distribute knowledge about the production, movement, and sale of commodities as they stream across the grid.[19]

Integration, flexibility, flow—the economic substrate of the immersive vanGoghga with which this book began.

If the circuit of exchange was shortened through computational technologies at work in JIT logistics, the rise of networks linking computational power to communication virtually "instant-ified" that circuit. A signature example is the financial industry's adoption of high-frequency trading (HFT). In the same period that material processes were sped up to reduce storage costs and limit excess inventory sell-offs, innovations and deregulations facilitated a new dominance of inventory activity by high-frequency trading. The trading floor of yore was virtualized by fiber-optic cables stretched as tautly as possible to reduce the milliseconds for data transmission between Chicago and New Jersey. The fact that firms using this cable and other HFT technology (such as "colocation" of the matching engine for an exchange next to a firm's computers) for competitive advantage have been investigated by the Securities and Exchange Commission, the Federal Bureau of Investigation, and the Justice Department on numerous charges of insider trading and other violations suggests the power of HFT: moving information faster to act upon information faster. Cables allow computers to intercept communications from other computers, such that a large order for a stock may be intercepted by a firm that immediately buys up that stock for the purpose of selling to the initiating investor, at a higher price than he had intended. These speed

19 Jasper Bernes, "Logistics, Counterlogistics and the Communist Prospect," *Endnotes* 3 (September 2013), 172–201.

traps, what financial journalist Michael Lewis calls "front-running," orient the global financial system around rapidity, automaticity, and algorithmic pattern recognition.[20] Fast logistics in commodity chains and instantaneous information transfer in capital chains merge as material highways for immediacy's speedy DMs.

The syncing of logistics and investor systems in platform startups deliver the new "sharing" economy, the disintermediated infrastructure of immediacy style. In this gigification of labor, companies and jobs are on the wane, while services sold by the unit are on the rise.[21] The resulting conditions for both workers and consumers bypass the firm as middleman to facilitate direct contact and instant fulfillment, begetting an image of the economy as consentingly intimate independent contractors: Mutuality, Inc., immediacy's in-firm form. In constant pursuit of reputational capital to shore up their contractor profiles, individual laborers are rendered "auto-entrepreneurs," self-employees who charismatically radiate their intrinsic value.[22]

That image of flexible labor spotlights the lone serf who comes to your door ready to chauffeur, taskrabbit, or amazon-turk. But workplaces have not simply dissipated. Rather, like the laboring itself, the very fora of economic exchange have also been restructured by the circulation-forward economy. In the crunch of the instant and across the connectivity of sites, space itself reconfigures. Pop-up shops, open-concept residences, retailtainment, adaptive reuse, and dynamic we-work venues (networking, meeting space, party space, and dining under one roof) effectuate immediacy as commercial architectural style. Co-living, tiny

20 Michael Lewis, *Flash Boys: A Wall Street Revolt* (New York: Norton, 2015).

21 For more elaboration of this argument about disappearing firms, see Davis, *Vanishing American Corporation*.

22 In his analysis of gigification, Michel Feher notes that "auto-entrepreneur" became a category of French law in 2008; he also cites TED Talker Rachel Botsman's promotion of the concept of reputational capital. See *Rated Agency: Investee Politics in a Speculative Age* (Brooklyn, NY: Zone Books, 2018), 180.

houses, and shipping-container structures are its residential real estate holdings, while Airbnb, Peerspace, and Swimply reintroduce private property to circulate again in the temporary marketplace. The "flexible architecture" movement touts modular design, less reliance on columns and structural walls, and use of movable walls/ceilings or retractable roofs to customize space at any time; start-ups like Curri and consortiums such as Built-worlds are promising finally to disrupt construction (an industry long thought impervious to standardization and automation) with 3D printing, robotics, AI, and gig platforms for day labor and last-mile delivery.[23] Through these arrangements, space as the solid medium of social relations is itself pressed into fluid circulation. Even though architecture may be one of the mediums most resistant to immediacy, it still molds to the pervasive style; the circulatory straits upon it suggest the wide-reaching mandates of the present.

always on

The systemic industrial and technological conditions of intensified and immediatized circulation have experiential coordinates as well. Instantification of communications and exchange precipitate a sensation of immediacy not only as rapidity but as fullness, the instant as intense presence, an "always on," indistinct from time off. "Presence bleed," as the social scientist and Intel Corp engineer Melissa Gregg deems it, spreads our engagement everywhere all the time, a ferment vehiculated by social networking sites where "deliberate confusion of work and friendship" marries labor and enjoyment, extraction and connection.[24] The resulting immanentization and instantification (total presence, every

23 For a book-length study of the movement, see Robert Kronenburg, *Flexible: Architecture That Responds to Change* (London: Laurence King Publishing, 2007).

24 Melissa Gregg, *Work's Intimacy* (London: Polity, 2011), 6.

moment everything all at once) contrives, as the art historian Jonathan Crary chronicles, "a time without time"—the sleepless Groundhog Day in which we socialize all the time, work all the time, consume all the time, answer all the time. And the tax for this absolutization of time is "homogeneity" and "monotonous indistinction."[25] Total activation in undifferentiated continuity, immediacy's zombie phenomenality.

Social media platforms, along with communications and network technology, furnish infrastructure for this networked blurring. Immediatism issues from developments in hardware and software that alter the landscape of representation. The suite of i-tech—including the smart phone and social media—began broadly in 2006–7, with the iPhone launch in June 2007 and the opening of Facebook beyond Harvard University's walls in September 2006. In 2010, Instagram kicked off, gaining 10 million users within its first year and selling to Facebook in 2012. Twitter started in 2006, adding photo sharing in 2011, growing to 330 million users at its peak. These technologies facilitate the circulation of images for and by the masses, since everyone has a camera in their pocket and a ready-made platform to accommodate uploads and distributions, and the image-hosting functionality of the technology melds with the image-generating vocation of the users. Over one-third of the earth's population uses Facebook; the platform teaches these individuals to think of themselves as image managers and avatars, performing exhaustive unwaged digital labor as brand-identity consultants and data producers. Every moment, every element of one's life—tiny observations, banal occurrences, numberless meals—is fodder for instant affirmation. The omnitemporal quality is crucial, an injunction social media theorist Nathan Jurgenson describes as "atomiz[ing] the infinity of life into discrete, manageable elements to be collected, shared, and saved."[26] "Sharing" "what's on

25 Jonathan Crary, 24/7 (London: Verso, 2014), 29, 30.
26 Nathan Jurgenson, *The Social Photo* (London: Verso, 2019), 25.

your mind" (as the Facebook status box inquires) or "what's happening" (as does Twitter) dozens of times a day creates the traffic the platforms need for monetization and creates user identification with virtual presentation.

Through these incentives and imperatives for incessant self-facement, conviction in transparency and emanation scripts a philosophy of representation that strives to eradicate the gap between representation and presentation, appearance and phenomena, "telling it like it is" and "it is what is." This gapless "flow of ideas," propagated through what scholars Henry Jenkins, Sam Ford, and Joshua Green deem "spreadable media," elevates she who circulates.[27] While an older, less participatory media landscape would center companies who produce content and consumers who receive it, the spreadability model centers *prosumers* who direct the flows of content through appropriation, remixing, and de/recontextualizing—meme it up. As a result, formerly separate economic functions like producer, marketer, and audience undergo "a blurring of the distinctions between these roles."[28] Moreover, as political theorist Jodi Dean argues, the particularity of messages in such a blurred circulation system is subsumed and sublated into "mere contributions to the circulation of content."[29] The importance of circulation to the economy conscripts the immanence of circulation into quotidian communication.

The interface is the imaginary portal to the circulation of information. Along with our imaginary illusions and cathected images, what the circuit propels is data, which must be harvested from more semantically full and/or ambiguous relations in order to then be exchanged. Philosopher Bernard Stiegler describes this compositing process as one of "discretization," a flattening that

27 Henry Jenkins, Sam Ford, and Joshua Green, *Spreadable Media: Creating Value and Meaning in a Networked Culture* (New York: New York University Press, 2013), 5, 295.

28 Ibid., 7.

29 Jodi Dean, "Communicative Capitalism: Circulation and the Foreclosure of Politics," *Cultural Politics* 1:1 (2005), 54.

advances the data revolution: to arrive at countable quanta of information, behaviors and words must be compressed into tags.[30] Such desemanticization is foundational for information circulation and activates the tech basis for the mediation compression we will study in literature, televisuality, and theory in the coming chapters. Even a random list of twenty-first-century additions to the dictionary expresses this compression, the pre-lexical networked babble central to the style of immediacy: Fomo. Yolo. Athleisure. Mansplain. Screenager. Frenemy. Listicle.

The discretizing short-circuiting for the information economy determines the anti-mediation ethos of contemporary aesthetic production. Nothing makes this more obvious than the quintessential format of our time, the emoji. Exchanged more than 6 billion times per day in text messages and on social media, emoji replace words with tiny pictures, as generic as a smile or as specific as two Rockettes dancing in formation, available in a range of skin colors.[31] Emojis instantaneously flash an affirmation (heart 💕), opinion (thumbs up 👍), an affective state (pouty face ☹), an evaluative judgment (bananas 🍌). Efficient treasure, they function as written communication for the pre-literate (young children love them) as well as across language barriers (emoji speak Japanese *and* English *and* Arabic). Not indexical but iconic, they accelerate the dynamic of the instant messaging that is their milieu, generating the illusion of dragless

30 Bernard Stiegler, *For a New Critique of Political Economy*, trans. Daniel Ross (Cambridge, UK: Polity, 2010). Stiegler sees discretization as a historically specific component of computer-aided economic transactions, but he also sees it as a certain culmination of a more transhistorical transformation of qualitative semanticism into quantitative data. For greater elaboration of discretization as a general rule of mathematics in society, see Alexander Galloway, "The Poverty of Philosophy: Realism and Post-Fordism," *Critical Inquiry* 39:2 (2013): 347–66. And, for the original conception of information as discrete, see Claude Shannon, "A Mathematical Theory of Communication," *Bell System Technical Journal* 27:3 (July 1948), 379–423.

31 For more scholarly exploration of this popularity, see Philip Seargeant, *The Emoji Revolution: How Technology Is Shaping the Future of Communication* (Cambridge, UK: Cambridge University Press, 2019).

expression. In their anti-semanticism, emojis oppose symbolic delegation, auto-constructing as pure immanence and aesthetically crystallizing the political economy of instantaneity and flow. The world is flat, and so is representation.[32]

periodizing circulation culture

When critics have periodized the cultural production of the present, they have most frequently looked to the advent of so-called new media and the associated "revolution" beginning in the 1990s.[33] Constitutively computational and delivered digitally, new media (user interfaces, email, websites, gaming, social platforms, and streaming services) rework and redirect old analog and print media into technologically and aesthetically different forms and conditions. The pivotal event in this revolution is the occlusion of code. Long before the rise of "social" media, our quotidian interaction with mainframe computing was radicalized by the rise of the user interface. Interface is here understood as the dissemblance of material relations; thus does theorist Wendy Chun directly analogize software to Althusser's famous definition of ideology as the imaginary relation of individuals to their real conditions of existence.[34] The symbolic operations that

32 The art historian Boris Groys understands this flatness as a function of the platform (hence medium) convergence of formerly discrete modes like art, literature, and theater. As he writes, "On the Internet art and literature do not get a fixed, institutional framing, as they did in the analogue-dominated world. Here the factory, there the theatre; here the stock market, there the museum. On the Internet, art and literature operate in the same space as military planning, tourist business, capital flows, and so on; Google shows, among other things, that there are no walls in the space of the Internet." Boris Groys, *In the Flow* (London: Verso, 2016), 173–4.

33 In Lev Manovich's foundational formulations, "new media" are distinct because the computer "affects all stages of communication, including acquisition, manipulating, storage and distribution; it also affects all types of media—text, still images, moving images, sound, and spatial constructions." Lev Manovich, *The Language of New Media* (Cambridge, MA: MIT Press, 2001), 43.

34 Wendy Chun, "On Software, or, The Persistence of Visual Knowledge," *Grey Room* 18 (2004), 26–51.

structure the conditions of circulation-forward capitalism—namely, computer code—are vanishing mediators, leaving us in an imaginary mirror hall of rippleless icons. Early commercial and consumer computing in the 1970s and '80s averted this obscurity: users directly encountered and executed coding and code functions. *Boot up. PR#6. RUN. B Load, C Load.* The personal computer was not simply "a device for consuming media" but a "fixture in the home for work" that essentially presumed individuals would become programmers.[35] However, after the rise of the graphic user interface, game designer and author Ian Bogost has argued, users no longer interact with computational media at the level of the symbolic; instead, we click folders on tidy desktops.[36] As a range of contemporary scholars have shown, the ubiquity of these interactions makes this front only more Delphic. Zara Dinnen observes, "When code is working properly, we don't see it . . . if source code has been written effectively, it effaces itself."[37] Similarly, in the ultimate media theory of immediacy, Alexander Galloway diagnoses: "Software is the medium that is not a medium."[38] Fittingly for our style category pursuant to this negation, N. Katherine Hayles identifies the introduction of the first interface-forward internet browser, Netscape, as a grave transformation of cultural production: "On or about August 1995, postmodernism died."[39]

The new media hypothesis begins to explain the transition to immediacy as cultural style. Code is the hidden medium of digital culture, virtually invisible and unknowable even in its omnipotent omnipresence in everyday life, an occlusion that

35 Ian Bogost, "Pascal Spoken Here," in *The Geek's Chihuahua: Living with Apple* (Minneapolis: University of Minnesota Press, 2015).

36 Ibid.

37 Zara Dinnen, *The Digital Banal: New Media and American Literature and Culture* (New York: Columbia University Press, 2018), 4, 12.

38 *The Interface Effect* (Cambridge, UK: Polity, 2012), 69.

39 N. Katherine Hayles and Todd Gannon, "Mood Swings: The Aesthetics of Ambient Emergence," in *The Morning After: Attending the Wake of Postmodernism* (London: Brill, 2007).

comprises the technological basis for postmodernism's withering, and for immediacy's obscuring of mediation. But there are a few problems with this story, and we need a wider frame to periodize. For starters, code is also ideology—it is hardly as if programmers who "see the matrix" thereby more deeply comprehend exploitation and geopolitics than the rest of us swiping plebs. What is more, many contemporary media theorists oddly essentialize the waning of medium into the very vocation or desire of media itself across its history: from Plato's cave to virtual reality effects, an ever more technologically enhanced, perennial pursuit of increased immediacy.[40] Marxist historiography of production

40 See Jay David Bolter and Richard Grusin, *Remediation: Understanding New Media* (Cambridge MA: MIT Press, 1998), 24; Heike Schaefer, *American Literature and Immediacy: Literary Innovation and the Emergence of Photography, Film, and Television* (Cambridge, UK: Cambridge University Press, 2019). See also Alexander Galloway on the "quality shared by painting, photography, film, and a number of other art forms. It is the desire that the world be brought near to us" (*The Interface Effect* [Cambridge, UK: Polity, 2012], 10). See also Longinus: "Art is only perfect when it looks like nature" (*On the Sublime*, trans. W. H. Fyfe [Cambridge, MA: Loeb Classical Library, 1999], 22); W. J. T. Mitchell: "At moments of technological innovation . . . a new medium makes possible new kinds of images, often more lifelike and persuasive than ever before" (*Critical Terms for Media Studies*, ed. W. J. T. Mitchell and Mark B. N. Hansen [Chicago: University of Chicago Press, 2010], 38); Henri Bergson: "Art has no other object than to brush aside the utilitarian symbols, the conventional and socially accepted generalities, in short, everything that veils reality from us, in order to bring us face to face with reality itself" ("Laughter," in *Key Writings*, ed. Keith Ansell Pearson and John Mullarkey [London: Bloomsbury, 2014], 387); and John Durham Peters: "Media are not only about the world . . . they *are* the world" (*The Marvelous Clouds: Toward a Philosophy of Elemental Media* [Chicago: University of Chicago Press, 2015], 21). David Parisi's *Archaeologies of Touch: Interfacing with Haptics from Electricity to Computing* (Minneapolis: University of Minnesota Press, 2018) also argues that media like virtual reality games activate a "continuing technogenesis" that move ever closer to haptic "immersion" (329). Ian Bogost describes games in terms of "actual experience" and vividness (*Persuasive Games: The Expressive Power of Video Games* [Cambridge MA: MIT Press, 2007], 35). See also Dinnen, *The Digital Banal*: "We need to be able to recognize processes of mediation as forms of efface-ment. When a medium is working, it disappears from view . . . The digital is a reification of the effacing condition of all media" (4). Finally, see Niklas Luhmann, *The Reality of the Mass Media*, trans. Kathleen Cross (Stanford, CA: Stanford University Press, 2000): "The observation of events throughout society now occurs almost at the same time as the events themselves" (26).

crises and the intensification of circulation suggests something else: immediacy is not an inner disposition of media, attaining ever-greater actualization in the digital era, but an outer configuration of the circulation system that digital media effectuate, with the mode of production as its cause.

The theory of new media's decisive impact often braces the distinction of the contemporary, as denominated through numerous diagnoses and manifestoes: "digital capitalism" (1999), "informatization capitalism" (2000), "communicative capitalism" (2005), "surveillance capitalism" (2014), "platform capitalism" (2016), and even no longer capitalism but "something worse": rule by a "vectoralist class" (2016).[41] It is as if the pressures of circulation-forward capitalism compel a brand competition among synonyms for circulation. Alongside these, economic historians often narrate the transformative potential of networked computing and microelectronics as "the third industrial revolution."[42] But the analogy is rather off because, as the same historians admit, computational and communicational advances forever altered information management but only minimally increased

41 Dan Schiller, *Digital Capitalism: Networking the Global Market System* (Cambridge, MA: MIT Press, 1999). For Srnicek, "the digital economy" refers to the prevalence of "business that increasingly rely upon information technology, data, and the internet for their business models. This is an area that cuts across traditional sectors—including manufacturing, services, transportation, mining, and telecommunications." Nick Srnicek, *Platform Capitalism* (Cambridge, UK: Polity, 2017), 4. Hardt and Negri outline "informatization of the mode of production" as the superseding of industrial production by data production and service rendering fueled by "knowledge, information, affect, and communication." Michael Hardt and Antonio Negri, *Empire* (Cambridge, MA: Harvard University Press, 2000), 285. For an argument that capitalism has been information capitalism since at least the nineteenth century, see Jamie Pietruska, "The Information Economy," *Oxford Research Encyclopedia of American History*, May 26, 2021, oxfordre.com. On surveillance capitalism, see John Bellamy Foster and Robert McChesney, "Surveillance Capitalism: Monopoly-Finance Capital, the Military-Industrial Complex, and the Digital Age," *Monthly Review* 66:3 (July/August 2014), 1; Shoshana Zuboff, *The Age of Surveillance Capitalism* (New York: Profile Books, 2019). On communicative capitalism, see Dean, "Communicative Capitalism." On vectoralism, see McKenzie Wark, *Capital Is Dead: Is This Something Worse?* (New York, NY: Verso, 2019).

42 Gordon, *Rise and Fall*, 320.

productivity.[43] For circulation, though, the results were significant: the virtualization of the exchange sphere enables the circulation of goods that circumvents the brick-and-mortar costs of retail, facilitates the coordination of information that circumvents on-the-ground human resources costs of journalism and communications, and underwrites the gig economy that circumvents the whole apparatus of a workplace as abode of production. It also converts exchange itself into a commodity, since automated and computerized interactions can be discretized into data that in turn commands a high price among firms and licenses ever greater expansion of surveillance and securitization.

The magnification of the circulation process impresses the express—everything emanates; everything is instant—and creates the conditions for immediacy. After the digital, we remain in the same historical phase of the accumulation crisis that defines postmodernism, but, through the severity and duration of secular stagnation, we take up a different relation to the very media of which that style might be composed: an obfuscation of mediation. Immediatized circulation has not delivered a resolution to the long-term crisis over the last fifty years, but neither has the law of the falling rate of profit delivered a social revolution. What has been delivered, instead, is immediacy as cultural style: demediation, immanentization, flow.

43 "You can see the computer age everywhere but in the productivity statistics." Robert M. Solow, "We'd Better Watch Out," *New York Times Book Review*, July 12, 1987, 36.

Imaginary

Immediacy stylizes the intensification of circulation, and nothing circulates faster than images. The human visual cortex processes stimuli at somewhere around sixty frames per second, with the ocular lens mirroring light into the retina, where photoreceptor cells convert it to electrical signals that the optic nerve ferries to the brain. Images viewed for as little as thirteen milliseconds can complete this information flow, called "feedforward processing," and connect to concepts without any further feedback processes in the brain.[1] The media ecology of the twenty-first century capitalizes upon this rapidity: user interface icons and integrated wearable devices obfuscate code; 5G data networks attain transfer speeds of ten gigabits per second; images online replace the fuller sensory experience of communicating, shopping, learning, or traveling in person; image-driven networks are the most popular media companies in the world and the most powerful, profitable data enterprises. There's an app for that.

Google may be making us stupid, or Twitter may be making us mean—but, surely, the speed of the flow of information and the velocity of discretization are making our internal processors run on different stimuli.[2] With algorithmicized consciousness, we click,

1 Anne Trafton, "In the Blink of an Eye," *MIT News*, January 16, 2014, news.mit.edu.

2 Nicholas Carr, "Is Google Making Us Stupid?," *Atlantic*, July/August 2008, theatlantic.com. This claim recurs throughout media history, starting of course with Socrates warning in the *Phaedrus* that writing is ruining memory.

we uptake. Seeing is reading. The superhighway acclimatizes perceptual faculties to racing, skimming, browsing, and other quick integrations. Immediacy style rapidly inputs information available on the surface as immanent unto itself, without need for slow, long reading or interpretation.[3] And the internet as we know it has been built and regulated to ensure that this celerity of "surfing" concords with profit: as technology writer Nicholas Carr observes, "The faster we surf across the Web—the more links we click and pages we view—the more opportunities Amazon, Apple, and Alphabet gain to collect information about us and to feed us advertisements."[4] Platform capitalism entails the hyperfunctioning of visuality as surrogate for other senses and precipitates the cognitive state of "image overload."[5] The frames per second the eye can handle are less than half what video cameras can relay; a torrent of images is wreaking serious symptoms researchers identify as memory impairment, heightened anxiety, generalized frustration, chronic fatigue, and simply "being overwhelmed by a constant flow."[6]

Drowning in a deluge of images without context, words without meaning, information without distinction—this is the subjective experience in an economy of immediacy. Whether or not technological advances in image circulation have a net democratizing effect (as many media scholars argue), and whether or not circulation can dispel the crisis of production, it is certain that they reconfigure cognition and affect. In the coming chapters of this book, we will mostly study how contemporary

3 For a developmental psychologist's argument about the changing faculties of reading, see Maryanne Wolf, *Proust and the Squid: The Story and Science of the Reading Brain* (New York: Harper, 2007).

4 Carr, "Is Google Making Us Stupid?"

5 Rebecca MacMillan, "Here's What Image Overload Is Doing to Your Brain," *Nova*, February 12, 2016, pbs.org.

6 For "infowhelm" see Heather Houser, "The Covid-19 'Infowhelm,'" *New York Review of Books*, May 6, 2020, nybooks.com. See also her academic monograph, *Infowhelm: Environmental Art and Literature in an Age of Data* (New York: Columbia University Press, 2020).

cultural aesthetics express circulation-intensification, seeking to understand the modulation of that base in art, literature, video, and theory that enthuse presence and immersion while negating mediation. This further prefatory chapter thickens the analysis by examining the everyday psychic contours that are both mainspring of and feedback to that style.

The psychic peculiarity of contemporary life, according to a certain trendy leitmotif, is an abundance of narcissism—"Generation Me" aggrandizement, measured definitively on the Narcissist Personality Index and Rosenberg Self-Esteem Scale.[7] But, just as the most essential aspect of its pathology is false self-centering, our era of narcissism does not perceive its own structural causes. Nor does the narcissism hypothesis adequately comprehend the irrepressible crisis in mental experience at present. Ours is a miserable society (though the very palpability of this misery can prioritize psychological categories as somehow more primary or immediate than structural ones). For three years in a row and counting, the US has been the only developed country to experience a decline in average life expectancy, which the American Medical Association attributes to suicide, opioid addiction, alcoholism, and obesity, explicitly connecting these factors to wealth inequality.[8] Group traumas like mass shootings and racist extrajudicial killing are escalating. Viral losses exacerbate all this distress: governmental abandon in the pandemic has made the US the world leader in excess death and suspended millions in protracted isolation. The teenage suicide rate increased 70 percent from 2006 to 2019, while overall suicide rates increased 2 percent per year over the same period.[9] Significant majorities

7 See, for example, this story in the *New York Times* about a 2009 book that has subsequently enjoyed revised editions: Douglas Quenqua, "Seeing Narcissists Everywhere," *New York Times*, August 5, 2013, nytimes.com.

8 Aylin Woodward, "Life Expectancy in the US Keeps Going Down, and a New Study Says America's Worsening Inequality Could Be to Blame," *Business Insider*, November 30, 2019, businessinsider.com.

9 Cynthia Koons, "Latest Suicide Data Show the Depth of US Mental Health Crisis," *Bloomberg*, June 20, 2019, bloomberg.com. For post-2019 rates, see Farzana

of young people in wealthy countries are repeatedly rated "extremely pessimistic about their economic futures."[10] Too-lateness also looms: according to the Pew Research Center, fully two-thirds of Americans say the federal government is doing too little to mitigate climate change, and one in five college students pursues treatment for climate grief.[11] Recent studies estimate that over 40 percent of Americans are suffering from anxiety and depression.[12] Anxiety is immersive, a case of apprehension involving breathlessness, dizziness, palpitations, an accumulation of undischargeable excitation. Depression, too, is immersive, an intrapsychic conflict of ego and superego that results in apathy, unwillingness to engage, and an inability to work through. Futurelessness, isolation, anxiety, distance: these plights trigger an overwhelming absorption, an incapacity to relate beyond the self in either language or action.

The category of immediacy connects both these immersive miseries and the apparent excess of ego to the technological transformations and economic contradictions we studied in "Circulation." Immediacy's stylized engrossments mimic our epidemic paths of suffering, its inundative presence swallows the horizon of no-future, its urgent extremities affright and awe, and its prized flow perpetuates the cult of "resilience" to which we are remaindered. Too late capitalism's circulation-centricity expedites a historically contingent inflation of the image, and arguably, the subjective corollary is an inflation of *the imaginary*. An inner flood marked by a lack of symbolic constraint—an

Akkas, "Youth Suicide Risk Increased over Past Decade," Pew Charitable Trusts, March 3, 2023, pewtrusts.org.

10 Chris Moriss, "Economic Pessimism Is on the Rise among Many Youths," Nasdaq, Jan 11, 2022, nasdaq.com.

11 Cary Funk and Brian Kennedy, "How Americans See Climate Change and the Environment in 7 Charts," Pew Research Center, April 21, 2020, pewresearch .org; Avichai Scher, "Climate Grief Hits the Self-Care Generation," *CUNY Academic Works*, December 14, 2018, academicworks.cuny.edu.

12 Jan Hoffman, "Young Adults Report Rising Levels of Anxiety and Depression in Pandemic," *New York Times*, August 13, 2020, nytimes.com.

insufficiency of language ("no words"), a dearth of social ties, a reflective glass maze, overflowing oceanic feeling—casts the psychic style through which immediacy grips.[13] Intensity intensifies.

the imaginary in psychoanalysis

Exactly what is the imaginary, anyway? Image substantialized, the imaginary connotes a realm of shiny surface and alluring illusion, identification and reciprocity, wholeness and flow, that is also always volatilized by the prospect of delamination— dashed glass, discordant depths, and irreconcilable differences. The psychoanalyst Jacques Lacan posits the *imaginary*, the *symbolic*, and the *real* as the three distinct but interdependent orders of psychic experience. These reframe Sigmund Freud's topography of the *ego*, the *superego*, and the *id*, respectively, elucidating that the domains of the subject are also objective realms of the social. The imaginary is the register of images, identifications, wholes, and projections; the symbolic is the register of language, institutions, norms, laws, practices, and order; the real is the register of what catalyzes the imaginary and eludes the symbolic—the impossible, the unrepresentable, the material, the contradictory or unmeaningful. In one sense, these registers describe psychic development: an infantile experience of embodiment and umbilical reciprocity (imaginary) matures into the mediations of language (symbolic), while an inkling of something inaccessible and unspeakable is retroactively effected by this progression (real). In another sense, though, simultaneous overlap and underlap of these three is fundamental, since the subject of the unconscious is variegated, divergent, never directly fully itself. Through both this developmental and this structural

13 By many measures, like marriage rates, mental health rates, and surveys, researchers in a variety of contexts document an isolation epidemic well preceding the distancing pandemic. Neil How, "Millennials and the Loneliness Epidemic," *Forbes*, May 3, 2019, forbes.com.

model, psychoanalysis enacts an unprecedented science of mediation: a study of how language and norms inform desires; how desires can only make themselves legible in the distortions of parapraxes, dreams, fumbles, and symptoms; how the self is not self-evident but rather a product of social relations. With its conviction that psychic experience is socially produced, psychoanalytic theory can help explore the ways that circulation impresses upon the psyche: an overemphasis on instantaneous fluid exchange, an overabundance of images, an overweighting of presence, and overvaluing of identity can all preclude or foreclose the functioning of the symbolic. Representation slackens, and an unintegrable real impends. Immersion in the imaginary initiates all kinds of psychic dischord, from fantasies of self-possession and delusions of wholeness, to refusals of the other and proliferating dualities, to paranoiac gusts and polarized fluctuation. Each of these disorders vividly characterizes contemporary media culture and contemporary algorithmic logic.

A trope of mirroring elemental to the theory of the imaginary illustrates the role of images in generating the subject's view of itself: an infant perceives itself as a pool of sensations, fluid and disunified and fraughtly continuous with the mother, until they encounter their own specular image in a mirror, which imposes wholeness and coherence that fuses the sense of self, the ego.[14] The image in the mirror opens to recognition and affirmation, affording presence, fullness. But desilvering shades these benefits, volatility besets the image, and error lodes the ego: mirrors do, after all, crack. The smooth and the shattered, the immersed and the imploded—the polarities of the imaginary.

As the mirror trope emphasizes, the imaginary is primarily a visual register of cognition: "I" see myself seeing myself; "I" am transparent to myself. This mirror relation models in a primary

14 Jacques Lacan, "The Mirror Stage as Formative of the *I* Function, as Revealed in Psychoanalytic Experience," *Écrits*, trans. Bruce Fink (New York: Norton, 2006), 75–81.

way what relations with others seem to involve: "I" identify with my own whole image and symmetrically presume that the other is similarly whole; "I" consolidate at the cost of separation from a newly discretized (m)other, who would, after all, prop the baby before the mirror. The image of the self as integrated and ideal redounds to an image of the other that absents their noncoincidence with their image. In the imaginary, self and other only relate as these two wholes, in binary "rivalry": friend or foe, same or different, superior or inferior.[15] Within this flat interaction, through these identifications and disindentifications, an imagined self, autoerotically sustained, projects an imagined relation to an imagined other, one to one—even though only one can truly be one.

Analogizing the mirror to the screen (and sometimes forgetting this analogy), film and media theorists have long elaborated the imaginary conscription ensuing from image consumption. We enjoy "the perceptual wealth" of the image, especially the moving image, for its conferral of the sense of mastery the mirrored ego imparts, but that wealth is often tainted by its merely replicatory status, igniting the worry that the real eludes our sight.[16] Fullness pings so quickly to emptiness; complete ingestion bursts to utter shards. The more that images comprise our life-world—the greater the glut of hypercirculation, the shinier the pivot to video, the profuser the selfies—the more effectually the media substrate impels an immense imaginary.

Ordinarily—or, in less image-abundant times—the imaginary's one-to-one equation is complicated in the symbolic, the realm of the signifier. The symbolic spans spoken and written language, with all their detours, confusions, and metaphors; language as a system; institutions, laws, norms not of the individual's

15 For more on this "rivalry," see Bruce Fink, *A Clinical Introduction to Lacanian Psychoanalysis* (Cambridge, MA: Harvard University Press, 1997).

16 The phrase "perceptual wealth" and the mirror-screen analogy most famously hail from Christian Metz, *The Imaginary Signifier* (Bloomington: Indiana University Press, 1982), 45.

making. The symbolic stopples the dyadic mirror liquidity of body and ego / I and other-I, introducing instead lack, inconsistency, and negation. Signifiers extrude flatness into volume, scaffolding the space of the social in greater amplitude than the plane of the image. The symbolic girds more than the identities of the imaginary: it is the terrain of alterity. Such alterity might assert itself as a kind of thirdness that disrupts the imaginary duo, auguring not just self and other but the other of the other. It might inscribe itself as the grammar or norms that structure the exchange between I and image, belying the nonverbal fluidity of one-to-one infantile relay. And it might make itself legible, in parapraxes and other symptoms, as the unconscious, the other side of imaginary self-consciousness. With its alterizing activation of the unconscious, contradiction, and lack, the symbolic evokes absence in contrast to imaginary presence, unpleasure in contrast to pleasure, death in contrast to life.

When this ordinary entrance into the symbolic is obstructed, the subject remains too much in the imaginary—the specular state we commonly recognize as "narcissism." In colloquial references, narcissism is a condition characterized by grandiosity of self and a lack of empathy for others. The name comes from the ancient Greek myth of Narcissus, a young man who found his own reflection in a pool so captivating that he could not tear himself away from water's edge and literally wasted away into death. For Freud, such wasting unto death connotes an imbalance, so balance or equilibrium becomes one of the defining questions of narcissistic structure. Freud hypothesized that human subjects have a kind of scarcity of libido, and that narcissism rests in overallocating libido inward to the self and underallocating outward to the other. With his signature commitment to normalizing psychopathology, Freud took this matter of balance as fulcrum for arguing that all libidinal economies involve some degree of narcissism, since care of the self is required for self-preservation. This degree he deems "primary" narcissism, or even "normal" narcissism. Narcissism, in

turn, becomes abnormal when contingent cultural conditions whet it.

As part of his point about cultural conditioning, Freud locates the ego itself—the object of libidinal investment in narcissism—not as something innate but as a mediation, the product of a construction: "We are bound to suppose that a unity comparable to the ego cannot exist in the individual from the start; the ego has to be developed."[17] This development of the ego as a lived, contingent, and therefore social process becomes the focus for Lacan's elaborations of narcissism, which hinge on image technologies. Narcissism fundamentally pertains to the image; the subject invests libidinally not in a substantiality like "ego" but in a speculative effect of the technology of the mirror.[18] In the ancient myth, the image floats on water and might therefore be construed as naturally occurring. But in Lacan's retelling, the mirror function encompasses glass, photography, screens. Narcissism becomes qualified as an attachment to the ego qua *effect of the mirror*, and the constitutive role of mirroring repeats in the narcissist's concepts of development, growth, and action.

Conditioning the very existence of the narcissist, mirroring also composes their primal demand: the reflection must be repeated. One selfie is never enough. An insistence on recognition is at the core, often distending into demands to be recognized in a particular way, and flattening the other as mirror, mere vehicle of reflection. This negation of the other perpetuates sameness: where there is no opacity or desire, there is no contradiction and no distinction, only replicating identity. It also flirts with psychosis, an overinvestment of libido in the self as object, repudiating representation, propounding paranoia; there is something of the psychotic's experience in immediacy's pendulating between

17 Sigmund Freud, "On Narcissism," in *The Standard Edition of the Complete Psychological Works of Sigmund Freud*, vol. 14, *On the History of the Psycho-Analytic Movement, Papers on Metapsychology and Other Works* (London: Hogarth Press, 1953), 67–102.

18 Lacan, "Mirror Stage."

unison and cacophony. The narcissist's recruitment of the other's confirmation invertedly transmits an effort to make contact with a zone of otherness; now, such efforts are channeled by technologies engineered to short-circuit deliberate relation into ever more images and ever-faster circulation. Freud's greatest insight is that all clinical structures are effects of cultural arrangement rather than personality electives; the very project of civilization necessarily engenders discontent. An economy that prizes the circulation of images, human capital entrepreneurs, and the datafication of everything into endless counting of the homogenized same realizes in plasma the mythic promise of the fluid screen. Narcissus's mirror is industrially ordained.

imaginary economies

When cultural commentators and medical experts refer in the present to a narcissism epidemic, they are labeling the phenomenon of self-engrossment and other-flattening that evinces the immediacy style of psychic life. Notably, however, such vocabulary neglects the explanatory purchase of economic context. You're so vain—but it's not about you. Psychoanalysis enjoins us to theorize with a lens other than moral panic—one that elucidates the historical and cultural conditions for the overvaluation of the imaginary. It is no coincidence that the word "narcissist" becomes a term of precipitously increasing interest beginning in 1973, that same nerve point for the particularity of recent economic history which we chronicled in "Circulation."[19] Contractions of the productive economy have brought expansions of the image economy. For a snapshot, consider the intersection of media companies and self-care commerce. Instagram and Oprah Winfrey's Harpo Media, life-coaching and brand identity

19 See Google ngram, the computational view of books, for "narcissism," books.google.com/ngrams.

management, the $4 trillion wellness industry, First Lady Melania Trump's "I really don't care" couture, and the increasingly common phenomenon of death-by-selfie all bespeak the big business of self-care and self-promotion via technology supercompanies.[20] Revealingly, these economic activities expressly code themselves as "art": as the image creator Hito Steyerl observes, "today, almost everyone is an artist. We are pitching, phishing, spamming, chain-linking or mansplaining. We are twitching, tweeting, and toasting as some form of solo relational art, high on dual processing."[21] Here is, then, the flip side of the charisma-immediacy of Abramović's *The Artist Is Present* we saw in the introduction: no art but in being / all being is art. Every I, lousy with panache.

Uber-creative spirit, hyperproximity, and insatiable imaging industries immure the psyche in imaginary coordinates. What sociologist Eva Illouz marks as "scopic capitalism"—relentless "consumption of the image" in an "economy of reputation created by internet platforms and social media"—inflates the ego and compels its ostentation.[22] Mirror, mirror, on the wall, we look, and we look at ourselves being looked at; we expose and are exposed in turn. Faster fluid circulation burns in the economy of goods and services, and churns psychically through images, perpetuating not just commodity fetishism but what cultural theorist Christopher Breu terms "avatar fetishism."[23] Avatar fetishists behold the images at their fingertips, especially the ones they themselves generate in personal "presence"

20 Christina Gough, "Wellness Industry—Statistics and Facts," Statista, February 16, 2023, statista.com. A *Rolling Stone* article in 2016 identified the phenomena, and the subsequent *Wikipedia* page for it is a disturbing list: Bryn Lovitt, "Death by Selfie: 11 Disturbing Stories of Social Media Pics Gone Wrong," *Rolling Stone*, July 14, 2016, rollingstone.com; "List of Selfie-Related Injuries and Deaths," en.wikipedia.org.

21 Hito Steyerl, *Duty Free Art: Art in the Age of Planetary Civil War* (London: Verso, 2017), 149–50.

22 Eva Illouz, *The End of Love: A Sociology of Negative Relations* (New York: Oxford University Press, 2019), 98–143.

23 Christopher Breu, *Insistence of the Material: Literature in the Age of Biopolitics* (Minneapolis: University of Minnesota Press, 2014).

management, as spontaneous shimmer, with nary a thought for the scandium mines, chip microprocessors, server farms, and embodied people who physically toil to produce and operate them.[24] Plate the dinner, frame the photo, upload it to the hashtag, bank your brand—and thus fetishistically elide the economic relationships of data analytics. The willing ignorance in such fetishism is advanced by the internalization of "visibility mandates," which lead individuals to misperceive digital architectures as their own self-expression.[25] Again and again, quick visual processing occludes the technological and social conditions, and an illusory transparency obliterates any internal opacity. The philosopher Anne Dufourmantelle laments this absence of absence: "In today's age, it has become intolerable to 'withdraw ourselves,' or else this withdrawal must be announced, scheduled, and registered, the secret garden is identified by a sign, which means that it is no longer secret."[26] If Roland Barthes could still conceive, in his reflections on photography back in 1980, of "private life" as "that zone of space, of time, where I am not an image, an object," then it seems clear that the 2020 vision of digital-image society preserves virtually no privacy, legal or metaphysical.[27] The ego, the first construction, more and more staged, more and more managed, then brittleizes. Unable to withdraw, subject to demands for transparency at once personal and political, we lose our own opacities, we forget that the chronically manifest self is not all, and, in this forgetting, we overlook the material infrastructures of its illusory emanation.

24 A good study of ecological costs of media culture is Jussi Parikka's *A Geology of Media* (Minneapolis: University of Minnesota Press, 2015).

25 Communication theorists and sociologists even call this "a visibility mandate." See Brooke Erin Duffy and Emily Hund, "Gendered Visibility on Social Media: Navigating Instagram's Authenticity Bind," *International Journal of Communication* 13 (2019): 4983–5002.

26 Anne Dufourmantelle, *Power of Gentleness: Meditations on the Risk of Living*, trans. Katherine Payne and Vincent Sallé (New York: Forham University Press, 2018), 59.

27 Roland Barthes, *Camera Lucida*, trans. Richard Howard (New York: Hill & Wang, 1981), 15.

Emanation entails endless presentation: always on, hyper-stylized, self-identical, perpetually in view. Obscuring the effort behind such visages foments a fantasy of economic relations as a plane of equally immanent fullnesses reflecting one another intimately, a forum of mirroring:

> In our socio-economic order, the place of maximum proximity is not, say, the neighborhood, but the (now global) market: it is there that our most intimate and precious possession mingles shamelessly with other people's intimate possessions and values . . . the market is the place of compulsory, structural proximity.[28]

A society of spectacle in which sociality transpires through eyes, it can often seem to individuals as though our work is the production of our own image, keeping up with self-manifestation while lacking most means to do so.[29] Hypervisibility pressurizes meticulous self-manicuring, but the disassembled social—demolished public institutions, declining social welfare—makes it the individual's job to reproduce themselves. You do you.

Circulating self-image also commissions the imaging of the other. A narcissist's auto-affection circumscribes the other, in a diminishment intimately connected to sadism (an instinct to master, a gratification in harm). The sadist flattens the other, engineering infliction to proscribe response. Barthes helps articulate the overpresence and overexposure in self-branding with sadism: in "the Sadean world," he writes, "the function of discourse . . . is to conceive the inconceivable, that is, to leave nothing outside words and to allow the world no ineffables."[30]

28 Alenka Zupančič, "Love Thy Neighbor as Thyself?!," *Problemi International* 3:3 (2019), 101.

29 Guy Debord, *The Society of the Spectacle*, trans. Donald Nicholson-Smith (New York: Zone Books, 1995).

30 Roland Barthes, *Sade, Fourier, Loyola*, trans. Richard Miller (Berkeley: University of California Press, 1989), 37.

Everything is enjoined to presence; nothing evades. Immediacy's auto-emanations and perpetual fluidity paradoxically calcify in this way in the stone of sadism, in its inexorable control and invocatory cruelty. Without the symbolic to intervene as a certain defusing of the real, the outsize imaginary conduces to sadistic mores courting real eruptions. Philosophers have, for this reason, identified recent history with a "passion for the real" or a "reality hunger"—a pursuit of extremity, violence, and suffering as some antidote to abundant artifice—questing for intensity behind all the bullshit, for irrefutable stuff that resists representation.[31] While such passions animated the twentieth century's projects of world war, they become simultaneously totalized and banalized by the twenty-first century's opening of near-universal access to immersive technologies virtuosically hiding their own mediations: on Instagram, everyone can be General Patton.

Much of immediacy's lure rests in the momentary compensatory solidities of imagined contact with an imagined real. "An imagined real" might imply that there is a *real* real out there for a different kind of aesthetics. But for psychoanalysis, a *real* real is an "impossibility." The mundane manifestations of this impossibility are contradictory: the real can seem exterior to language—putative solidities like the body; indescribable enigmas like death; unspeakable gaps like trauma; the unthought unthinkables; the anti-negation of the unconscious—but can also seem interior to language, as with the evasive chain of metonymy or the disturbing parapraxis of symptoms and desire. These semblances endow imaginary reals: ineffable experiences struggling for expression, signifiers that mean exactly what we want them to mean. Immediatism demands these imaginary reals, grasping encounters with what circumvents or precedes mediation—but

31 Alain Badiou, *The Century*, trans. Alberto Toscano (Cambridge, UK: Polity, 2007); David Shields, *Reality Hunger: A Manifesto* (New York: Vintage, 2011); Byung-Chul Han, *The Transparency Society*, trans. Erik Butler (Stanford, CA: Stanford University Press, 2015); Kate Marshall, "The Readers of the Future Have Become Shitty Literary Critics," *b2o*, February 26, 2018, boundary2.org.

its aesthetic and political effects propagate infinite, individual-ized, phenomenalized attempts that perpetually, repetitively circle, multiplying into a hall of mirrors. Trapped in the reflective one-to-one chamber, images eclipse signifiers, presence fore-closes absence, and plenitude averts lack. Then, reality-hungry immediacy egos ultimately disavow subjectivity itself, evacuating the dynamic of *sub-ject*, the throwing under the bar of symboli-zation, in a castration denialism ensuring there is no otherness, least of all in ourselves. Instead of opaque subjects and enigmatic others, limits and contradictions, the immediacy imaginary posits only self-commanded human resources, a vital reservoir of affective flow and identity property.

In the scopic and fetishistic terrain, reals erupt, and the imag-inary waxes while the symbolic wanes. It is this slackening that thinkers like Jodi Dean, Slavoj Žižek, Mark Andrejevic, Byung-Chul Han and others have warned of as a decline of the symbolic: a malfunctioning of socially sanctioned language, a sagging of meaning and norms.[32] In general, symbolic consistency is a func-tion of tacit buy-in, collective identification, and repetitive social practices. We learn to speak and write, and we observe institu-tions coordinating and responding to language as though it is held in common. To say that the symbolic is in decline or disarray is thus to mark the loss of this effective common, to find that the authority backing the use of signifiers and grounding their felic-itous signification across differences in context and groups has dissipated. Words drift freely and, as a result, fail to secure an order of stable interpretation; to the extent that interpretations held in common can provide defenses against traumatic

32 Žižek names it though doesn't use word "decline." Slavoj Žižek, *The Ticklish Subject: The Absent Center of Political Ontology* (London: Verso, 1999), 322. Jodi Dean develops the concept, first on her blog and later in her work on communicative capitalism: Jodi Dean, "Decline of Symbolic Efficiency," *I Cite* (blog), April 14, 2005, jdeanicite.typepad.com. See also Mark Andrejevic, *Infoglut: How Too Much Information Is Changing the Way We Think and Know* (New York: Routledge, 2013), and Alexander Galloway, "Golden Age of Analog," *Critical Inquiry* 48:2 (2022), 211–32.

antagonisms, the loss of functional meaning harbingers intensi-
fied encounters with the unassimilable. Such heightened exposure
to unspeakables tends to generate a sense of immediacy: lacking
common language, there is only the funhouse mirror of "alter-
native facts" and ghastly visages, distortion and eruption.
Skepticism toward reality, quantum performance, suspicion of
experts, post-fact: swirls cutting off collective norms and serving
up personalized truth. In the imaginary, there is only appear-
ance, and thus there is always unmasking, the interminable
coronation of naked emperors.

The premier index of symbolic decline is probably, as Dean
argues, Fox News: a frenetic propagation of alternate reality with
chaotic signification and extreme agon.[33] But think, too, of the
recent metastasis of QAnon, the baroque conspiracy of a Demo-
cratic Party vampire pedophile cabal, supercharged not on
institutional television but the dark web image board 4chan,
fomenting absolute apophenic conviction among millions—those
who refuse to be duped. Amid untrustworthy entities without
means of discernment, the paranoiac position results in an
impenetrability: impervious to facts, anathema to reason, lacking
common language, there is no communication possible; as Dean
cautions, "no amount of information, technology, or surveillance
will compensate for the change in the symbolic."[34] This wholly
irrational dynamic points to the dimension of enjoyment and
desire: symbolic systems have changed, and the medium of
language has undergone transformation, leaving individuals
jammed in their own sovereign mini-reality, identification and
projection, imaginary unbound.

33 Jodi Dean, "Communicative Capitalism: Circulation and the Foreclosure
of Politics," *Cultural Politics* 1:1 (2005), 51–74. See also Dean, "Decline of Symbolic
Efficacy."

34 Jodi Dean, *Blog Theory* (London: Wiley, 2010), 129.

algorithmic cultural categories

The imaginary's one-to-one dyadic reflective paradigm for nonrelation shapes and is shaped by the algorithmic epistemes of the circulation economy, adhering the binarisms of social and cultural intercourse. In imaginary-flush immediacy style, everything flickers good or bad, relatable or hateable; the gray falls away. The two-dimensional images on screens seek to simulate the sensory immersiveness of off-screen experience, but they lack viscosity and depth of field; repetitive, mindless behavior like scrolling ensues in search of dopamine hits that mimic full sensory experience; observation of events via moving images virtually coincides with events themselves—whether we're filming ourselves seeing a famous work of art in a museum or attending a protest, sharing viral video of police violence or fixating on hashtags for immanent transmissions from active-shooter situations. Images, clicks, dopamine hits, and their capture as data become the modalities in which we live out our self-presence. Swipe left, swipe right.

Two sides of the same coin, these polarities embed the logic of discretization and data capture. Binarized consciousness, hot-take-itis, chronic opinionating, and feedback loops ensue from monetized clickbait, the twenty-four-hour news cycle, i-tech, the "extremely online," as well as a reverberating bankrupt ethico-political demand for either affirmation or cancellation. The flatness of this binary coin is crucial: when presentation is personalization, when all content is self, when experience trumps idea, any dimensionality, ambivalence, or ambiguity disappears. As a result, tension and contradiction are excluded; only opposition remains. This is all the better for the infotech companies, since the algorithm does not distinguish between good and bad clicks. Over 70 percent of Google's annual revenues are from advertising—roughly $160 billion in 2019—and whether the

activity is ecstatic or outraged, impressions are impressions. The scanning proceeds apace; it's all data.

Affirmation is the flat mutuality that immediacy style most often solicits. Consuming the style, we mirror it in merger: "It me!" Versions of affirmation orient everything from the accumulation of social media likes to university composition pedagogy, from "I feel seen" mantras to industrial-scale self-help, from Hollywood writers' rooms to electoral candidates. It is an attenuated version of "recognition," what the political theorist Nancy Fraser has long described as the vector of liberalism that deflects struggles over power and resources into struggles over respect and identity.[35] The diminished struggle makes affirmation a truly hollow cultural goal, a rallying cry and demand devoid of almost any political content.

Disjection, the one-against-one opposite of affirmation, is an equally flat malice, whose quotidian installment is denunciatory exclusion. Snap judgment, main character of the day, zero tolerance: at varying levels of carceral severity, it is a common logic, cultural theorist Mark Fisher argues, of propagating guilt. What he refers to as "the Vampire Castle" is this fort of disjection, the bloodsucking gotcha ethos behind "a priest's desire to excommunicate and condemn, an academic-pedant's desire to be the first to be seen to spot a mistake, and a hipster's desire to be one of the in-crowd."[36] Fisher has himself been denounced for this analysis by those who view rage as democratically promising. But the Black feminist activist Loretta Ross cautions against the misperception that "calling out" is a tool of the many against the mighty, underscoring instead that "most public shaming is horizontal and done by those who believe they have greater integrity or more sophisticated analyses."[37] Vilification sucks as a strategy

35 Nancy Fraser, "From Redistribution to Recognition? Dilemmas of Justice in a 'Post-Socialist' Age," *New Left Review* 212 (July/August 1995), 68–93.

36 Mark Fisher, "Exiting the Vampire Castle," *Open Democracy*, November 24, 2013, opendemocracy.net.

37 Loretta Ross, "I'm a Black Feminist. I Think Call-Out Culture Is Toxic," *New York Times*, August 17, 2019, nytimes.com.

for solidarity, which requires carefully sieving differences to establish common goals; Ross thus teaches courses in the kinds of private communication, open conversations, and careful contextualizations that make up an alternative, the "call-in."[38] Immediacy's surfacing of extreme affect poses as liberatory—authentic, righteous, spontaneous, unrepressed—but its delegitimation of mediation and auto-authority of presence, the impatience for intensity and the convicted certainties, vandalize relation.

To clasp the drag in these algorithmically ordained oppositions, to actuate the symbolic as a crack in the smoothness of the imaginary and also a frame that scaffolds against shattering, is also to encounter a symbolic real, where what is contradictory—or excluded from dyads, or in between in an age of extremes—finds relation, even if not direct expression. Just as interpersonal connections and political bridges require deliberate construction, just as the psyche is freed from the imaginary by the symbolic, a theorization of immediacy as dominant necessitates stepping away from the thick of things. The foregoing three rounds of the introduction, "Circulation," and "Imaginary" comprise an effort to grasp immediacy in manifold determinations, fingering the texture unapparent in so many smooth planes of omnisensory engagement, iridescent presence, and instant fulfillment. As we turn in the subsequent sections of this book from these general conditions toward the medium-specific animations of imaginary-propelled, circulation-forward too late capitalism, it is perhaps illustrative already to conclude this contextualizing chapter by considering one quick example of how the algorithmicized, inflated imaginary spurs current cultural aesthetics.

In contemporary movies and TV, much beloved content is governed by the imaginary's duality of immersive flow and sadistic punctures. On every channel and every platform, horror,

supernaturalism, cringe, and staggering violence total the pre-dominant genres. While the tide of offerings might appear differentiated, a common endeavor of visceral activation through charged exactitude unites so very much content in a continuum of smoothness and shattering. If shows like *Game of Thrones* or *The Walking Dead* are openly proclaimed high-gloss sadism, if a project like Lena Waithe's *Them* crosses the line, there is none-theless more reluctance to admit that revered boutique pieces like *Watchmen* or *I May Destroy You*, *Get Out* or *Girls*, *Babadook* or *Unbelievable*, in purveying unprecedented explications of Black trauma and sexual violence, are equally commanded by the prism of the imaginary and its ruse of the real. Infliction, bound up with its mastery, links many of the most circulated images in the present, even though that is often obfuscated by moral right-eousness, laudable inclusiveness, or seductive frisson.

A critical correlation of the prevalence of such aesthetics to the immediacy economy also tacitly asks for something else from art and mass media cultural forms, and poses a demand different from the passion for the real: a formalized solicitation of the symbolic. Though a genuine psychic emergency and a genuine stuckness underlie the imprisonment in the imaginary and hence the enjoyment of immediacy as style, the genuine response to such a situation must be more rather than less mediation—more arts and ideas, more ambiguity and adumbration. No matter how trendy or expedient, opting to drown in the extremity of bad affects without the punctuating relation to an other, to propagate immersiveness against contradiction, and to circulate ever more egoic image can do little but hinder working through. New con-structions, new signifiers, new bases for connection, new orders of sociality can emerge only from mediation, not immediacy. Even our TV could be giving us more.

True, TV may not be the place to look for psychic relief. The clinic in psychoanalysis has understood itself as a venue for these constructions, because its form establishes a problematizing encounter with the other. Politically, mediating bodies like the

union and the party have performed a similar function, erecting groundwork for struggles and inspiration in crises. Historically, the university has also made itself available as such a forum, minimally introducing students to other zeitgeists, cultures, epistemologies, and languages. Conceptually, the project of critical theory has been to work through symptoms and resistances, to propel thought through impasses, to negate what is merely given, and then to negate the negation, convoking readers to collective composition. The calamity is that both the omnicrisis and the inflated imaginary impede all of these mediations—so maybe TV is the thing this year.

Writing

Just the thought of fiction, just the thought of a fabricated character in a fabricated plot made me feel nauseous, I reacted in a physical way ... Over recent years I had increasingly lost faith in literature. I read and thought, this is something someone has made up ... made-up people in a made-up, though realistic, world ... It was a crisis ... I couldn't write like this, it wouldn't work, every sentence was met with the thought: but you're just making this up. It has no value. Fictional writing has no value ... The only genres I saw value in, which still conferred meaning, were diaries and essays, the types of literature that did not deal with narrative, that were not about anything, but just consisted of a voice, the voice of your own personality ... Art cannot be experienced collectively, nothing can.

Karl Ove Knausgaard, *My Struggle*, book 2

Fictional writing has no value. A maxim for a disintermediated world. Circulation-forward too late capitalism has no time for dallying in divagations. Synced to this state of affairs, writers at their best realize, as Knausgaard avows, that "the duty of literature is to fight fiction."[1] Made-up plots and made-up characters used to fool us that narrative, impersonality, and, worst of all, collectivity, hold value. But "in reality there is no

1 Joshua Rothman, "Karl Ove Knausgaard Looks Back on 'My Struggle,'" *New Yorker*, November 11, 2018, newyorker.com.

such thing as the social dimension, only single human beings . . .
if you want to describe reality as it is, for the individual, and
there is no other way, you have to really go there."[2] Negations,
redactions, singularizations—these demediations alone circu-
late value.

Crucially, Knausgaard's philosophical rejection of fictional
mediation transpires not as a statement in some interview or trea-
tise but in the due course of the defictionalized omnigeneric
fluency of *My Struggle* itself. Over 3,600 pages of roving docu-
mentism, his voice resounds across the tundra of subtraction:
near-formless effulgence gleams without frames such as chapters
or even books (indeed, he wanted all 3,600 pages bound as one
volume). Instead of *histoire* or even *récit*, there is a close present
tense immanent to the time of writing (the 3,600 pages composed
constantly in less than two years' time, at speeds of up to twenty
pages per day, fallout from their publication enfolded into their
current); instead of the novel as a theory of the world *and* a
theory of possible worlds, there is only micrology ("There are a
lot of brilliant analyses of our time, but they are by nature about
the big picture, the general structures and the long-term tenden-
cies. What a novel can do is the opposite—it can go into the
particular, into the concrete, singular life. That's the only thing
that really exists.");[3] instead of character, there is real person
("Tonje isn't a 'character.' She is Tonje. Linda isn't a character.
She is Linda . . . They are real.");[4] and, of course, instead of
focalizations, third-person narrativity, or free indirect discourse,
there is a voice and nothing more. "I wanted to just *say* it, you
know. As it is."[5] Elemental to all these negations is syntax that

2 Karl Ove Knausgaard, *My Struggle*, book 6, trans. Don Bartlett and Martin
Aitken (Brooklyn, NY: Archipelago, 2018), 1077.

3 Rothman, "Karl Ove Knausgaard Looks Back.'"

4 Knausgaard, *My Struggle*, book 6, 1077–8.

5 Karl Ove Knausgaard, "Karl Ove Knausgaard Became a Literary Sensation
Exposing His Every Secret: Readers Love Him, He Hates Himself," interview by
Evan Hughes, *New Republic*, April 7, 2014.

pours out without makeup, "if not dry then raw, in the sense of unrefined, direct, without metaphors or other linguistic decoration."[6] For its conclusion, then, book 6 perfects these negations in a concrete gazette of equally important unimportant quanta that countenance no limit or cut:

> Everything had its own significance. The fabric of a pair of trousers was significant, the width of a trouser leg was significant, the pattern in the curtain hung in front of a window was significant . . . Everything became visible in its light, the bits of food on the floor, the trail of coffee stains that ran from the counter on the right to the sink on the other side, the globules of fat that specked the surface of the sausage water in the saucepan, the two bloated sausages.[7]

This list continues for three whole pages. And it is merely one of countless such sequences. An acid-brilliant flat ontology, a virtually endless and utterly homogeneous stream that Fredric Jameson calls "itemization," Liesl Olson calls "the celestial everyday," and Ben Lerner calls "just one thing after another," the demediated accumulations here "fight fiction" precisely by revoking the premise Georg Lukács had identified as "the dissonance special to the novel, the refusal of the immanence of being to enter into empirical life."[8] Particulars, sausages, voice— that's immanence beaming from the empirical, a dazzling and dazing successional liturgy of obdurate concretudes, greasy

6 Knausgaard, *My Struggle*, book 6, 174.

7 Ibid., 273.

8 Fredric Jameson, "Itemised," *London Review of Books* 40:21 (November 8, 2018), lrb.co.uk; Liesl Olson, "On Worrying about Linda," *Avidly*, November 30, 2018, avidly.lareviewofbooks.org. See also Liesl Olson, *Modernism and the Ordinary* (Oxford: Oxford University Press, 2009). Ben Lerner asks, "Does *My Struggle* ultimately have an aesthetic form? Or is it just one thing after another?" Ben Lerner, "Each Cornflake," *London Review of Books* 36:10 (May 22, 2014), lrb. co.uk. Georg Lukács, *Theory of the Novel*, trans. Anna Bostock (Cambridge, MA: MIT Press, 1971), 71.

crescents, shimmering single entendres intransitively evident. That's immediacy as literary style.

Unmediated presence has funded concepts of value in the Western metaphysical tradition since its origins, but Knausgaard's ingenuity, and the global resonance of his voice (blockbuster sales and translation into thirty-five languages; an avant-garde cohort at work on the antifiction he enunciates) foretell something historically situated right now. Indeed, he names it: value crisis. Nothing more than what phenomenally exists can be produced; all that remains is fluid, effulgent, sui generis exchange. Fiction, narrative, impersonality, and collectivity withdraw; reality, voice, personality, and atomism ascend. To get at value, get rid of mediation.

Among literati, immediacy as literary style goes more readily by the name "autofiction."[9] *Auto* is a Greek reflexive pronoun: self, same, of itself, independent, natural, not made. In English compounds, it usually means self-acting and spontaneous, as in "automatic." The recently surging autofictions acquit as fictions that are not fictions, not made but just extant, exalting a presence preceding representation. As a rule, autofictions follow the fight plan Knausgaard outlines for eschewing the devices of fictification (character, plot, and narrative). Rather than building character, they advance a protagonist who is the same as the author in name and circumstance and real friends and real family and, above all, real voice. Rather than narrativity and plot, they purvey first-person present-tense uneventful short-spans, just elliptical ruminations in real time. Redacting fictional construction, duration, and figuration, autofiction delivers identity, instantaneity, it-ness. It moves "to get to the things in themselves."[10] Through these varying neutralizations of literary synthesis, autofictions put fictionality itself under

9 See works by, among others, César Aira, J. M. Coetzee, Teju Cole, Akwaeke Emezi, Tikashi Hiraide, Chris Kraus, Tao Lin, Hitomi Kanehara, Francisco Goldman, and Sherman Alexie.

10 Rothman, "Karl Ove Knausgaard Looks Back."

erasure, crowning immediacy as writerly imperative for the moment.

This chapter argues that the autofiction billow, the Knausgaard marvel, and many other inclinations in contemporary literary production effect a surprising unity perceivable through the prism of immediacy style:

autofiction
a new prevalence of first-person narration in fiction
a supervalence of memoir in the literary marketplace
the personal-essay boom
proliferating realisms
a swelling of the abject
the prose-poetry upsurge
and its Rubin vase companion, the twittering archipelagization
 of prose

The circulation economy crafts this stylistic unity of annulled mediation, in conditions encompassing the expansion of university writing programs amid a university labor crisis, the dramatic downsizing in the publishing and journalism industries, and the ubiquity of freelance entrepreneurs. Professions without experts leave individuals flailing to auto-actualize alone in the society that does not exist. Contemporary jettisoning of literary mediation simply aestheticizes these conditions, shedding literature's potential to immanently criticize the known world. Instead, immediacy writing is too close with us. It's suffocating.

autofiction

So many critics' darlings openly urge this stifling. Rachel Cusk frankly assesses Knausgaard's visceral "crisis of narrative's distance from reality," testifying that fiction is "fake and embarrassing . . . the idea of making up John and Jane and having them

do things seems utterly ridiculous."[11] She proclaims her much lauded *Outline* trilogy instead "intensely real," hewing to a "fiction-averse component to human experience."[12] Cusk's self-secreting realism in which she presents herself as a screen for people she encounters to speak for themselves has been received as a brilliant new mode of passive fiction, even though there can be no mistaking her active antifictionality. Obsoletizing character by staging a series of appearances of often-unnamed persons, puncturing narrative impersonality with the icy charisma of an upstage genius estranged from the writing classes and literary festivals that furnish the books' settings, and propelling plotlessness with cumulative sponging of every iota of "the unmediated," Cusk achieves novel evacuations.[13] MacArthur Genius Ocean Vuong portrays his autofiction as a composite of autobiography, epistolary address, and poetry, all of which are rooted in the real truth: "For me as a poet, I was always beginning with truth . . . As a novelist, that seemed natural to me, to begin to see the truth as only the foundation." And he explicitly poses this truth foundation as a way of resisting "the realities of the market . . . you can say no to the things that hinder you and say yes to yourself."[14] Another trailblazing autofictionalist, Tao Lin—who used his blog to stage an IPO for his unwritten second novel—defines his practice as being "strict with only using material that really happened to me," and he disdains fiction as subservience to readers, asserting, "I don't want to make stuff up to entertain people. I want the writing to be helpful to me. When I'm making stuff up it feels like it's confusing me, adding stuff to my memory that

11 Rachel Cusk, "A Man in Love," *Guardian*, April 12, 2013, theguardian. com. Houman Barekat, "Is Non-Fiction the New Fiction?," *TLS*, January 26, 2017, the-tls.co.uk.

12 Megan O'Grady, "Rachel Cusk on Her Quietly Radical New Novel, *Outline*," *Vogue*, January 14, 2015, vogue.com.

13 For another dissenting take on Cusk as "cruel," see Merve Emre, "Of Note: Rachel Cusk's Unforgiving Eye," *Harper's Magazine*, June 2018, harpers.org.

14 Dorany Pineda, "Ocean Vuong Shares Stories behind 'On Earth We're Briefly Gorgeous,'" *Los Angeles Times*, January 28, 2020, latimes.com.

never happened."[15] Sheila Heti similarly declares, "I'm less interested in writing about fictional people, because it seems so tiresome to make up a fake person and put them through the paces of a fake story. I just—I can't do it." Her resultant *How Should a Person Be?*, a *New York Times* "notable book" on many a best-of-the-century list, compiles a scrapbook of transcribed conversations, real emails, and "essay-ettes," hosting in its polyform "the unfurling of the soul on the page." *LIVEBLOG* creator Megan Boyle's identification as "averse to all fiction" roots her project of updating a blog every hour of her waking life for six months, time-stamping bowel movements, meals, errands, sex (all subsequently published in book form as an autofiction).[16] Tope Folarin, a Whiting Award winner who has been vocal about establishment habits of excluding nonwhite writers from the autofiction canon, directly proclaims that rejection of distinction which immediacy stylizes, arguing that autofiction dismantles "Western binaries" between truth and lie or fact and fiction, embracing instead the flux of "the and."[17] For these and countless other successful and revered writers, the streaming consciousness of open spread continually conjures a revolt against character, form, and fictionality itself, after which liquesces the truth and the real. No bonds, no cuts, no distinctions: only the deluging flow, always *and*, always *all*.

The category of immediacy situates these antifictional energies in conjunction with the emissive proclivities of a circulation-forward economic phase, with the obfuscation of symbolic code that underwrites digital interfaces, and with the regime of the imaginary that ecstatically charges "the voice of your own personality" (as Knausgaard put it). These contexts and their historical specificity help us precisely to apprise the novelty of

15 "Tao Lin: Chadded out of Society and into Sincerity," *Interview*, August 6, 2020, interviewmagazine.com.

16 Megan Boyle, *LIVEBLOG* (New York: Tyrant Books, 2018), 166.

17 Tope Folarin, "Can a Black Novelist Write Autofiction?," *New Republic*, October 27, 2020, newrepublic.com.

contemporary autofiction, even though the term was coined in the 1970s, and even though many critics insist that the current movement is merely a matter of white guys taking over the rightful property of women and queers (while, simultaneously, others argue that it is indistinguishable from the novel as such.)[18] The rampant crushing of mediation in twenty-first-century culture finds its most explicit rationalization in autofiction's ardor, in a trajectory that less resembles appropriation than the hegemonization of lucid intransitivity. If autofiction strikes us as exceptional, this is surely because it functions as the conspicuous self-justifying wing of contemporary literary production's unprecedented preoccupation with the "auto," across a variety of sole-proprietor genres ensuing from the industrial restructuring of publishing, journalism, and academic labor.

To be sure, the premises of contemporary autofiction accord with those of its originators—but the tenor has changed, as has the underlying economic and political situation. Since the word's first usage in English in the *New York Times* in 1972 when Paul West began to refer to (and eventually write his own book of) "a mode of tethered autobiography, or *autofiction*, in which the thing of paramount importance is the presiding mind itself, which endures after the fiction collapses," it has connoted a break with fiction that unleashes presence.[19] The more

18 The 2021 MLA Panel "Contemporary Autofiction," for example, presented an introduction and four papers, and all save one were unanimous in situating autofiction as an inherent propensity of the novel that was especially wielded in the '70s. Ralph Clare, Tim Bewes, Annabel Kim, and Ellen Lee McCallum were in agreement; only Lee Konstantinou maintained that there was a specificity to the twenty-first-century autofictional project. Recent special journal issues and Lauren Fournier's monograph also cement this long genealogical position. Ben Lerner calls autofiction as old as the novel. "Ben Lerner in Conversation with Maggie Nelson," *City Arts and Lectures*, November 21, 2019, cityarts.net.

19 Paul West's review of Richard Elman's *Fredi & Shirl & the Kids* was printed in English in the *New York Times*. See Paul West, "The Sorrows of Young Werther, Brooklyn-Style," *New York Times*, June 25, 1972. He then used the term in an academic article in 1976, "Sheer Fiction: Mind and the Fabulist's Mirage," *New Literary History* 7:3 (1976), 549–61. West then published his own "auto-fiction" in

commonly cited, though later, origin of the term was a joke ultimately deleted from the text of a book by Serge Doubrovsky in 1977: "Si j'ecris dans ma voiture mon autobiographie sera mon AUTO-FICTION" (If I write in my car my autobiography will be my auto-fiction). The book's back cover inscribed the word in a tagline while omitting the joke: "fiction of strictly real events or facts; autofiction."[20] Autofiction's route, amid a crisis of literary value, from joke and play toward the zeal of the real defines its historical development (not coincidentally in the epoch from 1972 to the present), an ever more explicit expressiveness nauseated by mediation. While gestures of hybridity and metadiscourse are recognizable postmodern moves issuing in ambiguity, autofiction deploys them to reconfirm the realities of voice, body, and self. While '70s autofiction breeds fictions, in the contemporary, as we have seen, "the duty of literature is to fight fiction." While irony rides '70s waves, sincerity rules today. By the '90s Doubrovsky himself would ravel his gamesmanship into earnestness, in his main essay on the subject: "All the threads of my auto biography/fiction/analysis/critique become inextricably entangled."[21] Thus did the significant '90s practitioner Christine Angot locate autofiction's achievement not as the playful *roman en jeu* (novel in game) but as the pure *roman en je* (novel in I), a fulsome personalism whose currents "bring the real into existence" (*faire exister le réel*).[22] Such sensations of substantification ford immediacy as that without

1977. See also Claudia Gronemann's entry "Autofiction" in *Handbook of Autobiography and Autofiction*, ed. Martina Wagner-Egelhaaf (Berlin: De Gruyter, 2019).

20 For more on the English divergence from the French, see Myra Bloom, "Sources of the Self(ie): An Introduction to the Study of Autofiction in English," *English Studies in Canada* 45:1–2 (March/June 2019), 1–18.

21 Serge Doubrovsky, "Autobiography/Truth/Psychoanalysis," *Genre* 26 (1993): 42.

22 "*L'objectif n'est pas d'exister ou de faire exister une histoire mais de la casser au contraire en tant que scénario pour faire exister le réel qui se trouve dévitalisé.*" Nelly Kapriélian, "L'autofiction: Un genre passé de mode, mais toujours aussi percutant," *Les inrockuptibles*, September 4, 2012, lesinrocks.com.

cut. The critic Annabel Kim highlights that conventional autofiction's hermetic grip on the real is a function of its knowing avowal of the gaps inherent in autobiography; acknowledging the desires and biases and opacities in its self-regard "gives autofiction its claims to a certain reality that plain fiction, without the *auto*, cannot accede to and that plain autobiography cannot adequately capture."[23] A knowingness about unknowingness encloses.

proliferating realisms

Containing multitudes, cascading the real into existence has become the mantle of significant swaths of contemporary literary production. In a book heralded as clarion by every venue from academic journals to *The Colbert Report*, David Shields denounced postmodern irony and urged "serious writing" to cast off the bondage of fiction, exactly at the same moment Knausgaard and many others were concluding that conventional fictional plots and characterization were no longer capable of "embodying what it's like to be alive." The starving artists of Shields's *Reality Hunger* promote instead antifiction and anti-genre: "a deliberate unartiness, raw material, seemingly unprocessed, unfiltered, uncensored . . . literal tone . . . autobiography; self-reflexivity, self-ethnography, anthropological autobiography; a blurring to the point of invisibility of any distinction between fiction and nonfiction: the lure and blur of the real."[24] (Get this "blur": it will become our master image of immediacy style in "Writing," "Video," and "Imaginary.") Proliferative uncut reality has recently been esteemed by literary scholars hailing a new turn to what they call "realism" in literature in the twenty-first century.[25]

23 Annabel L. Kim, "Autofiction Infiltrated: Anne Garréta's *Pas un Jour*," *PMLA* 133:3 (2018), 563.

24 David Shields, *Reality Hunger, A Manifesto* (New York: Vintage, 2011), 5.

25 This is, of course, not the only way to understand "realism." The personalization that autofiction produces as the shortest path to the real, away from the

"In the present . . . realisms are flourishing everywhere," both Jed Esty and Ulka Anjaria observe, not only in "reality-based forms" saturating the popular market like *The Real World*, *The Real*

fake and the fictive, is at once a kind of destination for one tradition of thinking about realism, and a swerve that must be understood in terms of changing sociohistorical formations. So, a continuity and a discontinuity. In terms of continuity, the enshrining of the person as the vehicle of the real consummates the foundational account, if not the literary practice itself, of realism as the seating of worldly knowing in the perceiving subject. Such an account spans some of the earliest theories of realism and some of the most recent. Ian Watt's originating definition of realist form pivots on the prism of the individual person in a sensate body: "The novel allows a more immediate imitation of individual experience . . . than do other literary forms" through an embodied empiricism for which it "is particular concrete objects of sense-perception," not "universals, classes or abstractions," "which are the true realities." Ian Watt, *The Rise of the Novel: Studies in Defoe, Richardson and Fielding* (Berkeley: University of California Press, 1957), 11, 32. This individualism he, of course, famously links to capitalist gutting of social hierarchies, and concomitant vestiture of meaning in the formally liberal subject. Fredric Jameson's *Antinomies of Realism* (London: Verso, 2013) remarkably echoes Watt, casting realism as a project to find names for affects, the "singularities and intensities" of sentient perceptual experience in "the personal intonation . . . of the individual body . . . in order to reach some richer representation of subjectivity and thereby a more multidimensional representation of reality itself." Circumventing the Marxist terms with which he has generally written about realism—reification, embourgeoisement, the production of daily life, the problem of totality—Jameson here associates the struggle to bring embodied affect into language with a quest for "immanence," a perpetual present tense effort to attain "some new heightened representational presence" (35), and he elucidates the thrust of all realism as the immediatist streaming of Heti's unfurling or Knausgaard's formlessness.

Thus, representational plenitude of the worldly, embodied, individual experience may tenably be claimed as a governing topos of realism. But the fascinating mutation in the latest realisms, a mutation discernible only in the large frame of the history of the novel, is that personalization in the novel's worldview—phenomenality, the mortal time-space continuum, the embodied sensorium, the concretude of detail, the banality of *Bildung*—has now become a personalization of its point of view, of narrativity itself—which is to say, its erasure. The personal material has subjectivated itself as personal frame. Current realism virtually exclusively composes itself in the first person. The practitioners, as we have seen, theorize this phenomenal consciousness as the antifictional, identifying author and "I," razing the inventive houses of fiction, laminating plotlessness to the sensate plane of experience, abrading the representational capacities of language down into imagistic expressivism. Immediatist, expressivist self-possession of the first-person dominant evicts the radical fictionality of nonphenomenal consciousness, forecloses the project of regarding the lives of others, and hocks literature instead as the idiomatically privatized circulation of human capital, good only for stroking ego psychology and soliciting identifications.

Housewives, and the too-real *The Apprentice*, but in more unlikely corners like so-called post-postcolonial novels "set in the present rather than the past" and which "trim modernist, metaphorical, and metafictional language for a more stripped-down and less ostensibly self-conscious aesthetic."[26] After the global financial crisis of 2008, realism has become important and popular again, since, according to Leigh Claire La Berge and Alison Shonkwiler, it offers "the most thorough possible indexing of capitalism."[27] For Colleen Lye and Jed Esty, new realisms focused on the twenty-first-century world "offer an epistemologically grounded account of life inside the world system rather than negatively allegorizing the system's indescribability."[28] With similar admiration, Heather Love uses "realism" to name the "antiliterary quality" of "the facts speaking for themselves" in the microdetail of everyday life rendered by projects like Claudia Rankine's *Citizen*.[29] From National Book Award–winning poetry to six franchises of elite wives in faux documentary, culture has obliged the critics. Rankine and *Real Housewives* may be strange bedfellows, but the haute literary cohort of autofiction explicates the connection; as Dan Sinykin quips, "autofiction is the prestige version of reality TV."[30]

The capaciousness of autofiction and capaciousness of realism fuse in the scholarly esteem of Knausgaard as "the central realist innovator of our time," and of autofiction itself as a "neorealism" endeavoring to "jump the gap between the sign and the referent, licens(ing) a fantasy that one might escape linguistic and

26 Jed Esty, "Realism Wars," *Novel: A Forum on Fiction* 49:2 (2016), 316–42; Ulka Anjaria, "The Realist Impulse and the Future of Postcoloniality," *Novel: A Forum on Fiction* 49:2 (2016), 278–94.

27 Leigh Claire La Berge and Alison Shonkwiler, *Reading Capitalist Realism* (Iowa City: University of Iowa Press, 2014), 3.

28 Jed Esty and Colleen Lye, "Peripheral Realisms Now," *Modern Language Quarterly* 73:3 (2012), 269–88.

29 Heather Love, "Small Change: Realism, Immanence, and the Politics of the Micro," *Modern Language Quarterly* 77, no. 3 (2016), 419–45.

30 Dan N. Sinykin, "The Conglomerate Era: Publishing, Authorship, and Literary Form, 1965–2007," *Contemporary Literature* 58:4 (2017), 476.

conceptual mediation and thereby gain access to the real itself."[31] Neorealisms extremize an ideological conceit of nonrepresentation and immediacy—a conceit not necessarily held by historical realists who worked in antiphenomenal omniscience, but one that remains attractive as a fantasy of un-art. Some critical discourse about neorealism is not celebratory; the philosopher Alain Badiou, for instance, cautions that the "passion for the real," an obsession with "what is immediately practicable, here and now" intensifies over the course of the twentieth century and lurks behind great acts of violence.[32] We will return to realisms at greater length in "Antitheory," but for now, we can underline how its literary practitioners associate it with freedom, including the freedom of self-actualization, and emancipation from mediation.

first-personalism

Freedom from fictionality animates not only autofiction, and not only the prolific realnesses of contemporary cultural production, but also another dynamic in the literary field at present that starkly instantiates immediacy: *a new hegemony of first-person narration*. In this context, autofiction functions as the precocious autotheory of contemporary literary circulation. Elevation of voice, authentication of the real, and repudiation of fictionality launder writing out of its abstractions, and in to flowing voice.

The paramount exemplar of this hegemony is a dramatic change in the novel. For most of its 300-year existence, third person has been the norm for the anglophone novel. Now, a

31 Taylor Johnston, "The Corpse as Novelistic Form: Knausgaard's Deconstruction of Proustian Memory," *Critique* 59:3 (2018), 368–82. Lee Konstantinou, "Neorealist Fiction," in *American Literature in Transition: 2000–2010*, ed. Rachel Greenwald Smith (Cambridge, UK: Cambridge University Press, 2018), 111.

32 Alain Badiou, *The Century*, trans. Alberto Toscano (Cambridge, UK: Polity, 2007), 3.

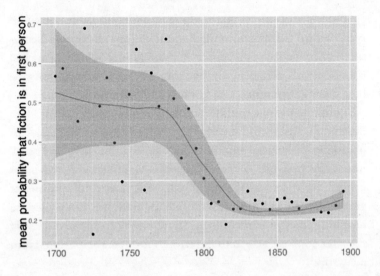

Figure 1: Mean probability that fiction is in first person, 1700–1900

serious formal mutation is underway, with first person becoming the dominant. Very early English novelists like Daniel Defoe and Samuel Richardson often used first-person narration, though they did so with editorial prefaces and frame narratives, and with a formal importance of *Bildung* or long temporal arcs that differentiated the narrating self from the character self—all aspects that cast a lot of static in the way of writing as self-effusion. But, after this initial period, there is a sudden and profound change. Computational analytics expert and Romanticist Ted Underwood has calculated the prevalence of the third person, showing how even as the total number of novels begins to skyrocket in the early eighteenth century, the number in the first person drops by more than 50 percent, from a majority to a margin.[33] Then, this proportion of third-person prevalence holds extremely steady across the entire nineteenth century.

33 Ted Underwood, "Genre, Gender, and Point of View," *Ted Underwood* (blog), September 22, 2013, tedunderwood.com.

The third person proves definitional for the novel form: an extraordinary construction of a mode of thought unavailable to us in everyday lived experience, in our own stupid envelopes. Third person stretches away from phenomenal subjectivity, toward speculative objectivity. It enacts a kind of thinking unavailable anywhere else—and that's the magic.

A half-awake critic wandering bookstore aisles and contemplating prize winners may have noticed that this definitionality now falters: third person is shockingly scarce. *My Brilliant Friend, Fifty Shades of Grey, The Sympathizer, Severance, The Goldfinch, An Untamed State, What Belongs to You, Prep, Conversations with Friends, 10:04, The Round House, Swing Time, How to Be Both, Me before You, Milkman, The Mars Room, Absurdistan, Lost Children Archive, The Friend, Ready Player One, The Vegetarian, Luster*—the list of bestselling and beloved contemporary first-person fictions does not end. Quantitative proof isn't the point of this argument, but when Underwood graciously fulfilled a request to run his code on an expanded data

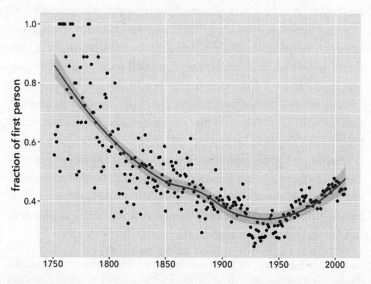

Figure 2: Fraction of first-person narration 1750–2020

set counting the twentieth century and extending into the twenty-first, he found what we would expect: the consistent dominance of the third person holds across the twentieth century too—until its last quarter, when a 250-year trend ends.[34] The definitive third person recedes, and the first person begins to markedly increase around 1970. By the first decade of the twenty-first century, the rate of increase is precipitous.

First personalism in the novel is an overarching mutation, a gutting of literary objectivity, an event of epic proportions for which serious explanation is due. Autofiction's naked rejection of fictionality is thus only the most self-conscious expression of a much wider representational tendency to redact the very impersonal, antiphenomenal, speculative point of view that defined the novel across its history. We might even say that, in its anti-medium expressiveness and nauseous angst, autofiction functions as the patent theory of this mutation.

So, what is its cause? For more than a century, scholars have understood the novel and capitalism to have a very special relationship; because the novel is the literary form unique to capitalism, it uniquely mediates capitalist relations, propelled as it is by a dialectic of society and the individual, the exemplary and the exceptional, worldly details and astral wisdom. Thus, the early English novel confronts capitalist dynamics like enclosure and mercantilism through adventures of shipwreck and casting on to the marriage market; or the great nineteenth-century novel reckons with urbanization, revolution, and colonialism through large casts of characters jostling for social coherence; or the modernist novel contemplates total war and the global market through streams of consciousness and cinematic propulsion; or the postmodern novel stages complete commoditization through metafictional irony and pastiche. If there is

34 Cris Mazza has also done a computational study, tracking in creative writing workshops and literary magazine submissions a "too much of moi." See Cris Mazza, "Too Much of Moi?," *The Writer's Chronicle* 42:2 (October/November 2009).

transformation in the history of the novel in the twenty-first century, to what capitalist transformation does it correspond?

Since the last quarter of the twentieth century, economic restructuring in the anglophone world, and especially the United Kingdom and United States, has sculpted every aspect of social life to the model of market competition, blazing new frontiers in reconceiving human being as human capital. This has involved channeling wealth upward by defunding public institutions, slashing corporate and upper-income-bracket tax rates, promoting corporate welfare and corporate personhood above public well-being, responsibilization—making individuals and families bear the costs of social reproduction like education and health care—and commodifying the commons and the body. Genomes, quantified habits, drinking water, air and shade and sun are all for sale; land grabs on several continents; violent policing of formerly public spaces like parks and bus stop benches and sidewalk vending all repeat the historical processes of the birth of the nation state in the sixteenth century, the expulsion from common lands in the eighteenth, and the extraction of planetary minerals in the twentieth. These are some of the many elements that historians and political theorists like David Harvey, Silvia Federici, Ashley Dawson, and others deem "the new enclosures."[35] Enclosure is inscribed as literature in the gestures of privatization and prosaicism this chapter catalogs. Literature now encloses and reifies the substance of real bodies and real identities, excluding the less phenomenal, more speculative processes of fictionality and figuration.

The mode of production in the twenty-first century does not fundamentally differ from that in the 1960s, but, as we saw in "Circulation," the relative importance accorded to circulation (including financialization, communications, and networking) is new. Similarly, the conceit of the self as the scaturient seat of

35 Ashley Dawson, "Introduction: New Enclosures," *New Formations* 69 (2009), 8–22.

human capital, a conceit we in "Imaginary" saw constituted as psychic truth by the enterprise to squeeze efficiencies from the social reproduction process, is also a determinant of literary immediacy as style. Economic premiums on speed, flow, and auto-actualization inscribe themselves into literary style; immediacy writing's anti-representational, antifictional centrifugality of charisma aestheticizes this capitalist base. But, if this all sounds like vulgar Marxism, pinpointing a cause for the privatization and demediation of fiction in the privatization and stalling of macroeconomic relations, we can granulate that causality by attending to more mundane and institutional levels; at the same time, we can also appreciate the array of effects of these causes by studying other significant trends activating immediacy in contemporary literary production. And, later, we will make the dialectical swerve, attending in the conclusion to counterhegemonic literary projects that capacitate critique of the contradictory conditions immediacy symptomatizes.

Let's begin the granulation by exploring some circumstances for literary value in the publishing industry and the university. Next to Knausgaard's struggle, everyone's favorite autofictional work—the foremost example in every academic article, symposium, and syllabus—is Maggie Nelson's 2015 *The Argonauts*.[36] Both a *New York Times* bestseller and a National Book Critics Circle Award winner, as well as the occasion for a MacArthur Genius grant, it offers a deeply exposing personal meditation

36 See Emily Spiers, *Pop Feminist Narratives* (Oxford: Oxford University Press, 2018); Hal Foster, *What Comes after Farce? Art and Criticism at a Time of Debacle* (London: Verso, 2020); Arne De Boever, *Finance Fictions: Realism and Psychosis in a Time of Economic Crisis* (New York: Fordham University Press, 2018); Chelsea Largent, "The Absolute Self(ie): How Autofiction Writes the Relational," *English Studies in Canada* 45:1–2 (March/June 2019), 113–40; Kaye Mitchell, *Writing Shame: Gender, Contemporary Literature, and Negative Affect* (Edinburgh, UK: University of Edinburgh Press, 2021); Prudence Bussey-Chamberlain, *Queer Troublemakers: The Poetics of Flippancy* (New York: Bloomsbury, 2019).

about sex, embodiment, pregnancy, and transition, structured in lyrical fragments that interweave impressions of—and frequent screeds against—queer theory, gender theory, psychoanalysis, and cultural studies. In homage to these theoretical antagonists, if somewhat confounding given its status as beloved autofiction, Nelson herself calls the book "autotheory," but these blurs are the point. Revealingly, Nelson connects her nomenclature to university labor configurations in the second decade of the twenty-first century:

> I'm always looking for terms that are not "memoir" . . . and since this book has more theory in it than other books of mine, ["autotheory"] seemed an apt description . . . I can teach most anything in the humanities I want; further, our MFA program was specifically founded on its lack of partition between so-called "critical" and "creative" writing. While writing this book I taught a course called "Wild Theory" for my grad students, focused on theoretical writing that falls out of boundaries or disciplines, or even sense-making—that was a lot of fun.[37]

For Nelson, autotheory is the fun, free wilding in "lack of partition," what she also calls in *The Argonauts* "flow . . . plethora . . . kaleidoscopic shifting . . . excess"—so many virtues of immediacy synonymized by her flexible labor. "I can teach most anything in the humanities I want" is at once a product of her position as a tenured full professor at a wealthy school and an inverted image of the generalism now demanded of most contingent humanists who "fall out of boundaries or disciplines" and cobble together employment teaching in "writing" programs—which have grown exponentially in recent decades, including as majors and fields of advanced research, all while English majors on the

37 Micah McCrary, "Riding the Blinds," *Los Angeles Review of Books*, April 26, 2015, lareviewofbooks.org.

whole have declined.[38] This efflorescence of writing without reading and Nelson's bounding omnivorism bespeak immediacy as genre dissolve: in its blur, autotheory and autofiction function as two names for the same thing: wilding against genre, against theory, against fiction, against mediation.

The melt that opposes itself to genre bounds or defined job responsibilities or making sense pools on the page as a rejection of linguistic mediation: theory, genre, and even words all miss the mark. "I am not interested in a hermeneutics, or an erotics, or a metaphorics, of my anus. I am interested in ass-fucking." In service of the immediatist intimacies generated in this raising of theory only to reject it, Nelson theorizes the pronouns of her prose, circumventing representation of her gender-nonconforming partner by addressing them instead: "I want the you no one else can see, the you so close the third person never need apply." Representation itself is constantly at issue, the insufficiency of words. In a telling moment she writes, "I have never been able to answer to *comrade . . . Our diagnosis is similar, but our perversities are not compatible.*" Words that imply that individuals "share" a common view or hold a common meaning betray the libidinally charged corporeal ineffabilities that cannot be united; "perhaps it's the word *radical* that needs rethinking. But what could we angle ourselves toward instead or in addition? Openness?" Openness crackles in the spaces between the unlinked aphoristic paragraphs, in the audit of meager words, in the recurrent avowal "I don't want to represent anything. I am interested in offering up my experience and performing my particular manner of thinking, for whatever they are worth."[39] Insufficient words, inadequate theories, unspeakable intensities, outmoded genres— so many refrains against mediation, toward immediacy.

38 See the computational analysis in Juliana Spahr and Stephanie Young, "The Program Era and the Mainly White Room," *Los Angeles Review of Books*, September 20, 2015, lareviewofbooks.org.

39 Maggie Nelson, *The Argonauts* (Minneapolis: Graywolf Press, 2016), 85, 7, 27, 96.

service learning

Nelson's conjugation of autoemanation with professional agility raises the specter of the flexibility that has been the buzzword of circulation capitalism, often gilded with aesthetic caché as a "creative economy," that also shapes the day jobs and credentialing of many would-be literary authors.[40] "Writing that falls out of boundaries or even disciplines" fairly describes the labor uncertainty as well as mission creep in the academic writing universe. Forced austerity has vanished tenure-track positions while deskilling academic labor; "falling out" of disciplines evokes the adjunct expelled from professional forums like conferences and journals while cobbling together poverty wages in multiple departments at multiple schools. "Writing" as academic formation disperses itself "across the disciplines" and covers courses and concentrations in professional and technical writing, business writing, science writing, media writing, publishing, rhetoric and composition, and creative writing. As indices of the multiplication of writing, more than seventy US universities have established PhDs programs in composition since the 1970s; there are eighty-two BAs in professional writing that have almost all opened in the twenty-first century. According to the Association of Writers and Writing Programs (AWP), there are now 728 BA programs in creative writing nationwide, which reflects a large increase during the same thirty-year period in which humanities majors overall and English majors in particular have declined.[41] As poet-critics Juliana Spahr and Stephanie Young show in their

40 For the classical exponent, see Richard Florida, *The Rise of the Creative Class* (New York: Basic Books, 2002). For a more critical analysis, see Sarah Brouillette, *Literature and the Creative Economy* (Stanford, CA: Stanford University Press, 2014).

41 "Guide to Writing Programs," Association of Writers and Writing Programs, awpwriter.org.

study of the whiteness (or not) of MFA programs, the growth of creative writing degrees (BA, BFA, MA, and MFA) has been exponential in the period that concerns us: at the end of the 1980s, around 1,000 degrees were awarded per year; by 2013, the annual figure was 6,500.[42] The rising demand for degrees meant a growth in programs (for instance, 300 schools have added creative writing graduate programs since 1975), yet this growth also coincided with ruinous declines in the percentage of instruction performed by tenured faculty, and with enormous tuition increases. Central to this growth is the boom of "creative nonfiction" as a capacious binder for expressive documentary across memoir and journalism, which is also reflected at the graduate level in new specialized academic programs like the Oxford Centre for Life-Writing or King's College Network for Life-Writing Research.[43]

Universities themselves cannot have wholly manufactured this explosive demand for writing degrees. Rather, the popularity of these paths of study exemplifies the broader culture of privatization and personalization. "Americans typically targeted by media, marketers, and job recruiters are constantly being reminded that their individuality matters—that each person is a unique, authentic, rebellious, sexy, interesting, entertaining self with a lot to say and share," writes Megan Brown in *American Autobiography after 9/11*.[44] Reporting in the *New York Times* in an effort to explain the growth of MFAs at a time when visual culture appears to be eclipsing literary culture, Steve Almond relays of his observations at AWP's enormous yearly writing convention:

In each case, what strikes me aren't the particulars—age, attitude, ambitions—so much as their essential motive. What

42 Spahr and Young, "The Program Era."

43 See Daniel Worden, *Neoliberal Nonfictions: The Documentary Aesthetic from Joan Didion to Jay-Z* (Charlottesville: University of Virginia Press, 2020), 12.

44 Megan Brown, *American Autobiography after 9/11* (Madison: University of Wisconsin Press, 2017), 100.

they really want isn't fame or fortune but permission to artic- ulate feelings that were somehow off limits within the fragile habitat of their families. They are hoping to find, by means of literary art, braver and more-forgiving versions of them- selves.[45]

Almond describes creative writing workshops as involving "direct engagement with inner life, as well as a demand for greater empa- thy and disclosure. These goals are fundamentally therapeutic." Seen in this therapeutic light, we can understand some of the outsize growth of these programs: our culture is enduring a mental health epidemic without accessible mental (or other) health care, and, while the student debt crisis betrays that degrees are scarcely more accessible, graduating with a BFA and debt at least gives one a credential that mental health care does not; after all, there's no CV line for completing therapy.

Consumer demand for graduate writing degrees merits much more study. But one elementary tributary to first-personalism in the echelons of MFA workshops is surely the pedagogy of the freshman composition courses required of virtually every college student in the country. Voice-centered experiential writing, reflective writing, and metacognitive writing anoint the meta- discipline writing classroom now, where the content of writing is not subject matter but the subject's intellective and spiritual jour- ney toward prose. The famous writing-program director and pedagogy theorist Peter Elbow articulated this sentiment as a basis for college composition: "writing without teachers" is self-directed, process-based generation of as much text as possi- ble in a "freewriting" mode that likens academic writing to diaries and letters.[46] Cutting-edge composition theory empha- sizes that students are already experts, positioning professors as

45 Steve Almond, "Why Talk Therapy Is on the Wane and Writing Workshops Are on the Rise," *New York Times Magazine*, March 23, 2012, nytimes.com.

46 Peter Elbow, *Writing without Teachers* (Oxford: Oxford University Press, 1973).

"coaches" rather than authorities and designing assignments around the effusion of native knowledge. The Conference on College Composition and Communication's manifesto, "Students' Right to Their Own Language," cites Langston Hughes in their 1974 exhortation to "dig all jive" in affirming "creativity and individuality" in writing pedagogy.[47] The egalitarian register of such commitments now conforms too often to market frames of equal consumer-producers and customer-satisfaction maxims of upper administrations. Jane Tompkins, a progenitor of reader-response theory and an author of autotheory, captures the suffusion of the literature classroom as well by this ethos of voice and experience: she says of her teaching that it "has not really been about explaining literature, it's really been more about getting people to come out of themselves and find out what they want, who they are, and what their relation to a text is. Literature becomes a kind of occasion or excuse for all this."[48] Literary studies that understands itself as fundamentally offering students self-exploration, therapy, and mirroring or affirmative representation harmonizes with composition studies that understands writing as a technique of self-deployment that students should practice en route to profitable employment; both train the literary producers whose output activates contemporary immediacy.

Inroads in student-centered pedagogy, in turn, propel the trend toward the personalization of academic study within traditional disciplines like psychology, philosophy, and even business. What might once have been a curriculum of the history of ideas or of normal/abnormal psych increasingly marshals disciplinary ingress to self-optimization; the resulting expertise is less in a method or corpus than in facets of persona. Take, for example, the twenty-first-century popularity of university courses in

47 "Students' Right to Their Own Language," *College Composition and Communication* 25 (Fall 1974), cccc.ncte.org.

48 Interviewed in Adam Begley, "The I's Have It: Duke's '*Moi*' Critics Expose Themselves," *Lingua Franca* 4:3 (March/April 1994).

positive psychology, what we might call "best life" studies, remarked in Beth Blum's history of self-help literature. Both Harvard and Yale have offered in the past fifteen years their two most popular courses of all time, Tal Ben-Shahar's "Happier: Learn the Secrets to Daily Joy and Lasting Fulfillment," and Laurie Santos's "Psychology and the Good Life," featuring as culminative assignment "The Hack Yo-Self Project."[49] Santos's course, in which fully one-quarter of Yale undergrads have enrolled, has since been recorded as one of twenty free offerings from Yale Online, as well as becoming a podcast, *The Happiness Lab*. Merve Emre has chronicled the literary curricula of business majors and MBAs, showing how they explicitly aim at "the performance of empathy: the ways in which flexible self-managing individuals explicitly acknowledge one another's needs and desires" for workplace harmony, corporate leadership, and marketing success.[50] Scholars, administrators, and the general public increasingly embrace therapeutic outcomes for humanistic study. The medical humanities professor Douglas Dowland recently penned a sweet essay about the commonalities between therapy and literature classrooms, writing, "Both, after all, are spaces of human striving. And both, after all, are spaces where people practice the art of being people."[51]

College pedagogy, labor footing in higher education, and the mental health epidemic in the first world all branch to the personalist blurring of genre and anti-representational immediacy in literary works today. These institutional conditions for the production and consumption of writing go some distance toward explaining the style—one in which voice and persona are solidities that precede forms, concepts, and canons. Beyond the

49 Beth Blum, *The Self-Help Compulsion: Searching for Advice in Modern Literature* (New York: Columbia University Press, 2020), 245.

50 Merve Emre, "Better Management through Belles Lettres: Literature at the B-School," *Baffler* 29 (October 2015), thebaffler.com.

51 Douglas Dowland, "Teaching as Therapy," *Avidly*, October 11, 2020, avidly.lareviewofbooks.org.

university, some similar conditions in the adjacent industry of publishing brace the personalism of immediacy style.

book it

One undeniable historical specificity for contemporary personal-ist anti-mediation is the necessity for authors to become, in the words of scholar and novelist Lee Konstantinou,

> something like a firm who must one the one hand, manage his own inner resources, his drives, his talents, and so on, and then, on the other hand, must, like any independent firm, hire and fire agents, editors, and publishers and must navigate personal and professional relationships that will, in time, get absorbed back into the maw of his writing.[52]

Autofiction's frequent chronicles of a real author's real embod-ied, banal, quotidian experience just as frequently document the process and even struggle of attaining and fulfilling the book contracts for the very pages in the reader's hands. Immediacy, here, unfolds from this incorporation of the industry of publish-ing into the literary subject matter of itself, an intellectual development that concords with industrial development: the corporate conglomeration of publishing and, as discussed below, the rise of self-publishing platforms, have meant serious down-sizing in the profession and a transposition of that labor on to authors themselves.[53] Pressing the publishing industry into the charismatic author, immediacy writing cuts out the middleman, immanentizing circulation.

52 Lee Konstantinou, "Autofiction and Autoreification," *The Habit of Tlön* (blog), February 6, 2021, leekonstantinou.com.

53 On consolidation and job losses for editors, staff, and booksellers, see André Schiffrin, "How Mergermania Is Destroying Book Publishing," *Nation*, November 28, 2012, thenation.com.

Although virtually all authors in the contemporary market-place—autofictionalists or not—must have social media "presence" as a precondition of book contracts, the growth of the self-publishing sector into a $1 billion market (including 30 to 35 percent of all e-book sales in English) circumvents the role of publishing houses while reinforcing the literary ideology of self-strut. Self-published authors not only write a book but also conduct the editing, design, and distribution, trading high up-front costs for notions of control, self-selection in a competitive sector, and greater profit share—should there be any profits. Literally relieved of the institutional assistance of agents, contracts, editors, and marketers, even as they are enabled by corporate innovation, self-publishers account for millions of texts, some of which actually sell hundreds of thousands of copies.[54] In his analysis of Amazon's Kindle Direct Publishing and its consequences for literary fructification, Mark McGurl astutely notes that Amazon's customer-is-king ethos has found its way into the self-publishing wing, with KDP authors favoring highly formulaic genres and series designed to appease repetitive consumer demands.[55] In these platforms, writers and readers alike enjoy real-time wish fulfillment—instantly emittable self-expression and instantly available, customized absorption.

Writers of all sorts have internalized the functions of the publishing industry while casting aspersions on the trappings of fictional mediation, and as a result their output flexes pangeneric and self-promotional. On the other side of this coin, some traditional avenues of creative employment like publishing and journalism have closed, but mainstream business has embraced bohemian ingenuity.[56] Most English majors, for instance, find

54 Innovation, e.g., the invention of e-book sales technology in the late 1990s, Amazon Kindle in 2007, and paradoxical self-publishing firms like Apple iBooks Author (2012), Barnes & Noble's Nook Press (2013), and Amazon's Kindle Direct Publishing (2007).

55 Mark McGurl, *Everything and Less: The Novel in the Age of Amazon* (London: Verso, 2021), 449.

56 For more history, see Thomas Frank, *The Conquest of Cool: Business*

remunerative and rewarding work for corporations. As the novelist and professor Tom McCarthy surmised in 2015, such professionalization and deinstitutionalization of creative writers relocates the sphere of literary production from the publishing house or magazine or classroom to the for-profit enterprise. His analysis is worth quoting at length:

> More than half of all anthropology graduates now work for corporations too. Not on but for: deploying ethnographic knowledge to help companies achieve deeper penetration of their markets, to advise cities how to brand and rebrand themselves, and governments how better to narrate their policy agendas.
>
> That last term—narrate—should bring this whole discussion back to the point it never really left. As for the world of anthropology, so for the world of literature. It is not just that people with degrees in English generally go to work for corporations (which of course they do); the point is that the company, in its most cutting-edge incarnation, has become the arena in which narratives and fictions, metaphors and metonymies and symbol networks at their most dynamic and incisive are being generated, worked through and transformed. While "official" fiction has retreated into comforting nostalgia about kings and queens, or supposed tales of the contemporary rendered in an equally nostalgic mode of unexamined realism, it is funky architecture firms, digital media companies and brand consultancies that have assumed the mantle of the cultural avant garde. It is they who, now, seem to be performing writers' essential task of working through the fragmentations of old orders of experience and representation, and coming up with radical new forms to chart and manage new, emergent ones. If there is an individual alive in 2015 with the genius

Culture, Counterculture, and the Rise of Hip Consumerism (Chicago: University of Chicago Press, 1997).

and vision of James Joyce, they're probably working for Google.[57]

McCarthy labels this relocation "the death of writing." But our analysis of blurring might also point to something else: the dispersion of writing beyond the recognizable register of literature and into almost every aspect of the corporate service and circulation economy. Marketing, consulting, design, law—these are circulatory sectors of outsize importance in the present accumulation crisis, creative industries expediting tremendous literary output, and commissioning elastic, generative writing. The resulting porousness is an industrial woof for the messy mesh of immediacy.

supervalent memoir

Along with the complexities of self-incorporation and the unprecedented predominance of the first person in the contemporary novel, literary immediacy's antifictional exudation streams from the present paramountcy of memoir. The *New York Times* now calls memoir "the dominant genre of contemporary literature" and has receipts: in the first decade of the new millennium, memoirs often accounted for as much as 80 percent of their bestseller list, and twenty-first-century memoir sales increased 400 percent from the twentieth-century average.[58] This generic hegemony is overtly thematized in the best-selling memoir of all time, Michelle Obama's 2018 *Becoming*, whose 14 million copies promise that anyone can capitalize on their life: "Your story is

57 Tom McCarthy, "The Death of Writing—If James Joyce Were Alive Today He'd Be Working for Google," *Guardian*, March 7, 2015, theguardian.com.

58 Thomas Larson, "The Age of Memoir," *Review Americana* 2:1 (Spring 2007), thomaslarson.com. From the 1940s to the 1990s, the number of memoirs released per year tripled; see Leigh Gilmore, *The Limits of Autobiography: Trauma and Testimony* (Ithaca, NY: Cornell University Press, 2001).

what you have, what you will always have. It is something to own."[59] In this image of ownership, the charismatic voice that embeds immediatist self-expression substantializes as content—a shiny, unique, self-begotten property. The composite of a voice and its property now offers itself as the real stuff exuding directly through any language, not only in the specifically taggable genre of memoir but in intellectual production at large. As the historian Ben Yagoda argues, "Memoir has become the central form of the culture: not only the way stories are told, but the way arguments are put forth, products and properties marketed, ideas floated, acts justified, reputations constructed or salvaged."[60]

How could other kinds of literature afford to ignore this gravitational force? The novelist Martin Amis frames an inevitable upending of literary imaginativeness at the beginning of his own 1999 memoir:

> It used to be said that everyone had a novel in them. And I used to believe it . . . if you're a novelist you must believe it, because that's part of your job: much of the time you are writing the fiction that other people have in them. Just now, though, in 1999, you would probably be obliged to doubt the basic proposition: what everyone has in them, these days, is not a novel but a memoir.[61]

Everyone does. The 1990s that Amis was observing starred numerous blockbuster memoirs, including those penned by first-time and unknown authors ("nobody memoirs"). Alongside *Angela's Ashes*, *The Liar's Club*, and *Tuesdays with Morrie* came *Running with Scissors*, *Reading Lolita in Tehran*, and *Eat, Pray, Love*. Celebrities, public figures, and nobodies vehiculating via memoir into public stature all found success in the form, as did so

59 Michelle Obama, *Becoming* (New York: Crown, 2018), xviii.
60 Ben Yagoda, *Memoir: A History* (New York: Riverhead Books, 2009), 7.
61 Martin Amis, *Experience: A Memoir* (New York: Vintage, 2001), 6.

many established novelists that the *New York Times* complemented its assessment of the genre's dominance with appraisal of its heights, calling the late 1990s and early 2000s "the age of the literary memoir." Primarily designating memoirs written by literary figures (rather than a stylization or literary elevation of memoir), this growth entails publishing companies' pursuit of memoirs from both novelists and poets, both aspiring and successful—and the more abject the better. Jesmyn Ward, Joan Didion, Hilary Mantel, Roxane Gay, Haruki Murakami, Dave Eggers, Amy Tan, Jonathan Franzen, Jamaica Kincaid, Salman Rushdie, J. G. Ballard, and Jeanette Winterson are all major novelists who've penned memoirs in the twenty-first century. Alexander Chee's is even called *How to Write an Autobiographical Novel.* The critically beloved Rachel Cusk, Ann Patchett, and Tobias Wolff have each written *two.* This memoir imperative does not stop with creative types; many writers traditionally oriented as critics have also fulfilled it: Frank Lentricchia (*The Edge of Night*), Jane Gallop (*Feminist Accused of Sexual Harassment*), Michael Ryan (*Secret Life*), Anne Cvetkovich (*Depression*), Hazel Carby (*Imperial Intimacies*), Samuel Delany (*Times Square Red, Times Square Blue*), Eve Sedgwick (*A Dialogue on Love*), Jane Tompkins (*A Life in School*), Henry Louis Gates (*Colored People*), Saidiya Hartman (*Lose Your Mother*), Colin Dayan (*In the Belly of Her Ghost*)—this is but a partial list of literary scholars who've authored memoirs, often domesticating versions of literary theory within. Success in one section of the bookstore does not suffice; writers of all stripes are urged to authenticate their voice, fortify their brands, and expand their audience by testifying more directly.

The centripetal pull exerted by this titan of the market can hardly be resisted by the holdout genres, and thus surfaces alongside the memoir grab a credible memoirization of fiction.[62]

62 Laura Miller first used this phrase, disparagingly, in "But Enough about Us," *Salon*, June 10, 1996, salon.com.

By "memoirization," we can connote the new dominance of first-person narration, but also the imprint of the imperative "Write what you know"; elevation of the individual subject's lived experience to literary treatment; a mistrust of authority untethered from experience; the filtering of social and historical dynamics through subjective lenses (or the active discrediting of objective lenses); the promotion of phenomenology as limit horizon for knowledge; the enterprise of confessionalism; preoccupation with domesticity (whether childhood or marriage); a torquing of the novel's fascination with orphans into an obsession with parental blame; the individual's heroic overcoming of circumstance; therapeutic narrativization of political, social, and corporeal challenges; a centering of the historical present; solemn solicitation of readerly recognition, identification, and empathy; a populism of the masses poised against an alleged elitism of the literati. Fiction less and less purveys the third person, less and less works through plots, less and less spans long time scales, and more and more resembles the personalist, presentist wallowing already for sale in the other aisles.

One such aisle is self-help, where rest at least one-quarter of the top twenty best-selling nonfiction titles in any given year of the twenty-first century.[63] Popular and even occasionally market dominant across its history—Samuel Smiles's *Self-Help* outsold every book except the Bible in the mid-nineteenth century—self-help differentiated and nichified in the later twentieth century, opening up ever more avenues of help (and sales): not just morality, spirituality, or psychology, but the physical body (exercise, fitness, makeovers, diets), economic success (personal finance, highly effective habits), and relationship success (the marriage of Venus and Mars, speaking love languages). The monetary profit many authors earn from self-help (not only in book sales but in banquet speaking and retreat leading) would

63 Matt Reiman, "The First Self-Help Author Would Hate What the Genre Has Become," *Timeline*, September 8, 2016, timeline.com.

seem to contrast with the elusive benefit to the average consumer, since the reams of positive-thinking and personal-empowerment literature have coincided with rising suicide rates, epidemic drug addiction, a $15-billion-per-year psycho-emotional pharmaceutical market, declining life expectancy, and exponentially expanding consumer, household, medical, and education debt. Appearing in ever more refined genres, self-help is big business, a magically self-perpetuating commodity.

Outside the bookstore, personalism's uplift and tunnel vision also animate the technological wave through which denizens of developed nations now write more than ever before.[64] This explosion of writing through social media also folds back into fictions who strain at their own genres and medium. Memoir becomes cultural dominant not merely as a matter of sales volume or cache of a defined genre, but through its scaffolding of generic excision and meaning as such. As we've seen in "Circulation" and "Imaginary," the current constellation of so-called social media centers the notion to speak our truth. The networks of the 2010s have rerouted the internet's original anonymity into self-expression; cultivating our personal brands, social media makes memoirists of us all, on the daily. The original format for the Facebook update, starting in 2005, positioned users to describe themselves in the third person (it used the formula "Member Name is_____"), but that was discarded in 2007, partly due to a member campaign of more than 500 separate groups against it.[65] First-person is instead the rule of the platform, with everyone immanently adding to their personal story. Instagram (owned by Meta), Twitter, and TikTok are also astonishingly ubiquitous technologies of self-presentation. There is even a popular genre of tweet, "_____: A Memoir," for which the user fills in an experience and the genre claimer:

64 For more on this claim, see Andrea Lunsford et al., *Everyone's an Author*, 3rd ed. (New York: Norton, 2021).

65 Betsy Schiffman, "Status Update: Facebook Is Letting Users Drop the 'Is,'" *Wired*, November 20, 2007, wired.com.

"Work Stress Insomnia on the Weekend: A Memoir." All these apps that provide opportunities to update, filter, and distill the private persona rally a pedagogy of self-manifestation consonant with the formal and tony literary echelons. It is no wonder, then, that so many contemporary novels not only braid themes of self-manifestation via networked technology but also fabricate their form in emulation of these now-unavoidable idioms of expression. We find in twenty-first-century fiction successful works of email epistolarity such as *Richard Yates* by Tao Lin or *e* by Matthew Beaumont (followed by a novel-in-SMS, *Squared*), successful works that mimic ubiquitous online genres like the customer review (Rick Moody's *Hotels of North America*) and acclaimed works that stitch together a novel out of fictional Yelp reviews (Gregg Gethard's *Karl G*).[66] There are novelty apps, like Hooked, for consuming fiction in the form of text messages, following the patterns established in Japan for offering seventy-word installments of novels on mobile phones.[67] Each of these social network forms has fed more traditional publishing, with app novels and Yelp-review novels being optioned for print and screenplay. And, perhaps most importantly, we find traditional novels that are born digital, structured as twitfic (Jennifer Egan's *Black Box*), Instagram posts (Olivia Sudjic's *Sympathy*), Facebook shares (Jeff VanderMeer's *Komodo*) or autofictions of the stream of all apps (Olivia Laing's *Crudo*). Paralleling these professional writers, what scholars now call "amateur writing communities" gather on Twitter and other platforms, using hashtags as genre markers to connect their tweet-length work to peers and audiences at #VeryShortStory or #Poem.[68] While the novel has always cannibalized other genres,

66 Mattie Kahn, "Man Publishes Novel in Series of Yelp Reviews," *ABC News*, August 4, 2014, abcnews.go.com.

67 Clive Thompson, "The Best New Way to Read? Novels Told through Text Messages," *Wired*, August 18, 2016, wired.com.

68 Christian Howard, "Studying and Preserving the Global Networks of Twitter Literature," *Post45*, September 17, 2019, post45.org.

the syncing of fiction with memoir, self-branding, and self-help in the contemporary combined with the economic pressures of self-manifestation evacuate fictionality today.

the personal essay boom

Social media platforms impart the habitus of voice-honing and property-maintaining, a literary weigh station between micro-memoir and book contract, which sanctifies itself in the skyrocketing mode of the personal essay. Enthusing social media as feminist immediacy, the writer Natalie Beach articulates this destination: social profiles are "busting open the form of non-fiction. Instagram is memoir in real time. It's memoir without the act of remembering. It's collapsing the distance between writer and reader and critic, which is why it's true feminist storytelling."[69] Beach's little turn of immediacy theory (form-busting, real-time, distance-collapsing) comes in a personal essay—a genre of writing with a very long history, and a specifically mass media history since the turn of the twentieth century, that has nonetheless developed differently in the twenty-first, thanks to a convergence of social media apps and publishing industry down-sizing. *New Yorker* staff writer and editor Jia Tolentino refers to a "personal essay boom" she sources to 2008, offering an economic analysis: where blogs of the early new millennium had habituated people to unpaid content generating of personal documentary, new forms of page-view monetizing arose before and during the Great Recession, at the same time that journalists and professionally compensated columnists were downsized. Thus, online platforms for commodifying blogs as quasi-edited content under a house brand snowballed, with the personal essay—the

69 Natalie Beach, "I Was Caroline Calloway: Seven Years after I Met the Infamous Instagram Star, I'm Ready to Tell My Side of the Story," *The Cut*, September 10, 2019, thecut.com.

more salacious, the more clickworthy—as the quintessential genre. Tolentino quotes the former personal-essay editor at *Salon* (which still operates but no longer has a dedicated editorial position): "The boom in personal essays . . . [was] a response to an online climate where more content was needed at the exact moment budgets were being slashed." While a number of the original venues that promoted this genre have closed since late 2015 (*Gawker*, *xoJane*, the *Toast*, the *Awl*, the *Hairpin*), other well-funded mainstream venues like *Huffington Post* and the *Guardian* have added their own regular proprietary personal essay features (e.g., *HuffPo*'s Voices). This rise has also been fed by the impression that personal essays are good gateway résumé lines for women and nonwhite people in an industry that too often relies upon networking. It doesn't so much matter who you know as what you've self-authorized.

Mapping the formal features of self-promotion in the personal essay, Emre appraises it as

> writing that serves primarily, and sometimes exclusively, to present the author as a more admirably complicated type of human subject than others. It is the literary equivalent of the ill-mannered man who, thinking himself to be very mature, declares, "I may be an asshole, but look how self-aware I am about it."[70]

Emre published that study before the rise of the inordinately popular Reddit forum "AITA" (Am I the asshole?), where upward of 2.5 million people gather daily to consult over individuals confessing the details of convoluted psycho-sexual-social circumstances they find displeasing. Binary judgment (either you're the asshole, or you're not) ensues from 30,000 posts on some 800 scenarios per day, a kind of moral workout routine for judger and

70 Merve Emre, "Two Paths for the Personal Essay," *Boston Review*, August 22, 2017, bostonreview.net.

judgee alike. The translator and scholar Emily Gould recently pronounced these fora "the dominant short fiction forms of the 2020s." In their converging of confession and invention, AITA and more formal personal essays alike elevate quotidian quagmires to clickworthy moral reckoning. These forms construct selves premised upon simultaneously singular and accessible qualities, and solidify "experience" as the capital of the self: something one does not cultivate so much as emanate; human resources auto-actualizing in ways at once economically remunerative and egoically gratifying.

Autofiction, first-person fiction, memoir, social media, and the personal essay comprise a continuum of auto-emission, indicating how much of literary production follows the human-capital ideology that makes of quotidian well-being a mandate to optimize one's inner material and to actualize the self, and how much contemporary literature is constituted by its rejection of mediation. Streaming content free-flowing from free-lancers, auto-writing without "the distance between writer, reader, and critic," writerly immediacy aestheticizes industrial conditions in publishing, which, as cultural scholar Sarah Brouillette points out, track closely with gigification and precaritization in other industries.[71] Absent institutions like writers' guilds and staff unions, absent salaries for hours on background, absent knowledge protocols like investigative reporting or long-form synthesis, and drowning in student loan debt, content creators wield their only asset: expression of their inner life. Your story is something to own.

Having mapped these many economic bases of immediacy as literary style, it remains to offer some more specifications of what immediacy looks like on the page. We have seen in autofiction that voice offers itself as the auratic solidity reverberating across

71 Sarah Brouillette, "The Talented Ms. Calloway," *Los Angeles Review of Books*, December 10, 2020, lareviewofbooks.org.

the plain of grafted genres. In the novel at large, a privatization of perspective evicts third-person narration, while this demediation homogenizes literary creation across the personal essay, the self-help industry, and self-facing media technologies. All this industrial expanse, pressure against fiction, and ecstatic preoccupation with "and-ness" culminates in forms and syntaxes of blur, distinction-defying effusive immediations.

archipelagic prose

Immediacy discomposes prose fictions. Sustained narration with distant perspective, multiple characters, evental plotting, quoted dialogue, and long paragraphs all come under pressure to reduce, instantify, sharpen. Paradigmatic in this is Jenny Offill's *Weather*, a 200-page novel composed entirely of short paragraphs that rarely exceed three sentences and often consist of simply one. Offill's brevity transpires entirely in the present tense, making the ellipses and imaginary links between paragraphs akin to a whirl of stimuli, the Twitter feed auto-refreshing, quotidian debris accumulating. "The moon will be fine I think. No one's worrying about the moon." "There are bills and supermarket flyers. Also a magazine addressed to a former tenant. The cover promises tips for helping depressive people." "Survival instructors have a saying: *get organized or die*." The protagonist is a librarian, inundated with books and mail and newspapers and bus stop ads, absolutely swimming in a river of words. And the words offer little ballast or solace; they seem rather to derange her cognition, which registers ecocide but cannot focus it, and feels lonely but cannot "only connect." The archipelagic associative sentences, the intimate impressions, the Twitter phenomenality, and the circuitous present envelop the reader in immediacy, that oceanic swell of continuity and whirl which is not without ecological overtone. "Of course the world continues to end."

102

The overflowing of genres and media lulls *Weather* into an immediacy of floating minima and oceanic feeling. It is writing whose immersive quality generally belies forms like chapter or short story or novel, becoming instead subnovella somehow pooling toward epic, with flow as the only discernible structure. Increasingly fused in an amorphous bustle, this writing constitutes a superfluent discourse whose main unit is not the newspaper or the novel so much as the run-on sentence, accruing in an unstaunchable mass. Sentences are a form so ordinary as to usually evade theorization.[72] In the history of rhetoric and poetics, the sentence has been understood as a basic unit of representation, surpassing deixis to compose relation, a "complete thought." In the present sphere of cultural style, sentences are in flux as the decline of punctuation and capitalization, the lack of dialogue markers or quotation marks, and the rise of informal writing propagate fragments, run-ons, and tonal ambiguities that all call into question the purported integrity of the "unit" or the "complete."[73] At once atomized and uberconnected, these decompositions of prose symptomatize immediacy's pressures on mediation: obviate fictionality, evacuate genre, and propagate pulsing intensities from a million glittering twitterati.

the prose poetry upsurge

Enisled flitting prose in novels finds its inverse in contemporary poetry's unprecedented prosification. An abundance of prose poetry fundamentally demotes the line and line break, rejecting the cut as the scaffold of meaning, espousing the plenitude of the sentence instead. Accomplished poets who have

72 At least until Jan Mieszkowski's recent book *Crises of the Sentence* (Chicago: University of Chicago Press, 2019).

73 For a linguist's discussion of informality, see Gretchen McCulloch, *Because Internet: Understanding the New Rules of Language* (New York: Riverhead Books, 2019).

recently turned away from the line and toward the sentence and even the paragraph, who have also been publishing essays they call "prose poems," include Claudia Rankine, Anne Boyer, Lydia Davis, C. S. Giscombe, Daniel Borzutzky, James Tate, Mark Strand, C. D. Wright, and many others. Two recent anthologies attest to the form's importance in the contemporary (*The Penguin Book of Prose Poems*, and *British Prose Poetry*), while a recent Princeton University Press book offers an authoritative critical introduction to "the contemporary renaissance" ushered in by the mode.[74] Prestige attends these moves: Charles Simic's *The World Doesn't End* first won a poetry Pulitzer for sentence and paragraph poems in 1990; in 2014 Rankine's *Citizen* won numerous prizes. Critics pose many ways to interpret the waning allure of the poetic line break—the ever-evolving "real language of men," or the deepening of "lyric shame," or an unescapable politicization, and each of these dovetails with immediacy's retreat from the symbolic into the delectation of formlessness.[75]

Prosification also instantiates the professionalizing imperatives for entrepreneurial writers, as the poet Brigitte Byrd helpfully catalogues:

> We are expected to check our phone and messages and emails daily, all day long . . . We are constantly under pressure. We cannot stop writing. And there it is. Compact, controlled, melodic, polyphonic, lyric, heroic. The poem in a box. The prose poem.[76]

74 *The Penguin Book of the Prose Poem: From Baudelaire to Anne Carson*, ed. Jeremy Noel-Tod (New York: Penguin, 2018); *British Prose Poetry*, ed. Jane Monson (London: Palgrave, 2018); Paul Hetherington and Cassandra Atherton, *Prose Poetry: An Introduction* (Princeton, NJ: Princeton University Press, 2020).

75 Gillian White, *Lyric Shame: The "Lyric" Subject of Contemporary American Poetry* (Cambridge, MA: Harvard University Press, 2014). Prose poems are often, Noel-Tod argues, efforts at conversations, since they tend "towards a plainer style, imitative of speech" (4).

76 Brigitte Byrd, "I Cannot Escape the Prose Poem," in *The Rose Metal Press Field Guide to Prose Poetry* (Brookline, MA: Rose Metal Press, 2010), 31–5.

While the movement is notable for the conventional prose it is producing, we can take the lead from Byrd's reference to "the poem in a box" to also appraise prosaic poetry destined to be consumed on smartphone screens. Prose is quick reading, rapid uptake; prose is the illusion of the unfigured; prose is the run-on continuity of quotidian temporality—while poetry is extraordinary rhythm, arresting images, opaque swerves.[77] Prose poems conduce to immediatism because the pieces strive for integration rather than break, for flow rather than disruption, for continuous consumption rather than punctuated production, for metonymy rather than metaphor. Jerome McGann long ago observed that, in general, "the object of the poetical text is to thicken the medium a much as possible" but the current vogue for prose poems suggests something else entirely: a thinning of the medium, a reduction of mediation toward tingling unformed speech-like continuous current.[78] This thinning undermines genre. Prose poems trouble the steadfast opposition associating prose with the merely worldly and situated, and poetry with ancient forms and timelessness. Dispelling the expectations of both poetry and prose, prose poems undo genre, dissembling rules and hierarchies and established forms of production and consumption, and immanentizing language fullness. The remarkable poet Anne Boyer's multi-award-winning *Garments against Women* features a prose poem that clarifyingly thematizes prosaicism as a literary flux uniting poetry, novels, social media, and memoirs. She writes:

> I am not
> Writing a scandalous memoir. I am not writing a pathetic
> memoir. I am not writing a memoir about poetry or love. I am

77 On novels as distinct from poetry in encouraging "rapid, inattentive, almost unconscious kind of reading," see Watt, *Rise of the Novel*, 47. On prose as "filler" and the importance of gerunds, ongoing-ness, and metonymy, see Franco Moretti, *The Bourgeois: Between History and Literature* (London: Verso, 2013).

78 Jerome J. McGann, *The Textual Condition* (Princeton, NJ: Princeton University Press, 1992).

not writing a memoir about poverty, debt collection, or bank-
ruptcy. I am not writing about family court. I am not writing
a memoir because memoirs are for property owners and not
writing a memoir about prohibitions of memoirs.

When I am not writing a memoir, I am also not writing any
kind of poetry, not prose poems contemporary or otherwise,
not poems made of fragments, not tightened and compressed
poems, not loosened and conversational poems, not concep-
tual poems, not virtuosic poems employing many different
types of euphonious devices, not poems with epiphanies and
not poems without, not documentary poems about recent
political moments, not poems heavy with allusions to critical
theory and popular song.

"Not writing" encircles, with its loose, looping negation—here at
the line turn, here not—the sweeping negation of medium at the
heart of immediacy. Enacting the unformed, unrepresentational
quality of the many genres that do not shape this blocked prose
poem, this is not quite a verse list, but it is a catalogue, whose
point seems to be accumulation. In not writing a poemy poem,
Boyer amasses negations in/and/as amassing text, an aggregation
of writing that isn't being done—accumulation by repetition.
Writing negates itself, the superabundance of prose and personal
gerunds undoes form and genre, but the repetitions and enjamb-
ments congeal. Boyer ends the prose poem:

> I am not writing a history of these times or of past times or
> of any future times and not even the history of these visions
> which are with me all day and all of the night.

The concluding weight given to history, figured as the unwritten
ledger of accumulated negated writing, ends by reciting a rock
song title from the Kinks, preserving its original beat, "All day
and all of the night." Mixing lyrics is not writing, blending lyric

and prose is not writing, history is not writing, but writing redounds to these paralleled negations. Generic indistinction, a prose poem residually attached to verse devices like stanzaic structure, a non-memoir rock song, a famous poem that is not— these blurs and enmeshments and multiplied negations fructify immediacy. As forms melt and voice soars, prosaicism suffuses in many-laureled accretion of the heft of the real defying genre, undoing mediation.

Boyer's striking work in de-versification importantly climaxed in a recent Pulitzer Prize–winning memoir, *The Undying*, suggesting the continuity of prosaic poetry and the prosaic lyrical "I" that has become the defining mode of the me-generations, both the baby boomers and the millennials. Her use of present tense also exemplifies another common feature in the stream of immediacy: present tense now comes to motor fictions—even those not in the first person, and even those whose subject matter would be categorized as historical fiction. Booker Prize winner Hilary Mantel speaks of the advantages of the present:

> It is humble and realistic—the author is not claiming superior knowledge—she is insider or very close to her character, sharing their focus, their limited perceptions. It doesn't suit authors who want to boss the reader around and like being God.[79]

Mantel makes clear the theological and ethical entailments of this grammatical choice. Writer Richard Lea notes the similarities of Mantel's tense with Kevin Barry, who explains that the use of present tense in his recent novel about the life of John Lennon aspired to impart the impression of voice above all: "It is a case of trying to plant a voice inside the reader's head, to make him or her hear the words as they read them . . . to make them read with their ears, essentially. You're aiming to

79 Richard Lea, "Make It Now: The Rise of the Present Tense in Fiction," *Guardian*, November 21, 2015, theguardian.com.

mesmerize."[80] Present tense is so prevalent in the twenty-first century that it envelops high literary works like Rachel Cusk's *The Bradshaw Variations*, John Banville's *The Infinities*, J. M. Coetzee's *Waiting for the Barbarians*, and Marlon James's *A Brief History of Seven Killings*, but also YA chart-busters like Suzanne Collins's *The Hunger Games*. Present tense compresses event and narration into one temporal register, an immediate here-now. Autofiction and the perpetual present of the status update (What's on your mind?) reinforce this grammatical functioning as a metaphysical index, instantaneity, and directness. Moreover, present tense often forecloses conclusiveness, judgment, or resolution, lacking hindsight and favoring openness or even nonsensical, unplotted, impressionistic indeterminacy.[81] All this advances to things speaking for themselves, fluid streams, the voice of your own personality.

The immanent presence of so much contemporary writing ticks the temporal register of immediacy. Digital humanities scholar Alan Liu emphasizes that "the new discourse paradigm" of internet writing prioritizes "postindustrial efficiency coupled with flexibility—that is, the ability to say anything to anyone quickly," an effusive instantaneity he contrasts with "academic knowledge," whether philosophical, historical, or artistic, that texturizes saying anything by saying it "fully, richly, openly, differently, kindly, or slowly."[82] Speed—of composition, publishing, circulation—founds the sensation of immediacy. Hot takes burning and bounding, episode recaps published minutes after airing, real-time reactions from live news scenes. But Liu's point also brings home how much this speed is not just technological but cognitive and affective: reflexive impressions pressed from the hip, #NoFilter.

80 Ibid.

81 For more on this nonjudgment function see Irmtraud Huber, *Present Tense Narration in Contemporary Fiction* (London: Palgrave, 2016).

82 Alan Liu, "Transcendental Data: Toward a Cultural History and Aesthetics of the New Encoded Discourse," *Critical Inquiry* 31:1 (Fall 2004), 49–84.

abject swelling

Oceanic prosaicism also defines broad bands of contemporary fiction that aim less at the representation of characters, settings, and events than presencing charisma or voice, especially the sensibility of the single consciousness in moment-to-moment sensation. Often composed in the present tense, or transpiring in a looping temporality heeding neither linear plotting nor substantial time-span, such texts generate a destination-less instantaneity of mesmerizing acuteness, a lassitude picaresque. What seems to be at stake is, then, transitive exchange: the full-throated but fleeting, vivid fervor of nerves resonating from the voice on the page out into the body that holds it. Stagnancy of the narrator's situation (asleep for a year, say) can enhance this transitivity; social isolation (in a country cottage for a year, say) both relieves the author of representing other people (again, the nausea of made-up people) and scaffolds the book as "big mood." Malaise—at professional precarity as in *Temporary*, or romantic torpor as in *A Separation*, or climate crisis as in *The New Wilderness*, or all of the above as in *Edie Richter Is Not Alone*—all equally occasions for elastic emanation. "I am one of those cogs going round and round. I have become a functioning part of the world" exudes the narrator flatly from her "transparent glass box" in *Convenience Store Woman*. Claustrophobia can ensue, or boredom, or both disidentification and relatability-ratios. And if we cannot say that ideas were had or that it was about anything, of reading them there is still a surety: at least it is an experience.

As we noted in "Imaginary," the quality of fluid transmission here is subject to undertows, irruptive spurts that can paradoxically reabsorb. Thus does an unlicensed partnership of blasé and sadism center blood, shit, vomit, miscarriages, cutting, or other abjections. Ottessa Moshfegh's *My Year of Rest and Relaxation* exemplarily punctuates spartan expressivity with corporeal excrescence, including an art gallery defiled by deliberate

defecation. In Ling Ma's *Severance*, it is the uncontrolled plague and the unexpected pregnancy; in Claire-Louise Bennett's *Pond* (which the *New York Times* calls "a novel" but the *New Yorker* calls a "story collection," while the publisher, Penguin, calls it only "a deceptively slender volume," and the author calls it "the mind in motion"), it is imagining whether rape is actually that bad. These corporeal and affective extremities are levers of immediacy as mood, magnetisms that magnify languor chronicles into irresistible immersion.

Dissolving into visceral ecstasy, revolting against mediation—from Knausgaard's nausea to Boyer's prose to everybody's first-person charisma—contemporary fiction often ends at the abject, an aesthetics of enthralling cruelty. The National Book Award winner and national bestseller *Salvage the Bones* furnishes an excruciating example. Narrated in an airless present-tense first person by a motherless pregnant child in the wild woods of Mississippi, Jesmyn Ward's book offers a relentless atlas of anthropogenic ecological catastrophe, harrowing poverty, racial capitalism, sexual degradation, mutilated bodies, and savagery among and against dogs. Her catalogue accretes through grueling language that tilts toward the figurative but collapses into grotesque literalism, and the concluding crescendo of the book cannot forbear to telegraph it all in case we missed it: a mother dead in childbirth, many puppies dying in birth, a child soon to be a mother to another child with at once no daddy and "plenty daddies," Medea, and the devastating hurricane itself also a mother,

> Katrina, the mother that swept into the Gulf and slaughtered. Her chariot was a storm so great and black the Greeks would say it was harnessed to dragons. She was the murderous mother who cut us to the bone but left us alive, left us naked and bewildered as wrinkled newborn babies, as blind puppies, as sun-starved newly hatched baby snakes.[83]

83 Jesmyn Ward, *Salvage the Bones* (New York: Bloomsbury, 2012), 255.

Laminated into one miasmic hurricanic meld, the swirling, asymmetrical histories of Black suffering and subjugation and Black women's nexus and governmental abandon combine with the immanentist temporality to produce a rivetingly brutal, all-subsuming eco-system. "These are my options, and they narrow to none," the protagonist observes of her chances at terminating the pregnancy, or scavenging enough food, or weathering the storm.[84] Like the pregnancy that won't end, irrepressible corporeality distends the book's words, bleeding and peeing and itching and puking, drowning and dismemberment, hunger, and fear so many reverberating fervors shuddering through the reader. Similes compulsively recur to pre-semantic elementality: "Blood smells like wet earth"; of the love interest she notes, "He was the sun"; if we couldn't tell from her name, the dog "China is as white as the sand that will become a pearl"; so many ways of redacting figuration into concretude. And through it all—the gathering storm, the throbbing bodies, the suffocating immanence, the pulsing present tense—vibrates immediacy.

Anti-mediation coalesces the literary field at present into a dominant style—one that converges hitherto-distinct genres of theory, fiction, memoir, the essay, and informal personal expression in a ubiquitous polyvalent writing. In the liquid emulsion of these modes, in their propensity for indistinct blur, in their churning flow, glides the writerly guise of propulsive circulation: frictionless uptake, fluid exchange, pouring directness, jet speed. Slick with this style, we may fail to read how the "auto" of autofiction inscribes the self-manifestive quality common to the governmental ideology of human capital, how the engulfing formlessness of genre melt ferries less the genius of authors than the flooded ruins of institutions like the university or the publishing house, how the defigurative realness of unadorned charismatic persons suffering execrably presages the dystopia already here. Immediacy

84 Ibid., 103.

as literary style holds incredible lure, but it sticks too close. In resigning the potential of writing to estrange, abstract, and mediate; in castigating the capacity of writing to collectivize and convoke; in deflating the power of writing to fabricate more than the immediately tangible detritus of evacuated sociality, immediacy writing collapses into self-identical emission: "This!"

Video

Zero in on an Ethiopian miner's hand holding a beige rock, an implausible neon lagoon glinting at its center, and delve deeper into the glittering facets, blur the tight focus, transgress the flat surface, seep into a volume of cloudy color, swerve to a quick black and gush of red, tunnel into a new crystalline depth, scramble letters to align "uncut gems," morph sparkly polyps into fleshly pinks and pearls, photorealize tissue, veins, and crenulations of a dimly spotlit channel, until, blur again to fade the footage to its housing in a grainy computer screen with blue letters "MIF" "Dr. B" "Hosp", and finally orient to a voice: "now reaching the right side of the colon."

Colonoscopy cinematography may not yet be recognized as a great art of our moment, and indeed the Safdie brothers (directors) and Darius Khondji (cinematographer) were snubbed by the 2020 Oscars, but this incredible ninety-second sequence—compositing actual scope video, digital animation, microscopic gem photography, and 35mm film shot on locations—consolidates immediacy as video style. How close can the camera get? Not just sweat beads and skin imperfections, but orifice penetration and organ texture; not just tight shots in tiny spaces but jittering cuts jibing the lurching guts and racing pulse of the gambling protagonist. How close can the spectator get? Intimate, internalized, poop-streaked, inside an antihero relentlessly driven to gut-wrenching binds. What does video "see"? The peristalsis of the tubes, circulation squeezing when there's nothing left to produce.

So, the pressure pumps, and the medium strains. A voracious technological meld: anachronistically shot mostly on analog but

seamlessly fusing a lot of digital, requiring significant colorist and editing work, and prominently constructing a digital aesthetic with tight frames, quick cuts, whip pans, and blue tones. A literalism of content: "meeting an asshole through an asshole," probing the acquisitiveness that links extractive mining to New York City's Forty-Seventh Street jewelers to NBA millionaires to Long Island loan sharks.[1] An extremity of mood: tension on the screen operating tension off screen, less a spectator than an accomplice riding what numerous critics deemed "a wild injection of pure cocaine."[2] In eerie synth music and chaotic multilayered sound, through a rapid-paced short-timespan pressure cooker narrative of debts coming due and new debts contracted to defer, and in dogged close-ups in claustrophobic spaces, the movie constructs excruciating stress, an adrenaline-torrent immersion.

Constant movement, beating pulse, clenching bowels, gasping breath, vibrating phone, deadline ticking all add up to a kineticism quite trying for 35mm, which was already conspicuously obsolete in Hollywood by the time the Safdies chose it for this production in 2019. Colonoscopy becomes a formal principle for overcoming that obstacle: exaggerated close-ups constrain the analog camera; digital was interspersed throughout—solving night shoots or tricky spacing in the tiny showroom/office where over half of the action takes place; and most importantly Khondji shot in "scope" (anamorphic cinemascope), employing long-lens prostheses to attain intense intimate range on performers freed from

1 Joe Berkowitz, "How Benny and Josh Safdie Created the Most Chaotic Moment Ever on Film in 'Uncut Gems,'" *Fast Company*, December 16, 2019, fastcompany.com.

2 An almost-compulsory reference to cocaine fuels many of the movie's reviews: "the cinematic equivalent to mixing cocaine with acid" (*LA Weekly*) and "a cinematic snort of cocaine" (*Uproxx*), as a "wild injection of pure cocaine" (*The Playlist*), "cocaine the movie" and "cocaine-fuelled" (journalists tweeting after the Telluride premier, as reported in Nick Chen, "The Safdie Bros Discuss Adam Sandler, Cocaine, and the Making of 'Uncut Gems,'" *Dazed*, January 3, 2020, dazed digital.com).

cameras in their faces, and using an unusual focus-calibrating device (the Light Ranger 2) to erect a subject out of the blurred background of widescreen. Colonoscopy cinematography confabulates a hyper-relief digital aesthetic that occludes its analog basis, practicing the medium dissolve integral to immediacy.

The object of all this engineered intentness is a desperate gamble, too late capitalism and its horrid subsidiaries. The abstract global system metabolizing miners and dealers and gamers and performers gurgles down to concrete viscera; though glimpsed fleetingly, the propulsion of colonoscopy cinema is away from networked relations and toward the sensate uncut. *Uncut Gems* telegraphs in its title the unmediated ore with which its visual production aligns. Its strategy to engage the libidinally charged, Semitically coded cataclysm of chronic capitalist speculation is shitscoping, so close and so strained you can smell it.

Throughout this book, we have studied immediacy as fundamentally negating mediation: cutting out the middleman for instant relay of emanative intensity in continuous flow. Fluidifying medium takes different forms when different media are in question; the circulation-forward economy of algorithmic discretization begets in culture a waning symbolic and heightened imaginary, which materializes in the expanded field of writing as a repudiation of fictionality and genre, purifying charismatic presence, affective extremity, and unfiltered authenticity. In the field of moving images, immediacy eddies "the stream" of increasingly homogenous customized content in a continuous loop of deformatted genre-fluid absorption, propelled by you-are-here experientialism, intimate confessionalism, and periodic surges. The stream is circulation, the infrastructure and modality for the exchange of moving images, and in the era of its dominance, the stream retroacts the images themselves.

To speak of "stream style" is to wade through the seemingly heterogeneous forms that characterize original streaming content and bob the aesthetic coherence of immediacy. This chapter argues for immediacy as stream style by ingesting some media

theory, caroming through the infrastructure of the moving-image industry, and passing some features of stream aesthetics. Video struck Fredric Jameson and other observers of the postmodern as the "art form par excellence of late capitalism" on account of its "total flow"; in the too late, immediacy consummates these propensities to instantaneity and dissolution.[3] Video's essence as instant relay emblematizes the immanentized circuit of value realization that has been the main source of economic activity in secular stagnation, while its fluidity courses in the current that immerses too late capitalism in an ineluctable present. No future, only flow. In the temporality of unremitting instantaneity, in the fluid pressure of stream aesthetics, what used to come after now comes before: the circulatory apparatus for streaming content determines what content gets produced. The end is the beginning; the colonoscope is the camera.

Focus on style makes this retroversion perceptible, redirecting back toward the medium, and form itself, a scholarly conversation that has been too preoccupied with behavior and affect.[4] Style is made up of formal features like cinematography and editing, plot and premise, genre and format. Immediacy as stream style, like its complements in artistic and literary style, negates mediation and essentializes presence. Just as immediacy style in art defies medium and prioritizes experience, just as immediacy style in writing blurs genres and personalizes perspective, immediacy style in video programs indistinction and corporealizes cinematography. The result across culture is an expressivity and immersiveness that aestheticizes circulation's dominance over production. And, in the vise of this valorization process, what is egested, as *Uncut Gems* so grossly distills, reeks like chyme.

3 Fredric Jameson, *Postmodernism; or, The Cultural Logic of Late Capitalism* (Durham, NC: Duke University Press, 1991), 75.

4 Garrett Stewart, *Cinemachines: An Essay on Media and Method* (Chicago: University of Chicago Press, 2020), 2.

video as medium, video as anti-medium

Video famously courts medium dissolve, and immediacy video crowns this predilection through the technology of streaming and the circulatory imperatives of too late capitalism. From the Latin "to see," "video" connotes a wildly wide variety of material and technical functions, elastically expanding over time. Its essential image-capture can be analog or digital, a magnetic tape of camera signals or an electronic compression of waves, at speeds that distinguish it from film (if something like 16 frames per second are required to simulate motion, film generally works at 24, while video can be as fast as 120), and in aspect ratios that are horizontal (as in film, TV, and computer screens) or vertical (as for phones).[5] Image data can be relayed via radio wave or through coaxial cables or over digital networks. In the industry for producing televisual culture, video can mean television as opposed to radio and film, or taping as opposed to TV broadcast, or digital as opposed to celluloid, or digital moving image media subsuming both television and film, recording and transmission and playback.[6] Visual transmission technology is thus a type of media whose medium is very fluid, rendering the material support

5 Technically film can also run faster, but screenings would require different projectors. In 2012 Peter Jackson filmed *The Hobbit* at forty-eight frames per second, presenting himself as avant garde, but theaters were not properly equipped, and audiences did not react well. The race for higher frame rate smacks of immediacy; as a star in the film noted of the speed: "It's so immersive . . . It has a level of reality that is unsurpassed." Emma Saunders, "*Hobbit* Director Peter Jackson Defends Fast Frame Rate," *BBC News*, December 11, 2012, bbc.com. In 2016 Ang Lee released two films shot at 120 frames per second, both of which bombed at the box office (while only fourteen theaters nationwide could actually screen them at that rate) and were panned for their "video game look." The belief is that the rates provide "clearer, smoother, more realistic images." See Bilge Ebiri, "How High-Frame-Rate Technology Killed Ang Lee's *Gemini Man*," *Vulture*, October 22, 2019, vulture.com.

6 Michael Z. Newman demonstrates this elasticity in *Video Revolutions: On the History of a Medium* (New York: Columbia University Press, 2014).

for immediacy as flow. On account of this fluidity, the art historian Rosalind Krauss influentially argued—in 1973 no less—that video precipitates "the end of medium-specificity . . . we inhabit a post-medium condition."[7] The very historical moment thought to definitively engender the crisis of accumulation that condenses circulation is also the very art-historical moment when the conditions for critical thinking about aesthetic production shift, with rapid sense-data circulation altering what is meant by relay, by medium. The contradiction to explore here, however, is how this heterogeneity and dissipation of medium paradoxically reconsolidates in the streaming age: the platforms for video circulation initiate a new homogeneity, a specificity whose trait is immediacy.

The liquidity of video, of course, enhances similar propensities in film and especially TV. By combining sight and sound in kinesis, and synchronizing temporal experience of audiences, film produces immediacy—so goes the theory from French impressionist Louis Delluc to Bordwell and Thompson to Deleuze, Stiegler, and Grusin. TV, then, advances this production: the quintessential media theorist Marshall McLuhan defined television as an "all-at-onceness," and Raymond Williams elaborated this fusive, integrative instantaneity as "flow" between text and context; as early as 1952, cultural critics and TV personalities like Gilbert Seldes distinguished television from cinema on the basis of "immediacy."[8] For these theorists, immediacy stemmed from TV's "liveness" in contrast to dead celluloid, while its poor image quality relative to film seemed to resemble human perception more than cinematic composition.[9] Similarly, the present-tense relay in news, talk shows, and sports constitute

7 Rosalind Krauss, "A Voyage on the North Sea": Art in the Age of the Post-Medium Condition (New York: Thames & Hudson, 2000), 31–2.

8 Gilbert Seldes, Writing for Television (New York: Doubleday, 1952), 32. Cited in Doron Galili, Seeing by Electricity: The Emergence of Television, 1878–1939 (Durham, NC: Duke University Press, 2020), 89.

9 Philip W. Sewell, Television in the Age of Radio: Modernity, Imagination, and the Making of a Medium (New Brunswick, NJ: Rutgers University Press, 2014), 33–4.

the "immediacy" identified by one of the first theorists of TV, Horace Newcomb, who argued that this "distinguishes television from film and photography."[10] The temporality of rapid relay, Heike Schaefer notes, is behind "the sense of spatial proximity, of being there . . . factuality, authenticity, and veracity," and "is an effect of the velocity with which televisual images are transmitted and received rather than of the precision, clarity, or motion of the images."[11] Moreover, spectators "adopt the time of its flow" while also becoming subject to what Bernard Stiegler deems "a massive synchronization machine" by which "consciousnesses all over the world interiorize, adopt, and live the same temporal objects at the same moment."[12] This "worlding" inextricably links television to "uninterrupted free trade, already transnational," premised upon liberal ideals of "mutual recognition, equal exchange, and an immediate symmetry between transmission and reception," as Richard Dienst argues.[13] Television's immediacy sensation is temporal and political, an ontological property of its technology and its metabolism of cinematic kinesis. Video, then, exaggerates these features, while streaming in turn flattens them into a hegemonic medium attribute.

Coming on to the scene later than cinema or TV, video was invented in the 1950s, entered the consumer market in 1971, was popularized for home producers in the 1980s, transformed in the 1990s through new compression processes and eventually the new format of the DVD, gained new institutional dominance in the

10 Horace Newcomb, *Television: The Critical View* (Oxford: Oxford University Press, 1994), 275.

11 Heike Schaefer, *American Literature and Immediacy: Literary Innovation and the Emergence of Photography, Film, and Television* (Cambridge, UK: Cambridge University Press, 2020), 175.

12 Bernard Stiegler, *Symbolic Misery*, trans. Barnaby Norman (Cambridge, UK: Polity, 2014), 19–20. This claim about synchronicity recalls Benedict Anderson's similar argument about the effects of that older medium, print newspapers, in *Imagined Communities* (London: Verso, 1983).

13 Richard Dienst, *Still Life in Real Time* (Durham, NC: Duke University Press, 1994), 4.

United States with the 1997 Federal Communications Commission announcement of an end to analog television by 2003, and has reconstituted radically since 2010 through revolutions in both hardware and software for both production and circulation. Much cheaper and easier to operate than film, video helped television specify itself by easing both live feeds and recorded programming, thereby decreasing the originally high percentage of TV programming made up of old movies, B movies, and Westerns. Convenience and cost aren't the only advantages of video over film: there is also speed, a crucial component of immediacy. With a frames-per-second rate up to five times higher than that of film, and a different aspect ratio, the images' speed and scope are more highly saturated, and their resolution clarity across height and width can be sustained from production to consumption without cropping or stretching. Such speed is understood again and again as the basis of video's immediacy effect, its simulation of presence; while cinema is represented time, Maurizio Lazzarato characteristically argues,

> with video we are no longer in the regime of representation. The temporality of video is a present that returns us to the time of the event, to time in the making, which simultaneously implies the artist and the spectator, an open duration that can provoke a reversibility between creation and reception.[14]

Perhaps more measuredly, David Rodowick argues that temporality is transformed in the shift from film to video: while the constitutive function of the pro-filmic event means that film "always returns us to a past world, a world of matter and existence" and thereby anchors itself in the presentation and even preservation of the past, in video the deemphasized pro-filmic and the manipulability or inventability of what is captured

14 Maurizio Lazzarato, *Videophilosophy: The Perception of Time in Post-Fordism*, trans. Jay Hetrick (New York: Columbia University Press, 2019), 95.

amounts to a different temporal regime—one not of pastness but of "simple duration or the real time of a continuous present."[15]

The speedy presence intrinsic to video has only been augmented by the rapidity of extrinsic technological innovations in cameras and data networks over the shelf life of the early 2000s and 2010s, thanks to which video can now be produced and consumed at almost any moment. We no longer go to the theater to see movies; we no longer carry portraits in our wallets; we no longer sit before a single screen at a particular time to watch our favorite shows, running to pee at the commercial break. Video screens networked to bursting archives fill our pockets, immersing us in moving-image content while we commute, while we wait in line, while we juggle three devices at once at work and at home. Pivot to video.

Video's polyform would seem to resist theorization in the classical vein of questions like "What is cinema?" But this despecification of medium paradoxically provides a way to think video's unity, in the stylization of negating mediation. Contemporary theorists often locate this negation in digitalization (both the rise of digital cinema and the preponderance of other modalities of video), a loss of distinction, the advent of the "post-cinematic," and in this surpassing we can read the melding of film, TV, and gaming.[16] Film has transmuted via digital processing, becoming both less defined by the pro-filmic and more resemblant to video

15 D. N. Rodowick, *The Virtual Life of Film* (Cambridge, MA: Harvard University Press, 2007), 171.

16 *Post-Cinema: Theorizing Twenty-First-Century Film*, ed. Shane Denson and Julia Leyda (Sussex, UK: Reframe Books, 2016). Denson and Leyda conceive post-cinema as a historical category that marks cinema's prolongation and complication as "essentially digital, interactive, networked, ludic, miniaturized, mobile, social, processual, algorithmic, aggregative, environmental, or convergent" (1). Like Steven Shaviro, however, who popularized the term in *Post-Cinematic Affect* (Winchester, UK: Zero Books, 2010), Denson and Leyda are ultimately most interested in "new forms of sensibility," defining post-cinema as a "structure of feeling," going so far as to introduce their volume on the subject with personal narratives of their childhood and adolescent attachment to cinema, which they assert "ground" theory. The analysis below is aimed at highlighting the formal aspects the term opens up.

games, *and* capable of rendering almost anything in a photoreal-ist idiom.[17] In turn, TV, long understood as overusing close-ups and medium shots for smaller screens inhospitable to landscapes, has become more cinematic: film directors have begun making original TV content for streaming services (Jane Campion's *Top of the Lake*; Ava DuVernay's *Queen Sugar*; David Lynch's *Twin Peaks: The Return*), the multi-camera sitcom has declined, sets for even half-hour comedies have become more elaborate and varied, and an aesthetics of spectacle is now central to original streaming content (*Watchmen*, *Westworld*). Video absorbs film and TV; the stream engorges. Indeed, film directors like Steven Spielberg, Spike Lee, J. J. Abrams, and John Woo have all created video games, and the superabundance of computer-generated imagery (CGI) rendering films more game-like in their aesthetic and the transmediations of works like *Ready Player One* are nothing compared to the promise of gamified, inter-active pick-a-path features like *Black Mirror: Bandersnatch*. All this melding finally also challenges the specificity of games, as becomes evident when we consider how adroitly the essential gaming values of first-person point of view, immersive experi-ence, and open-world autonomy—*enactive* rather than *enacted* aesthetics—reproduce the same stylistic tendencies we've noted in contemporary literature and art, and the same ideological ten-dencies critics describe as a gamification of culture.[18] Likewise,

17 Shaviro, *Post-Cinematic Affect*. For Shaviro, the post-cinematic involves a "post-continuity" aesthetic, one which we can use to help describe spectacle. As he argues, post-continuity is when digital techniques scramble the pro-filmic, resulting in a "preoccupation with immediate effects [that] trumps any concern for broader continuity" (123). Instead, viewers are offered, as he argues with regard to *Gamer*, a "barrage, with no respite . . . lurching camera movements, extreme angles, violent jump cuts, cutting so rapid as to induce vertigo, extreme close-ups, a deliberately ugly color palette, video glitches, and so on" (124). The pounding of effects means "there is no sense of spatiotemporal continuity; all that matters is delivering a continual series of shocks to the audience." Steven Shaviro, "Post-Continuity: Full Text of My Talk," *The Pinocchio Theory* (blog), March 26, 2012, shaviro.com.

18 On action as definitional for games, see Alexander Galloway, *Gaming: Essays on Algorithmic Culture* (Minneapolis: University of Minnesota Press, 2006): "Without action, games remain only in the pages of an abstract rule book. Without

consider the putatively unscripted content in user-generated influencer-aspirant TikToks and YouTubes: if this, rather than the multiplex, is where video lives, it's all stream, all a circulation-forward, expressivist, authentic nonfictional immediacy. The spate of the stream dilutes all tributary media, rendering stream style nothing more than liquid billow. To gauge this pressure, ponder the fact that since 2009—the interval in which the world's major distributors of video (Netflix, Amazon, HBO) have converted to producers—original scripted content has *more than doubled* in volume.[19] It is this deluge itself—the crush, speed, and immanence of circulation—that ultimately defines the stream. Not just *how* we consume TV, movies, games, and their increasing indistinction, the stream is therefore also *what* we consume. The material quantity of streaming content and the material qualities of the circulatory apparatus come now to condition the form of what appears, eventuating in the aesthetics of flood, fluidity, and flow.

video circulation

Flow is premium for the distribution company Netflix, whose brief history encapsulates the profound changes in circulation of video from the 1990s onward, which now become changes in its production. Revolutionizing video circulation by bypassing the brick-and-mortar rental store that had itself upended

the active participation of players and machines, video games exist only as static computer code. Video games come into being when the machine is powered up and the software is executed" (2). Gaming expert Patrick Jagoda links the rise of gaming to the context of neoliberalism: "Games simultaneously index and drive the development of neoliberalism." Patrick Jagoda, *Experimental Games: Critique, Play, and Design in the Age of Gamification* (Chicago: University of Chicago Press, 2020), 61, 12.

19 John Koblin, *"Peak TV Hits a New Peak, with 532 Scripted Shows," New York Times*, January 9, 2020, nytimes.com. See also Lesley Goldberg, "Peak TV Update: Scripted Originals Top 500 in 2019, FX Says," *Hollywood Reporter*, January 9, 2020, hollywoodreporter.com.

moving-image consumption, Netflix was founded in 1998 as a rent-by-mail DVD store with a catalog of 925 titles—basically all existing DVD films at the time, since the medium was only three years old. After what would become its DVD peak in 2011, when it delivered discs via the US Postal Service to 14 million subscribers, in 2012 Netflix transitioned from content provider to content producer, debuting its original series *Lilyhammer*, followed by the breakout success *House of Cards* in 2013.[20] That same year was the watershed moment when television advertising revenue was eclipsed by revenue from subscriptions to cable and streaming providers.[21] In this fast fourteen-year juvenescence, the company rapidly grew from a pay-by-the-disc model to a subscription model, offering virtually unlimited consumption to its 203 million users—making it the largest digital media company in the world, on a par with traditional firms like AT&T, which is by contrast a senescent 136 years old.

DVD killed the video store, and then Netflix further disintermediated moving-image circulation by circumventing the postal service with the advent of the stream (and the hidden infrastructures of data centers, and the vast tracts of dispossessed land and swirling pools of water required to sustain them).[22] Streaming is instant access over networks to video that does not require downloads or storage space, and it accounts for well over 50 percent—sometimes as much as 80 percent—of all web traffic at any given time. In just three years, from 2019 to 2022, made-for-streaming films went from disparaged ineligibles to Oscar

20 "In the Stream: Netflix Still Mailing DVDs," *Link*, June 22, 2020, link .usps.com.

21 Amanda D. Lotz, *The Television Will Be Revolutionized*, 2nd ed. (New York: New York University Press, 2014).

22 For a groundbreaking corrective for inattention to media infrastructures in the digital economy, see *Signal Traffic: Critical Studies of Media Infrastructures*, ed. Lisa Parks and Nicole Starosielski (Urbana, IL: University of Illinois Press, 2015). On the occlusion of infrastructure, see Tung-Hui Hu, *A Prehistory of the Cloud* (Cambridge, MA: MIT Press, 2015). On dispossession, see Phil A. Neel, *Hinterland: America's New Landscape of Class and Conflict* (New York: Reaktion Books, 2018).

Best Picture winners, while the video-sharing platform TikTok became the most widely used app in the world. Advanced compression algorithms, fiber-optic cable innovations, polymer/liquid crystal/plasma screen advances, and the smartphone explosion were essential. The first iPhone of 2007 included You-Tube in its suite of native apps, enabling users to watch videos off the couch—during a daily commute, in line at the post office, relaxing poolside—although they could not yet record them; while data plans and network limits initially checked the endless stream, soon consumers inhabited a mediascape in which it was possible to stream almost anything at almost any time. All these tech specs facilitate streaming as an experience of direct access, on-demand freedom, and real-time immersion.

As the centrality of the smartphone suggests, streaming is further defined by what the industry refers to as "device integration," a despecification of technology and medium ensuring that, as Microsoft CEO Steve Ballmer promised in a 2009 keynote address, "the boundary between the TV and the PC will dissolve."[23] His competitor Apple was already (since 2007) selling Apple TVs, a hardware device that converts TVs into digital players for things like podcasts and games, and that eventually presented a suite of apps on the television screen as though it were a personal computer. Moreover, the microconsole device has no manual controls; the iPhone is the preferred remote control, integrating the handheld phone, the TV, and the computer desktop. Many LCD and high-definition consumer televisions now come with their own operating systems that mimic this computerization of the TV screen; users need simply input their passwords for various streaming services and apps to navigate the TV as they would a computer. Such synergies form the circuits of electronic immediacy, with spectacular images flowing from fingertips and instant fulfillment for every video

23 Todd Spangler, "CES 2009: Microsoft CEO Says Screens Will Converge," *Multichannel News*, January 7, 2009, nexttv.com.

desire—our wish is on demand. A lie, alas. High costs of transferring old films to digital streaming files consign a huge back archive to inaccessible obscurity. Multiplying channels, platforms, subscription passwords, and rotating licensing agreements add up to a functionality where it often takes longer to access a movie from one's couch than it used to take to walk to the neighborhood Blockbuster. Moreover, the veneer of unlimited choice masks the material reality that we need to access prime-time drama at 11:30 p.m. in bed or 7:00 a.m. at the gym instead of the uniform 8–10 p.m. in the living room of old, because everybody now works 24/7. Flexible labor, flexible leisure.

Swigging at the spigot whenever we can squeeze it in, we find a stream always on: Netflix innovated an instant-access model for streaming, offering its first original shows as total seasons in one dump. "Binge-watch" became a term in 2013 and was "word of the year" for Collins English Dictionary in 2015; even though the practice existed diffusely as early as the 1980s (with cable channels airing all night broadcasts of multiple episodes of a single show, or in-person marathon viewing sessions of VHS in certain subcultures, or long cinema like *Shoah* [1985] or *Satantango* [1994], unsmeared by the binge label), it is truly definitive of the 2010s stream experience. In 2016, Netflix instituted Autoplay functionality, which automatically starts the next episode as the previous concludes, pacifying the viewer out of even pressing a button to affirmatively continue. The rare perverse director with adequate clout, such as David Lynch, can insist on week-by-week release (as for his 2017 reboot of *Twin Peaks*), and heirloom companies like HBO can still get away with spacing the initial rollout of original content to generate suspense and differentiate from the stream. But binge is the way and the life; the constant stream an oceanic jet of immersive flow.

The more we watch, the more of the same there is to watch. Entertainment production converges with data production as the algorithmic core of streaming services assists the companies to sell the service (rather than content) as their product, while

in turn selling user data to other companies. Algorithms are automated procedures for making patterns and exchanges, compositing differing units into higher-order categories. They thus fabricate consistency where there was variability and can effectuate a certain homogeneity: it's all data. Intellectually, algorithms may be generative of useful abstractions that can then be put to work for different purposes. For instance, Netflix uses a very powerful algorithm to generate its core product and service; but this book also uses a kind of algorithmic logic in attempting to induce the style of immediacy from a wide variety of phenomena and media. Netflix Cinematch works not only by tracking our preferences like how many stars we award a film but also by tracking our habits, like which kinds of films we finish or which kinds of films we watch at what times of day.

On the home screen for individual films, Cinematch now displays not the film's aggregate rating from a service like "Metacritic" but a more subjective correlation of the film—based on microtags and genre classifications—with our spectator habits and preferences. With the subdivision of Netflix accounts into individual household members, a mother receives different selections than her child, and different Match scores to boot; *Pitch Perfect* might show a Match score of 99 percent for one individual, but 33 percent for their spouse. Through algorithmic processes, the manner in which we consume TV as well as the content of what we choose is tilted toward an individualism and immediatism where we can instantly summon a "viewing experience" that is highly customized to our profile; we swim in a shitstream of our own excretive analytics, TV as safe space. Flow is thus intensified rather than dispersed by streaming platforms, media historian Dennis Broe argues, since individual spectators are even more oriented toward bingeing content and heeding the imperative to sustain new draw.[24] Writing of the algorithmic

24 Dennis Broe, *Birth of the Binge: Serial TV and the End of Leisure* (Detroit: Wayne State University Press, 2019), 23.

personalization used not only by Netflix and Amazon but also Google, media activist Eli Pariser notes that "your computer monitor is a kind of one-way mirror, reflecting your own interests while algorithmic observers watch what you click."[25] Both our information and our entertainment are tailored, including in media beyond the televisual: the Netflix style of immediatist consumption has bled into subscriber buffet models for music (Spotify), video games (Shadow), magazines (Next Issue), audiobooks (Audible) and more. And all this personalization upholds a permalingering mirror stage, a fortress of the imaginary, minimizing the possibility for mediations of the other.

Streaming services produce original content, aiming for marquee hits that propel new subscribers, but the boutique audience model also compels many niche shows that are algorithmically conceived and mediocrely executed. In this style, what is important is the derivative character of the plots and aesthetics. For instance, a show like *The Expanse* is recognizable to its boutique audience as a more tepid and politically defanged *Battlestar Galactica*.[26] Sameness is a crucial effect of these derivative processes; the availability of enormous quantities of content obscures the basic uniformity of its creation and the concentration of the industrial center in the four major networks and the Hollywood studio holdovers, through which most content is still made and/ or most of its creators are still developed.[27] Streaming formally homogenizes. It's not HBO; it's Hulu Plus Live TV.

These business shifts complicate the picture that we currently live in a "golden age of TV." The category of immediacy takes some of the shine off, demarking that this age has come stealthily to an end. What was prestige TV? A heightened quality

25 Eli Pariser, *The Filter Bubble: How the New Personalized Web Is Changing What We Read and How We Think* (New York: Penguin, 2011), 3.

26 Broe produces a list of these derivatives, in which he includes examples like *Sense8* as a TV version of *Cloud Atlas*, or *Girlboss* as a repeat of *New Girl*. Broe, *Birth of the Binge*, 110.

27 Ibid., 17.

consistency across basic and cable channels, megasuccess of individual shows, and, most importantly, aesthetic achievements in cinematography and storytelling in the late 1990s and early 2000s, with shows like *Buffy the Vampire Slayer*, *Oz*, *The Sopranos*, *The West Wing*, *The Wire*, and *The Shield*.[28] Quintessentially "complex," as media scholar Jason Mittell has formulated, prestige TV showcases complex protagonists—morally, psychologically, professionally, and socially conflicted and evolving, they might be sociopaths or drug dealers or vigilantes or politicians (or all of the above); complex plots—multiple, nonlinear, and often hinging on single words or tiny gestures; and reciprocally complex spectatorship—attuned, riveted, and detecting.[29] From the vantage of 2022, prestige comes into relief as a limited era of high-production-value ensemble-cast workplace dramas that secured the cache of cable brands when new subscription services were beginning to alter the cable business model, and that provided lower-risk investment when studios and talent were driven away from movies after the dot-com bust. What comes after is the stream, aqua regia for prestige gold.

As a starting point for theorizing stream aesthetics, look at one of the current top hits among proprietary series from Netflix: *Call My Agent!*, a self-referential showbiz romp that overtly thematizes the priority of circulation for stream style. Made in French for francophone audiences as *Dix Pour Cent*, the 10 percent fee agents collect, the show's soaring popularity has now occasioned an English remake. *Dix Pour Cent* metabolizes the streaming era's financial, distributional supremacy by thematizing the business end of cinema: it is a made-for streaming series about the most revered and glamorous center of the film

28 The French philosopher Alexis Pichard is credited by *Wikipedia* with first use of the term "new golden age," evidently in his 2011 book *Le nouvel age d'or des series américaines*, where he emphasizes these criteria of quality and success.

29 Jason Mittell, *Complex TV: The Poetics of Contemporary American Storytelling* (New York: New York University Press, 2015).

industry, a premise that transposes the silver screen into the small screen by vertiginously inverting away from the real stars like Juliette Binoche or Charlotte Gainsbourg it regularly features, and toward the agents who are the show's protagonists. The race for profit and the pressure of international conglomeration imperil the film industry, but its greatest threats are the dys-regulated affairs and exploits of the agents themselves. In irrepressible irruptions, the agents hurl every object and slam every door and yell at every interlocutor, and they seduce every-one they see—bosses, auditors, coworkers, clients. It is the agents who are the divas, the agents who need management—the petty business flushes the art.

Several distinctive formal features of original streaming con-tent exemplify this flush, as *Uncut Gems* has also previewed, and we will take them in turn:

immanentization
looping
genre fluidity
surging

immanentization

These fluid pressures on medium and form register in the cine-matography of immanence that *Uncut Gems* grossly extremizes. How close can the camera get? What if you swallowed it?

Accomplished practitioners of post-cinematic cinematography specifically theorize its immediatizing power. While the move-ment to digital video in general might hail an end to the pro-filmic event and a new prominence of simulation and simulacra, one of the hallmarks of immediacy is the response to these possibilities with the counter-embrace of cinematographic techniques that underscore the pro-filmic and the real of embodied human perception and physics.

The ideas and practice of two decorated contemporary auteurs, Steven Soderbergh and Kathryn Bigelow, attest to immanentization. Conditions of video production differ from film production in ways that redound back to an auteur paradigm or to the illusion of upspring from a single artist. Soderbergh, for instance, not only directs movies but conducts his own cinematography and performs his own editing and sound mixing, sometimes going so far as to include pseudonyms in his credits, and all this has intensified since he became his own cameraman, shooting movies entirely on the iPhone. For Soderbergh the attraction of the iPhone is that it does away with the 350-pound camera dolly and large lighting apparatuses, which in turn frees the movie to follow action more continuously, without elaborate shot setup. He directly links this stripping of apparatus to inklings of immediacy:

> As soon as I feel it, I want to shoot it. And so, that's one of the biggest benefits of this method—the time from the idea to seeing an iteration of it is incredibly short, like a minute, like, maybe less. For me, the energy that that creates on set, and I think on screen, is huge.

iPhone cinematography enables a flow between inspiration and iteration, a flow of the actors' energy, and, as Soderbergh ideologically conceives it, a flow of reality without the framing of stylized camerawork: "My attitude has always been, 'So, you think you can improve on real life? Like, the way things look in the real world, you think you can do better than that?'"[30]

Bigelow shares Soderbergh's experimentation with the iPhone and small digital cameras, as well as with camera equipment built for the purpose of creating "kinetic" energy in her signature violence sequences. Building upon the controversial short take

30 Chris O'Falt, "'High Flying Bird': What Soderbergh Begged Apple to Change about the iPhone," *Indie Wire*, February 12, 2019, indiewire.com.

length and rapid editing made popular by Paul Greengrass as he took over direction of the *Bourne* series, *The Hurt Locker* uses handheld cameras to achieve a documentary aesthetic, a jittery perspective with sudden pans and rapid cuts that precipitates serious spectator nausea. The film opens with a point-of-view shot—an angle used constantly throughout, dynamically in tandem with sequences shot with four cameras simultaneously, without the actors' knowledge of which was primary, and the resulting editing feat wildly vacillates between extreme close-ups and establishing shots on location in Jordan, with integrated sequences presented in varying apertures, changing the look from frame to frame. Aesthetically this work aimed "to replicate the feel of war, the chaos of war, the messiness of war"; the documentary aesthetic includes an episodic structure that minimizes narrative. As engrossing as it is unpredictable, the resulting immediacy fulfills Bigelow's wish: "My intention was to put the audience into the soldiers' shoes, into the Humvee, and almost ask them to be the fourth man on the team and have them experience what those soldiers experience."[31] The goal of the style and technique is experience propagating. By creating this immersive style for the topic of an Iraq War bomb unit, Bigelow reorients the famed spectacularization of wars in Iraq, the first to be covered by twenty-four-hour news and live video. Although the film faced charges of factual inaccuracies and was roundly criticized by both veteran and government groups, its formal achievements garnered a striking six Oscars, not only in technical categories like film editing, sound editing, and sound mixing but also in creative ones like Best Original Screenplay, Best Director, and Best Picture. The Best Director award is particularly notable: it was the first time a woman won.

Soderbergh's and Bigelow's enthusiasm for handheld cinematography and program for immediatist style are highly representative of mainstream film today. The verité, scale, and

31 *The Hurt Locker*, behind-the-scenes commentary, 2010, DVD.

effects they attribute to digital video comprise a norm for moving-image arts in our time: the absorption of the camera into phenomenality. Where classical Hollywood studio films involved elaborate sets and large dollies, tracks, and cranes for cameras, the era of the handheld or iPhone camera at once opens spatial vistas and invisibilizes infrastructure for the visual product. This immanentization of the camera has become a defining feature of immediacy video style, a colonoscoping in which the prosthesis of visuality recorporealizes itself.

"You know that feeling when a guy you like sends you a text at two o'clock on a Tuesday night?" You know that feeling when a show you like hails you directly at the zero-minute mark? The very first line of the very first episode of the much-beloved, critically praised, Emmy triumphant, Amazon Studios original made-for-streaming show *Fleabag* is confident you do know that feeling, because you've been accustomed to it ever since the first hit original content produced by a streaming service, Amazon competitor Netflix's *House of Cards*.[32] You expect it from a streaming show: direct address, leveled gaze, face framed, tight shot, a cinematography of interpellation that is now ubiquitous: *Insecure*, *Euphoria*, *Gentleman Jack*, *Abbott Elementary*, *Chewing Gum*, *Killing Eve*, *The Pentaverate*, *This Is Going to Hurt*, and so many others. Where early twentieth-century theater wielded such directness as a device-baring alienation effect, twenty-first-century streaming instead works through device integration: we watch shows on phones and tablets, emulating FaceTime and Zoom and other apps for apparently intimate conversation—with a rather different effect than alienation. Front-facing cinematography immanentizes the camera into the

32 Beau Willimon and David Fincher conceived the front-facing cinematography as "soliloquy," hyping the Shakespearean overtones and Spacey's expertise in theater, but they also directly name its immediatizing effect: "He makes you complicit in an odd way . . . intimately part of the thought process of this lead character, because he could take you aside and explain to you what he was doing and why he was doing it and where it was headed." Brian Stelter, "A Drama's Streaming Premiere," *New York Times*, January 18, 2013, nytimes.com.

spectator's gaze while intoning intimacies of confession and collusion. As that confessionalism gets consummated through intercourse with "Hot Priest," *Fleabag* literalistically liquidates trope, optimizes immersion with the generic melt of tragicomedy, and lubricates intimacy with inundatory divulgences. ("I have a horrible feeling I'm a greedy, perverted, selfish, apathetic, cynical, depraved, mannish-looking, morally bankrupt woman who can't even call herself a feminist.") Whirlpooling presence, gushing feeling, welling current—this is the superfluency of "stream style."

Fleabag opens herself to a relationship with the camera in ways she will not with the real people in her diegetic world; she shares her opinions, desires, and fears with the camera but not with her own sister or lovers or friends. Being a person is hard, but in *Fleabag*, the streaming form of hyperscrutinous closeness takes the camera as a prosthesis of intimacy that finally reifies banal social isolation; why make the effort to relate to the real other beside you when you can so seamlessly orate to the imaginary other in the screen? The melting of the world of the show into the platform of FaceTime friendship, the explicitness of the suffering and sex, the manic compensatory intimacy—these are hallmarks of immediacy's fluid merging, spectacular intensity, and affective pique.

Beyond simply looking, *Fleabag* also uses a vocative device of the second-person pronoun, hailing the camera as subject. The "you" is expansive, suggesting a generic audience, the specific dead friend Boo, or Fleabag addressing herself. Creator Phoebe Waller-Bridge emphasizes in her published script that the intent was to highlight the relationship with the audience: "The main focus of the process was her direct relationship with her audience and how she tries to manipulate and amuse and shock them, moment to moment, until she eventually bares her soul." Directness, moment-to-momentness, bareness: these are the immediatist effects the show's creator pursued. In another pronoun incorporation, Fleabag refers to herself as "us" during a

therapy session, and when the therapist repeats to her her own description of herself as "a girl with no friends and an empty heart" she incredulously retorts, "I have friends." The therapist presses, "Oh so you do have someone to talk to?" Fleabag winks at the camera. "Yeah." "Do you see them a lot?" "They're, oh they're always there. They're always there," she says directly into the camera on the repetition. Crucially, as in the flow of this conversation with the therapist, the direct address in *Fleabag* does not break the diegetic interaction; unlike *Saved by the Bell*'s signature "Time out!" sequences, the conversation proceeds and there are no freeze-frames or action pauses. The flow is continuous, the divulgences not retrospective but present tense. If first-person narrative in literature often involves the gap between the narrator "I" and the character "I" who experienced what is subsequently narrated (a gap, as we saw in "Writing," that often shutters in the short time span and present tense of autofiction), the first-person forward-facing camera closes that gap, producing an identity or indistinction between the two. This gapless immanentism, momentariness, and enmeshment is immediacy.

House of Cards makes the shame mutual; at the end of the first season, star villain Francis Underwood, played by Kevin Spacey, confronts the spectator about their duplicity:

> Every time I've spoken to you, you've never spoken back. Although given our mutual disdain, I can't blame you for the silent treatment. Perhaps I'm speaking to the wrong audience. Can you hear me? Are you even capable of language, or do you only understand depravity?

In a truly creepy turn that vividly illustrates the way the show's immediacy effects dispel the bounds of medium, Spacey reproduced the style of *House of Cards*—including direct address to the camera, the Southern accent, and overall Underwood persona—in his bizarre series of social media posts that followed

his firing from the show over allegations of sexual assault. Image manipulation, reality manufacture, confessional circulation: it all flows in the stream.

looping

Front-facing tight-shot cinematography integrates devices, operating continuity between scripted content and unscripted FaceTime. And this current is just one element of stream aesthetics, just one axis of streaming's fluid pressure on mediation. Circulation's squeeze on medium is also palpable in the moldering of plot that peculiarizes so much streaming content. Where the era of prestige TV was distinguished by its complex plotting and requisite high degree of attention, streaming's abundance conduces not only to the passive, "ambient" wallpapering of highly atmospheric, uneventful shows like *Emily in Paris*, *The Marvelous Mrs. Maisel*, and *Hollywood* but also to the outright liquefaction of plot.[33] "Eternal return"—the *Groundhog Day* looping of the same scenario over and over, the repetitive switchbacks of the colonoscope's journey—prevails in a sheer avalanche of original streaming series and films in the past few years: *Russian Doll*, *Palm Springs*, *Edge of Tomorrow*, *Happy Death Day*, *The Map of Tiny Perfect Things*, *The Final Girls*, *The Endless*, *12 Dates of Christmas*, *Boss Level*, *Before I Fall*, *Naked*. Eternal return transmutes the looping that is the technological medium of streaming into the content itself: loops have a long history in proto-cinematic technologies like the phantasmagoria, and they are essential labor-saving devices for animators (repeated sequences that preclude reinventing the wheel). In the

33 The term "ambient" was developed by media scholar Anna McCarthy in 2001, popularized by a *New Yorker* critic in 2020, and quickly adopted by industry executives. "Ambient TV" refers to TV that "you don't have to pay attention to in order to enjoy." Kyle Chayka, "'Emily in Paris' and the Rise of Ambient TV," *New Yorker*, November 16, 2020, newyorker.com.

era of streaming, loops are integral to compression engines for computers (commands for repeating lines of code), as well as cost-saving devices for production (economizing on wardrobe, setting, and insurance). The internalization of these mechanics into plotless ambience relays as form the monotonous spill of the sogging stream.

Perhaps the greatest loop of all, a widening gyre of swirling flush, is the universe recycling of sopping content, reaping efficiencies from sprawling recirculation of the same conceits. Behold, for example, the rushing of *Breaking Bad* into *Better Call Saul* and other spin-offs. *Breaking Bad*'s production history nicely encapsulates the trajectory from cable to streaming: it started out ambitiously, prestige aspirant, to be shot on film on location in Albuquerque in conspicuously "Western" cinematography, and with intricate moral and intellectual transformations for its characters. Rejected by HBO and Showtime, its pilot season was recorded for and aired on FX, and then the show was sold to AMC as they looked for a successor to their smash *Mad Men* (also rejected by HBO). However, it performed only middlingly until Netflix acquired distribution rights in 2010, shortly before the fourth season premiered on network. This acquisition so boosted the network ratings that it kept the show on the air, as the show's creator acknowledged in his Emmy acceptance speech. Netflix optimized its investment with a campaign to produce a prequel that it marketed as "a Netflix original," even though it too ultimately aired on AMC.[34] The franchisification achieved in *Better Call Saul*—which the show literalizes by opening its first episode in an Omaha mall food court Cinnabon franchise—siphons a wackier, more relatable *Breaking Bad*, and its success, outperforming the original series, has spilled over into other subseries (*Slippin' Jimmy* and *Better Call Saul*

34 Marisa Guthrie and Lacey Rose, "How AMC Almost Lost 'Breaking Bad' Spinoff 'Better Call Saul' to Netflix," *Hollywood Reporter*, September 18, 2013, hollywoodreporter.com.

Employee Training Video), as well as a film sequel to *Breaking Bad*, *El Camino* (produced directly by Netflix). Prequel, quel, sequel, quel surprise, a universe-sprawl of story bleed that is homogenous and low risk, each content vehicle functioning less as narrative representation and more as commercial for its own distension. Metastasized IP: the rolling loop of the stream spigot.

HBO launched its *Game of Thrones* prequel, *House of the Dragon*, in 2022; a movie of HBO's *Deadwood* was released in 2019, a movie of FX's *Bob's Burgers* was released in 2022, and a movie sequel to *Downton Abbey* enjoyed strong success. In all of these projects, "a textual environment in print, film, online, or other medium (often multiple media) with defined discursive borders," as one scholarly work describes it, exceeds its own definitional limits through homogenizing expansion.[35] Looping of this sort is a version of immediacy style insofar as the same content is stretched and stretched so as to be repeated, rewatched, reimmersed, and insofar as the cycling back and forth from small screen to large screen sandblasts any bright line separating film from television, drama from mockumentary, prequel from sequel. What matters in a universe is its endless replication, the distention without innovation of new ideas, new characters, new universes. And by "matters," one means "sells": the twenty highest-grossing Hollywood films since 2010 were *all* sequels, eighteen of them issued by Disney.[36]

Soaking plot and premise, the flow of the stream also waters down format, washing away differences not only between TV and film, not only in aspect ratio or image quality, but also in the previously defining structures of the series and duration. The economizations that propel looping seem to be the only criterion for classifying something a "series" now—in so-called anthology

35 Martin Flanagan, Andrew Livingstone, and Mike McKenny, *The Marvel Studios Phenomenon: Inside a Transmedia Universe* (New York: Bloomsbury, 2016), 4.

36 Gerry Canavan, "Disney's Endgame: How the Franchise Came to Rule Cinema," *Frieze*, December 6, 2019, frieze.com.

shows, sets may be the only fiber tying it all together—as in HBO's *Room 104* (changing genre, cast, and even writers every week while retaining setting in a single hotel room) or Netflix's *Criminal* (changing cast and country every season while retaining setting in a single police interrogation room)—but more likely there is only the contract for a creator, as with Nic Pizzolatto in HBO's three disconnected seasons of *True Detective*, or Ryan Murphy in FX's ten chapters of *American Horror Story*, all made for their forerunning streaming website starting in 2011 (and there, the business model also includes contracts for repurposing actors in numerous installments).[37] "Limited events" are often referred to by creatives as "a six-hour movie" or "a thirteen-hour movie," and, exemplarily, Showtime's new *Twin Peaks* was written, directed, and produced as a movie, with "episode" divisions introduced only in post-production, lacking a rhythm of plot, resolution, or suspense; the show was named the best television series of the 2010s by Vulture but also named the best film of the decade by *Cahiers du Cinema*.[38] To be sure, an unstable division between movies and TV is almost constitutive, dating back at least as far as the 1954 broadcast of three hour-long episodes of *Davy Crockett* that were then combined for the theatrical release *King of the Wild Frontier*, and encompassing formative marketing campaigns like the one promoting Michael Mann's 1984 *Miami Vice* (also featuring a "Crockett" protagonist) as cinema for TV. But in the streaming era, these indistinctions are the rule rather than the exception. It all moves down the tubes.

Format finally matters less in the streaming funding model: where broadcast required that viewers tune in to the same time

37 Michelle Chihara, "Kingmakers," *Los Angeles Review of Books*, June 21, 2015, lareviewofbooks.org.

38 Stelter, "A Drama's Streaming Premiere." Matt Zoller Seitz et al., "What Did We Just Watch? A Not-So-Abridged Guide to Prestige, Peak, and Every Other Kind of TV from the Past Decade," *Vulture*, December 18, 2019, vulture.com; Matt Goldberg, "Cahiers du Cinema Heralds 'Twin Peaks: The Return' as the Best Movie of the 2010s," Collider, December 6, 2019, collider.com.

slot and channel week after week so producers could sell ads, streaming only requires subscribers—and it turns out subscriptions are driven by different formats than drove must-see TV. Beyond this, duration no longer stands as a criterion of format; when video is always on, there's no appointment TV and there's no point to stopping.

Whereas prestige TV required a high degree of attention from viewers for its intricate plots and subtle twists and suspenseful build to dramatic events, ambient TV requires a low degree of attention and minimizes plot and event, cultivating instead tone and consistency. Some viewers thus use it to sleep, and Netflix is even experimenting with a new product it calls a "linear TV channel," Direct, which resembles the preprogrammed lineup of older models of broadcasting, offering round-the-clock streaming stuff.[39] Monotony, rewatchability, simple story lines, heavy dialogue, placidity, beautiful settings, and the internalization of instagramming and influencing into streaming shows themselves lull spectators into perpetual consumption that is also indistinguishable from other activities: if *Emily in Paris* is simply about instagramming, then of course you can use your phone while it's on.

If content no longer constitutes a series and length no longer distinguishes a TV series from a movie, amid this indistinction there is also an emerging specificity of stream series expanse: unlike the network open-ended series that might reach ten seasons of twenty or more episodes each, streaming shows tend to be both closed-ended and no more than three seasons, since financer data shows new subscriptions attenuate after the three-season mark.[40] Miniseries like AMC's *The Night Manager* or HBO's *The Undoing* (both six episodes) are increasingly common original content for streaming services, precisely

39 Briallen Hopper, "Learning to Make My Bed and Lie in It," *Curbed*, October 24, 2019, curbed.com.

40 Maureen Ryan, "Is TV Sabotaging Itself?," *Vanity Fair*, June 4, 2020, vanity fair.com.

because each "limited event" can be a novel occasion to attract new subscribers. Absorptive flings for low-commitment viewers, miniseries also appeal to talent more than open-ended series, because actors and writers can become involved with a project without losing out on many other opportunities. Always be hustlin'. The directors Mark and Jay Duplass expressly analogize this question of viewer commitment to the libidinal rhythms of dating apps: anthologies are "the Tinder of television . . . you pop in for one episode, have some sex with that episode, and you don't even have to come back."[41] The irrepressible flow of the stream promises infinite satisfaction, but the melting of formats makes everything taste the same. This, too, is the metabolic squishing by immediacy, the pablum pipeline of the colon.

genre fluidity

We can coast on this cruise of stream aesthetics by remarking another mechanism of coursing homogeneity: the abundance of genre melt in streaming content. Since syndication is no longer part of the business model, sitcoms give way to the long tail subscriber reach of short-arc topical genre mixing. Lights, camera, action, "dramedy"! Tonally mixed comedies with tragic content, dramedies are signature for streaming because they blend network aesthetic forms with cable quality expectations, dispensing with traditional comedies' laugh track, episodic plotting, and multicamera framing while incorporating more exterior locations and techniques like flashbacks or interspliced animation sequences. Visuals become as important as dialogue, striking images soliciting rapt attention, all within the constitutive thirty-minute structure.[42] *Search Party* (a girls' comedy, except it is also

41 Matt Fowler, "How HBO's *Room 104* Is the Tinder of Television," *IGN*, August 18, 2017, ign.com.

42 On the uninteresting visual quality of TV shows meant as company for housewives, see Spigel, *Make Room for TV*.

a grim detective story), *Schitts Creek* (a sitcom, except it is also a dynastic bildung-soap), *Insecure* (a comic's venue, except it is also a profound treatise on unemployment and Black struggle), and at least three different "forever war" veterans vehicles, which punctuate the absurdity of sham imperialism and meaningless death (*Patriot, Barry, Homecoming*). When dramedies do flip the coin to sixty-minute dramas larded with laughs, grave ills like mass incarceration, racialization, and rape burble with dark humor—an indistinction key to immersive engagement and mass appeal. The apotheosis here is *Orange Is the New Black*, an ensemble drama in a women's prison, often taken as Netflix's flagship revision of prestige TV's presumed white male centrism, and offering such an unclassifiable blend that it became the first show in Emmy history nominated in *both* comedy and drama categories.[43]

The unnerving phenomenon of adult cartoons also evinces genre fluidity. While the history of animation has always involved material addressed to adult audiences, the 2010s saw a marked increase in mature themes and explicit language on the coloring page. Hits like *Bojack Horseman, Undone,* or *Rick and Morty* have encouraged producers already enthusiastic about the ever-improving cost ratio of evolving animation technology to live action. Profit motive aside, the prevalence of adult cartoons evolves from the pressures on the medium of film that we've already named; as Lev Manovich argues, "Cinema can no longer be clearly distinguished from animation. It is no longer an index-ical media technology but, rather, a sub-genre of painting."[44] This blurring of pro-filmic and animation is important for this genre, wrought by the stretching of images beyond original aspect ratios through digital editing and enhancement or 3D fabri-cation. Adult cartoons can be thought of as a domestication of

43 Jorie Lagerwey, Julia Leyda, and Diane Negra, "Female-Centered Television in an Age of Precarity," *Genders* 1:1 (2016).

44 Lev Manovich, *The Language of New Media* (Cambridge, MA: MIT Press, 2001), 250.

this blurring, the elevation of content within the old form that is another side of the coin of the formal transformation of conventional dramatic adult fare.

Critics like to celebrate these generic undoings as aesthetically and politically radical, a liberatory flailing in the crisis ordinary, and writers for the small screen surely share the conceit of contemporary literary production as a whole we studied in "Writing"—namely, that boundary-pushing is freedom. But there's no guarantee that blurry indistinction aids cognitive mapping; far from crisis critique, flow is crisis continuous. What cultural theorist Lauren Berlant commends as the denormalizing function of "the waning of genre" might also be understood as a disorienting promotion of spectatorial immersion.[45] If genre manages expectations, immediacy as the dissolution of genre leaves us without expectations, other than the expectation that our expectations will be thwarted; that we will be caught gasping at the sudden turns from tragedy to comedy and back again; that we will be, paradoxically, attentionally inundated in the aesthetic stream. Immediacy is this engrossing disorienting flow, in the middle of things without mooring.

surging

As we explored in "Imaginary," smoothness is piqued by shattering, and in "Writing," immediacy's fluid dissolve of plot and character into presence and ambience also incites irruptions of sadistic spectacle. "Video" argues for the continuity of this style across streaming aesthetics, where immediacy surges in spectacularization as supplement to looping plotlessness and phenomenalized camerawork. Spectacle in streaming services may be a response to the general image saturation of culture, including

45 Lauren Berlant, *Cruel Optimism* (Durham, NC: Duke University Press, 2011), 6.

the blockbusterization of films and the elevation of CGI in combination with the waning of the pro-filmic actuality. As it has become necessary to differentiate theatergoing from home consumption, an epoch of large-scale blockbusters has seen high-budget big-effect films, often parts of franchises that seem to guarantee audiences and provide titanic opportunities for product integration like video games and merchandising. Blockbusters, the work of communications scholar Charles Acland suggests, may be defined as much by this economic function for studios as by their actual aesthetics.[46] Yet the dynamism and intensity of blockbusters' visuality, the general emphasis on action sequences that defy physics, the always-evolving sound engineering, and the downplaying of dialogue so as to facilitate international popularity establish a baseline, as it were, of extreme televisual style to which streaming services also respond. The league of the Marvel Cinematic Universe, *Harry Potter*, *Star Wars*, and *The Fast and the Furious* all shape the small-screen inclinations toward dazzling physicality, special effects, rapid editing, outlandish costumes, and supernatural plots—to say nothing of small screens getting wildly larger. Extremism of visual aesthetics in the twenty-first century can be understood, film scholars Nicholas Baer et al. argue, "in response to heightened media competition" and often takes shape as "transgressive representations of graphic sex and brutal violence"—but we can add that it can also include spectacularized visual imagery irresolvable into acts like sex or violence.[47] The splatter itself is the point: the recent worldwide rise in horror and gore dramatizes crises while literalizing the

46 Charles R. Acland, *American Blockbuster: Movies, Technology, and Wonder* (Durham, NC: Duke University Press, 2020).

47 Nicholas Baer et al., *Unwatchable* (New Brunswick, NJ: Rutgers University Press, 2019), 5. John Thornton Caldwell makes the same point about network TV's "excessive style" in relation to the rise of cable. See Caldwell's *Televisuality: Style, Crisis, and Authority in American Television* (New Brunswick, NJ: Rutgers University Press, 1995), 11.

stream.[48] Eviscerative spectacles in the *Saw* films or other torture porn spray torrents of blood, materializing the infrastructure of image circulation in extreme deluge.

This spectacle compulsion is nicely exemplified in Waller-Bridge's *Killing Eve*, in ways significantly continuous with her work *Fleabag*. A detective story in which an obsessive MI6 officer pursues a highly skilled female assassin, *Killing Eve* is gratuitously violent and derives great frisson from presenting a woman as the agent of slaughter and torture. In the common strangeness of the two women, the show embeds a synergistic queer bond. The special agent avows her aesthetic appreciation of the slaughter agent, remarking that the killer she seeks "doesn't have a signature, but she certainly has a style," eventually concluding "she is outsmarting the smartest of us and for that she deserves to do or kill whoever the hell she wants." Style and smarts are the panache that propel the crimes of protagonist Villanelle, legible in the scenes and legible in the suspect, for these superficial elements not only excuse but also justify the graver consequences. To sustain the spectacle, filming took place on location in London, Paris, Berlin, Bucharest, Tuscany, and elsewhere. Only slightly less arch than *Fleabag*, *Killing Eve* also uses the piercing gaze of front-facing cinematography, with the assassin Villanelle regularly, fleetingly acknowledging the camera.

The surging function of spectacle stylizes other profoundly violent, profoundly carnal, profoundly stylized shows like *Watchmen*, *Westworld*, and so many more, offering a realm of fantastical extremity that engrosses and shocks, in what media scholar Scott Bukatman calls "equal parts delirium, kinesis, and immersion."[49] Immediatist spectacle in the post-prestige era looks like *Game of Thrones*: signature production values put to work to showcase extravagant nudity and shocking violence, but

48 Mark Steven, *Splatter Capital: The Political Economy of Gore Films* (London: Repeater, 2017).

49 Scott Bukatman, *Matters of Gravity: Special Effects and Supermen in the Twentieth Century* (Durham, NC: Duke University Press, 2003), 114.

emptied out of the semantic heft that could yoke those extremities to concepts. The spectacle is for its own sake; there is no apparent further point, only relentless repetition and distribution (the violence in *Thrones* notably accreting from intimate and interpersonal to mass slaughter rendered in CGI). "Power is power," the queen Cersei pronounces; tautology is all. The allegory of "winter" is not ever cashed in: perhaps it was ecocide; more likely it was just jerks. This irrelevance of the plot is integral to spectacle, as visual extremities render plot obsolete, prioritizing instead "experienced" excess, as the critic Elizabeth Alsop outlines: excessive movement of both the camera and bodies (think swarming scenes of dance or labor through which the camera quickly moves), excess duration (long sequences, both with and without music, in which the camera does not move and nothing happens), excess spectacle (increased representations of sex, death, intoxication, consumption), and excess discontinuity (think dramatic ruptures in the diegetic universe or dramatic jump cuts in the film work).[50] Such modes of excess thwart summarization and demand a different kind of spectatorial engagement than watching for the plot: riding the waves.

The surfer's crouching posture describes another aspect of surge aesthetics: the prominence of "cringe." In an influential work on cinema, Linda Williams identified "body genres" as thematic and formal projects to produce off screen for audiences an experience of what was depicted on screen for characters. Her archetypes are melodrama, pornography, and horror, and the corresponding experiences are emotional pique, sexual arousal, and fear.[51] We can extend Williams's analysis by remarking cringe as a movement of inward shrinking and gutting

50 Notably, Alsop makes these identifications in a video essay for which the clips largely speak for themselves; I thus cite her identifications but supply my own descriptions since her "text" does not. Elizabeth Alsop, "The Television Will Not Be Summarized (Video Essay)," *Journal of Videographic Film and Moving Image Studies* 7:3 (2020), available at mediacommons.org.

51 Linda Williams, "Film Bodies: Gender, Genre, and Excess," *Film Quarterly* 44:4 (Summer 1991), 2–13.

discomfort, a bowel-seizing correlative to colonoscopy camerawork. Activated by banality and awkwardness rather than the explicitness of conventional body genres, cringe shows riposte the cerebralism of prestige dramas like *The Good Wife* or *Billions* with comedic charisma authorized by close proximity between the protagonist and the actor/creator (Larry David's *Curb Your Enthusiasm*, Aziz Ansari's *Master of None*, Louis C. K.'s *Louie*, Tina Fey's *30 Rock*, Lena Dunham's *Girls*, Issa Rae's *Insecure*, and Tig Notaro's *One Mississippi*).[52] Just as the characters are trapped in boring, meaningless, slightly precarious jobs and rote or degrading relationships, anxious and frustrated, the spectator is made similarly uneasy, in unremediable cortisol elevation. Even when surges verge on disequilibrating the passive consumption of the stream, the show's selfsame affects flood the spectator, immersive imperative undammed.

Immediacy video refracts the style projects we've tracked in other aesthetic fields: redaction of medium and form toward immanentized phenomenal experience; privatization of perspective from point-of-view and direct-address camerawork to customized content; an emptying out of figuration and fictionality in favor of ambience and affect, presence and expressivity, solvent and sadism. Contemporary cultural production prizes circulation, practicing flow and emanation in a bizarre swirl of emptiness and extremity that has come to define modes across media. It is a prizing so pinched that the heterogeneous composition of video as medium has curiously consolidated into the style of homogeneous flow. As the artform par excellence of too late capitalism, stream video is rushing, delugent. We might drown.

52 For a theory of cringe ahead of its time, see Adam Kotsko, *Awkwardness* (Winchester, UK: Zero Books, 2010). See also Lori Marso, "Feminist Cringe Comedy," *Academic Minute*, August 14, 2019, academicminute.org.

Antitheory

In his 700-page 2020 masterwork *Critique and Praxis*, the Columbia law professor, Foucauldian theory expert, NPR talking head, and death-penalty lawyer Bernard Harcourt pronounces that critique has become too divorced from praxis. The praxis renewal to which he enjoins his fellow theorists is surprisingly not, however, collective action, but—on the same wavelength as the immediatizing impulses of autofiction and stream aesthetics, in the same underpinning of circulatory disintermediation and imaginary inflation—anti-representational emanation:

> We critical theorists should no longer be speaking for others. The question "What is to be done?" must be reformulated today. Critical theory cannot speak for others. It must instead foster a space for everyone who shares the critical ambition to speak and be heard. The solution to the problem of speaking for others is not to silence anyone, but the opposite: to collaborate and cultivate spaces where all can be heard, especially those who are most affected by our crises today. This reflects as well a new writing style and grammar today. We no longer write in the third person, as Horkheimer did at midcentury. We do not write in universal form either, as Marx or Hegel did before that. Neither do we hide behind the passive tense. No, today, each and every one of us must write in the first person. And that means that we can no longer ask, passively, "What is to be done?" but must actively reformulate the very

question of critical praxis for ourselves. For me, it becomes: "What more shall I do?"[1]

Existing modes of writing cannot work; theory is no longer tenable. Collective demands and objective courses of action do not hold; only the subjective and singular are appropriately moderate. The very project of representation—presenting at some remove, binding together more than individuals, speaking for others—has become illegitimate. In opposition to the syntheses of critique, by which groups agree on what is bad (structural racism, say), and what is to be done (defunding the police, say), and with which common signifiers to constitute collectives ("Black Lives Matter," say), praxis here infinitizes minute actions of irreducible individuals, permanently deferring integration. Rather than compose demands or slogans or visions of what would be less bad for more people "in universal form" (freedom from fear of extrajudicial death, say), praxis extrudes "spaces where all can be heard," where perpetual presence abounds. Harcourt authorizes this conclusion with words from Bruno Latour, the contemporary prophet of assemblage and realism: "There, I've finished, now, if you wish, it is your turn to present yourself."[2]

Successional self-itemization configures praxis as a "decentering" in which "universality is replaced by particularity: what is true now turns on personal self-interests" and as a retreat "from institutions to the personal" because "organizations are obstacles to organizing ourselves . . . we need to turn inward to transform the self."[3] First-person present as idiom solves the democratic paradox of representing others, electing itself as more politically and aesthetically sound than theories or tactics scaffolded by

1 Bernard E. Harcourt, *Critique and Praxis* (New York: Columbia University Press, 2020), 17.

2 Ibid., 33.

3 Ibid., 237. The first part of the quote comes directly from the Invisible Committee's pamphlet *The Coming Insurrection* (Los Angeles: Semiotext(e), 2009), while the inward turn conclusion is Harcourt's.

collective subjectivity or shared signifiers. Of course, it's significant to see a white man voluntarily decenter himself, and gratifying to clock the practical effects of venerable theories that have audited the malfeasance of institutions and the harm of universals. Yet, in emptying out the convocative and generalizing dimensions of critique and then filling that void with the genre-bending fulminations of real talk, immediacy pronounces its univocity. Unrepresentative personalism becomes epistemic silo and political prophylactic, explicitly repudiating the middle ground between one experience and another. If you rightly thought praxis involved mediations like repetitive genres to scale upward from the individual and buttress a mass—the face-to-face production of using "we," the narrative of where power lives and how we might want to live, the email reminder to participate in rallies, the phone-bank script, the local op-ed, the concrete slogan around which many can unite—then *Critique and Praxis* is here to set you straight. That old notion of praxis owes too much to representation and synthesis, and yields too much impersonality and mediation. Against such abstractions, praxis must concretize itself, atomistically animating the magnetic "I."

Harcourt's adoption of the first person unfettered from the third person's coercive collectivization whirls in on itself, circling in the inchoateness of its calling, vibrating in the echo of its ethos. Rather than a narrowing, though, in the view of its proponents this inwardness exponentially expands:

> Everything we do as individuals, every choice we make, every action we take affects these struggles and upheavals. This is the unbearable and daunting reality: every one of our most minute actions will affect. Unbearable, indeed. Agonizing and excruciating. The burden is almost too much to bear. The utter singularity and endlessness of the struggle. It is urgent. Time is running out.[4]

4 Harcourt, *Critique and Praxis*, 539.

Hear in this electric charge immediacy as urgency, immediacy as immersive interiority, immediacy as infinitesimal tessellation—and, of course, hear the rhyme with Knausgaard's acid-brilliant flat ontology: *everything is everything.*

This algorithmic automanifestation, infinitizing identification and reduplicating direction, rivets immediacy as theory style for our time. Across a variety of disciplines, theory—the very tool that should help fathom how dominant culture is determined by the circulation-forward base—has now itself been submerged by immediacy as endgame. Declensionist blur and sui generis radicalism are immediacy marrow common to contemporary luminaries in legal theory, media theory, geography, gender theory, poetics, and communization theory. Righteously appealing, immediacy theory takes for its content self-scrutiny and indeterminate entanglement, and increasingly it takes for its form an auto-authorizing, lyrical, fragmented first-personalism. This makeover of theory as concrete, fluid—in the mix—derives from well-meant reprove of impersonal abstraction, masculinist reserve, and rationalist systematicity. Moving in formation, however, the overcorrection has swerved, with immediacy virtuously and undialectically opposing a hypostasized sin of too much mediation. Immediacy theory thus clinches the trends in cultural production we have studied in arts and letters: the absorptive relationality of practice without medium, the enclosed voice of emanative antifiction, the delugent flow of apostrophic recursion, and the premium on planate exchange. In this concurrence, contemporary theory verifies rather than relativizes the mode of production. Immersive intensity transmits an instant message; it brooks no abstract mediations. Sir, this is an Arby's.

Fast food for thought, immediacy theory gorges on the very unmitigated emission demanded by the intensified circulation dispositive of too late capitalism. Because theory emerges in conditions not of its own making (the ruling ideas in every epoch are the ideas of the ruling class), it must deliberately introduce a break among its determinants. Within the manifest zeitgeist of

too late capitalism, immediacy theory cleaves too close. If contemporary theory has not recognized or analyzed immediacy despite its undeniable hegemony in cultural production—if the summative descriptions and causal narrative this book provides have been necessary—this is finally because so many of the experts in cultural criticism across so many disciplines and traditions have spent the twenty-first century manufacturing immediacy themselves.

It is widely observed that ours is a culture of post-truth and anti-expert populism, in which every man does his own research in his own corner of the internet. Individuals live in impenetrable information bubbles; cults and conspiracies are on the rise; science rejection has been modeled by the world's largest corporations' knowing acceleration of atmospheric carbonization, a trickle-down denialism manifesting in vaccine truthers, home schoolers, and cabal believers. Immediacy reason issues from plutocratic destruction of public education and independent media, but it also bears the imprint of theory's divestment from knowledge and individuation of epistemology. Circling viciously, immediacy style for theory actively suborns further deskilling of academic labor.

Hegemonically ordained by all these vectors of power, ardently esteemed by all our leading lights, immediacy theory remains glaring in its negation of theory, which ought to be one of the ultimate media of mediation: intercession; thick, slow, strange relay; and hewing out relative autonomy. It ought to be the medium in which we can step back from the merely evident. It ought to be the medium in which we can situate the valorization of immediacy as a historical specificity. It ought to be the medium through which we can perceive the systematic and surprising interrelation of culture (what front-facing cinematography has to do with supply chain logistics, what engaged art has to do with networked algorithms). And it ought to be the medium in which ideas themselves negate their own delimiting determinations, shed their old baggage as mere interpretations, and hit the

dialectical jackpot to intervene in the world. Theory effects distance, abstraction, *movement away*. Immediacy foments intimacy, immersion, the negation of intercession. Theory takes us out of a situation, out of phenomenality, out of ourselves, and into realms of reflection that escalate to include the dislocation of our ineluctable situatedness, conceptualization of our many determinations, and speculation about inexperienced possibilities. Immediacy imbibes the immanent. Theory cultivates and cooks, constituting new nourishment for flourishing. Taking distance and cutting distinctions, lineating formations and daring construction, theory risks something other than absorption or blur. Through its orotund negations, immediacy theory is antitheory.

that old critique of immediacy

To fathom this negation more genealogically, recall that theory originates in the critique of immediacy. Definitionally, theory objectivates philosophy, critically interrogating the place from which philosophy is seeing in order to expand the philosopher's sightline from "being and the world" to a meta-level of reflection upon the problem of *how to know* being and the world. Hegel signifies this disruptive turn in philosophy, for he exposed the ruse of "immediacy" in his philosophical predecessors.[5] In his first book, *Phenomenology of Spirit*, Hegel right away introduces immediacy as a prevalent error that any rigorous philosophy taking up a critical relation to its own conditions of possibility must preempt. Charting this error, he argues that thinking happens via a first phase of "sense certainty," in which fundamental objects present themselves to the mind through the senses and the mind enjoys certainty that it knows the objects. Sense certainty is epistemological immediacy: simple data present

5 For one of the clearest assertions of this point, see Andrew Cole, *The Birth of Theory* (Chicago: University of Chicago Press, 2014).

themselves to perception as a "this-now," the senses input them, and consciousness immediately integrates the data into concepts of the objects. For Hegel, this immediacy is both insufficient and illusory. Thought worthy of its name reflects upon its apparent immediacy, its apparent seamless extrapolation from phenomenal senses, and the apparent givenness of phenomena. Through this reflection, thought registers its actual mediacy, "the complex process of mediation" by which the apparently given is constructed and the apparent passive reception of the given is active. The mind works with processing tools that are socially and linguistically determined—such as the categories of space and time that underwrite any recognition of "this-now." Adequate thought must fathom these processes and determinations, focusing on the primacy of relationality—of, in short, mediation. It therefore negates the putative coherence of experience, since neither the subject who experiences nor the object available to experience are self-identical. Hegel reiterates his problematization of immediacy in his next work, *The Science of Logic*, noting the pretense of "being" as indeterminate, undifferentiated immediacy and specifying that philosophy necessarily begins not with this empty abstraction but rather with a more mediated "essence," an actuality of being and reflection. Glossing this systematic program across both major works and beyond, Robert Pippin notes: "One way of putting the whole point of German idealism . . . is to note the denial by all those thinkers that there can be anything like 'unmediated immediacy,' an intuitive apprehension of pure being."[6] For philosophers in this wake then, immediacy has to be understood as a kind of anti-philosophical defense—an over-presence, over-identity, over-certainty that forecloses speculative and critical movement.

When Karl Marx initiated his radical break with the history of philosophy, he did so in large part by criticizing Hegel on

6 Robert B. Pippin, *Hegel's Idealism: The Satisfaction of Self-Consciousness* (Cambridge, UK: Cambridge University Press, 1989), 183.

Hegel's own terms. To take relationality as primary must mean, he argued, not just an abstraction, but rather an obligation to inquire into and acknowledge the very fabric of relations that make philosophy possible: the social structure that allots food, shelter, and time for literacy and speculation.[7] Mediation is not just an ideal process in the realm of ideas (we require categories of time and space to think) but a material process in the realm of corporeality and social interdependence (we tarry with nature to make our conditions of existence; our social relations are contingent rather than fixed). Philosophy cannot be content to wax about consciousness; it must also investigate its own position in society and history, grasping its own mediation by relations of the ruling class system. Moreover, philosophy focused on this mediation must grapple with the problem of mediation in its historical specificity—that is, as posed by capital, the medium which effaces itself. For money is a means of circulation (C–M–C), but capital is this means become end, the medium that self-substantializes as more than medium to obscure mediating functions (M–C–M). Mediation thus becomes the ultimate object of Marxian critique: how thought is mediated, how labor mediates nature, how social rule mediates social position, how capital mediates value while pretending it is not a medium.[8] The repudiation of mediation that characterizes the antitheoretical currents we will study below undoes theory's requisite criterion.

Still other permutations of mediation propel theory after Marx. Theodor Adorno extended the exploration of social mediation by more deeply investigating both the subject of philosophy and its object. It is not enough for critique to register that there is no immediately perceiving subject independent of its social

7 Karl Marx, "Contribution to the Critique of Hegel's Philosophy of Right," in *Marx: Early Political Writings*, trans. Joseph O'Malley (Cambridge, UK: Cambridge University Press, 1994).

8 This central importance of mediation is argued across the entire corpus of Raymond Williams. For an elaboration, see Anna Kornbluh, "Mediation Metabolized," in *Raymond Williams at 100*, ed. Paul Stasi (London: Rowman & Littlefield, 2021), 1–20.

constitution; critique must also explore how there is not any simply given object, how reality and phenomena are produced through means like war, bureaucracy, mass media, and ideology. As he insists, "It is through the transition to the priority of the object that the dialectic becomes materialist."[9] The social relations that determine and mediate the thinking subject do not immediately present themselves for analysis. Indeed, the very definition of thinking for Adorno is nothing other than "the rejection of the overweening demand of bowing to everything immediate."[10] Adorno's lesson is one that Marx knew, but maybe he sometimes forgot: you cannot simply add social and material considerations to Hegelian idealism, since ideology inflects any sense-certain uptake of those considerations. If taking an object as a given constitutes a mistake of an idealist stripe, then objects that insist upon their own givenness—their lack of mediation, their authenticity, their formlessness—must be equally suspicious. Art claiming its identity with reality doubly obfuscates the primacy of mediation, presenting a difficulty that perpetually concerned Adorno. When that art is mass-produced and mass-circulated, mass immersion compromises perceptual faculties. Spoon-fed soap operas, surrounded by billboards and saturated with sonic streams, whole cultures are made over into mass deception.

Trouncing all these outmoded mediations by name (Hegel; Marx; Horkheimer and Adorno; critique), Harcourt advances praxis as anti-mediation: if critique has foundationally held immediacy to be a mistake, then praxis—especially praxis after critique—should affirm immediacy. This oppositional alternative appears not as Harcourt's own genius invention but as the rightful consummation of Latourian history of science, feminism,

9　Theodor Adorno, *Negative Dialectics*, trans. E. B. Asthton (London: Continuum, 1981), 183–97.

10　"The effort implied in the concept of thought itself, as the counterpart of passive contemplation, is negative already, a revolt against being importuned to bow to every immediate thing." Ibid., 19.

analytic philosophy, and sociology, all of which importantly call into question the objectivity and generality that mediation effects. Dismiss not the immediacy program of everyone speaking for themself as grandiose white male melancholy, since deep traditions of feminist and Black epistemology and exploration underwrite it—as indeed Harcourt already attests in the paragraph following that with which we began, which cites Angela Davis, Fred Moten, Ruth Wilson Gilmore, Sara Ahmed, and Chantal Mouffe.[11]

Immediacy as self-substantiation metabolizes many flights of late-twentieth-century theory: authentications of situated knowing, elevations of personal experience, suspicions of grand narratives, transpositions of politics into ethos, and promotion of autoethnography across the disciplines. At the same time, this metabolic process should not be received as an organic trajectory endogenous to theory, since it so overdetermined by the crush in parallel domains: in literature (autofiction, #OwnVoices, self-help, university writing pedagogy); in the "speak your truth" industrial complex (personal branding, confessionalism); in perspectival cinematography and the intimate ambient video stream; in the algorithmic base of i-tech (exponential information organized by binary oppositions of ones and zeros); and in the instantaneity of the just-in-time, on-demand circulation economy. The startling redefinition of praxis as deluging self-presencing belongs, in other words, to a bustling market—one that capaciously promotes manifestism as internal redress of its own depravities, and flow as dissolution of its own contradictions.

11 Harcourt, *Critique and Praxis*, 17–18.

some prominent threads of immediacy

Amid that bustle, the most conspicuously hip form of negating theory's mediations is "autotheory," a self-surfacient, genre-busting lyric personalism ripping through disciplines university-wide. Like the autofictions we studied in "Writing," autotheory liquidates genre in quest of engrossment, repudiates constructions like concepts, trills charisma, and exults sui generis self-springing emanativeness. Like the fluidities we studied in "Video," autotheory dissolves medium, format, boundary in pursuit of presence and hyperexposure. Like the labor expulsions we studied in "Circulation," autotheory disintermediates institutions like the university press, the academic degree, and the tradition of theory itself in promotion of amateur knowing and antidisciplinarity.[12] And, like the shimmering ego we studied in "Imaginary," autotheory waxes smooth while intermittently shattering. The particularities and vulnerabilities it hosts body forth potent antidotes to bland generalizations and tedious abstrusity, and for that it is rightly widely cherished. For all its attraction, though, it leaves much to be desired.

A newer neologism than "autofiction," "autotheory" appears as a term in English starting around 2003, connoting self-legitimating premises in law, and is then widely popularized in 2008 by Paul Preciado's *Testo Junkie*, which calls itself in Spanish "una autoteoria," rendered in English in 2013 as "a theory of the

12 See, for example, the various iterations of "amateur criticism," "weak theory," "surface reading," and other Latourianisms. On "anti-," Joichi Ito, former director of MIT Media Lab, writes: "Interdisciplinary work is when people from different disciplines work together. But antidisciplinary is something very different; it's about working in spaces that simply do not fit into any existing academic discipline—a specific field of study with its own particular words, frameworks, and methods." See "Design and Science," *Journal of Design and Science* (2016), jods.mitpress.mit.edu. See also Fred Moten, "Blackness and Nothingness (Mysticism in the Flesh)," *South Atlantic Quarterly* 112:4 (October 2013), 737–80.

self, or self-theory."[13] With a premium on eroticized merging, Preciado elaborates that autotheory offers "a penetrating analysis of gender" incorporated into "a diaristic account" of daily life, and, indeed, it may be grasped as an enfolding of feminist, queer, psychoanalytic, and Foucauldian theory, among others, into a personal, confessional, playful presentation of the self.[14] Alongside *Testo Junkie*, an originative standard bearer is Maggie Nelson's 2015 *The Argonauts*, whose jacket copy anoints it a "genre-bending memoir, a work of autotheory," and which became a National Book Critics Circle Award winner and *New York Times* bestseller. The mode appeals to all manner of academicians: not only gender theorists, nor even literary personalities, but also anthropologists, art historians, sociologists, and experts from Black studies and Indigenous studies. It resonates admirably beyond academic audiences, finding significant welcome in mainstream media. In the brief period since the term was coined, autotheory works have enjoyed high sales and rhapsodic acclaim: Sara Ahmed's *Living a Feminist Life*, Brian Blanchfield's *Proxies*, Andrea Long Chu's *Females*, Wayne Koestenbaum's *The Pink Trance Notebooks*, Emma Lieber's *Writing Cure*, Frank Wilderson's *Afropessimism*, David Shields's *The Trouble with Men*, Julietta Singh's *No Archive Will Restore You*, and McKenzie Wark's *Reverse Cowgirl* are but a few. Explosively mushrooming in books, journal issues, prizes, and conferences, autotheory has been ecstatically received across rank within the university and across constituencies extramurally. (A data point: Ahmed's book was Duke University Press's best-selling book of the entire 2010s.)[15]

13 Paul Kahn, "The Cultural Study of Law," in *Cultural Analysis, Cultural Studies, and the Law* (Durham, NC: Duke University Press, 2003), 179. Notably, the English translation, which Preciado approved, belabors the self quality, but inserts an extra apposition "a theory of the self" where the Spanish has only "an autotheory."

14 Paul B. Preciado, *Testo Junkie: Sex, Drugs, and Biopolitics in the Pharmacopornographic Era* (New York: The Feminist Press, 2013), 1.

15 Laura Sell, "A Decade of Duke University Press," *News from Duke University Press* (blog), December 30, 2019, dukeupress.wordpress.com.

Autotheory's flexible modalities and limitless mobilities disperse it widely. In these lucrative and revered works, academics proffer lyrical expression of personal experience and impressionistic musing punctuated by theory quips. Often shaped as aphorisms, fragments, elliptical nonnarratives, and momentary illuminations, these texts rebuff systematic elucidation. Fullnesses of charismatic persona, corporeal receptivity, and affective flooding devise an evanescent plenum that preempts criticism. The trademark rhetorical posture of unassailability for the autotheorist, as Andrea Long Chu herself admits, "relies on her own vulnerability to insulate herself from close scrutiny."[16] Immediacy in theory is this argumentless intensity immured from dissent and devoid of higher-order integration. It goes down smooth.

Significant material forces we have studied in *Immediacy*—changes in academic labor, constriction of the publishing marketplace, the algorithmicization of culture, industrial constructions of I-capital from the policies of neoliberalism to the ideologies of "wellness"—markedly differentiate autotheory from the autobiographical writings in feminist, queer, and nonwhite traditions with which it has affinities. If one were to underestimate this difference, then contemporary theory's infatuation with immediacy could be explained as the endogenous culmination of many tendencies in late-twentieth-century theory—from standpoint feminism to trauma theory to deconstructive undecidability to Deleuzean immanence—or even as far back as Nietzsche and counter-Hegelian vitalisms.[17] And, surely for many, the immediacy of present theory is a success story: intellectuals have learned from the mistakes of their predecessors, and the resulting new knowledge is less complicit with oppressive regimes.

16 Andrea Long Chu, "You've Heard This One Before," *Vulture*, September 7, 2021, vulture.com.

17 On this trajectory in feminism, see Anna Kornbluh, "In Defense of Feminist Abstraction," *Diacritics* 49:2 (Winter 2021). For a critique of the prevalence of paradox as intellectual topos under the influence of deconstruction, see Elizabeth Anker, *On Paradox: The Claims of Theory* (Durham, NC: Duke University Press, 2022).

Except that theory is not made in a vacuum—and we read theory more aptly when we accord due weight to exogeneous factors. The fundamental conditions for the production of theory have changed dramatically since the 1970s, and in especially stark ways since the late 1990s. Although it has become fashionable to claim that autotheory is merely a vogue of men or young women taking credit for the innovations of older women of color, or that autotheory has only been named and popularized because men have started to make it, the specific contexts of the twenty-first-century circulation economy and the hegemonic style of immediacy furnish rather different understandings.[18] There are also different outcomes. As both Preciado and Nelson stress, the scope of autotheory necessarily differs from feminist life-writing, French theory, the literary movement of New Narrative, or the queer deconstruction of the system of gender, because the institutionalization and digestion of theory have altered popular epistemologies; autotheory reverses old polarities, from imaginative play to antifictional rubbing the real, from using the body and poetic language as the grounds for theoretical concept-building to using theoryspeak and poetized composition to bedazzle the contours of the concrete body and strum the charisma of, to recall again Knausgaard, "the voice of your own personality."

As this confluence with autofiction illustrates, the reduction of theory's mediations down to amiable oozing incorporates the niche of academic knowledge production into the booming personalist genre industry. Moreover, autotheory comports as dexterous academic labor, as we saw Nelson explain of genre bending in "Writing," projecting a fantasy that courting extramural audiences can make up for downsizing in the intellectual

18 Lauren Fournier, *Autotheory as Feminist Practice in Art, Writing, and Criticism* (Cambridge, MA: MIT Press, 2021). See also Max Cavitch, "Everybody's Autotheory," *Modern Language Quarterly* 83:1 (March 2022), 81–116; and Kyla Wazana Tompkins: "How is autotheory not what women of color were already doing in the 1980s. Someone please explain this amnesia to me, or unpack the differences" (@kwazana, Twitter post, August 19, 2021, twitter.com).

professions. Its vulnerability enkindles senior academics bored of theory's many funerals, imagining eager readerships in a great beyond, and ignites younger academics searching for openings in an economic and professional landscape of foreboding foreclosure; its elasticity bodes a space for young academics to create work and find recognition even though the university as an institution has largely expelled them. Gigification of academic labor crams academic production: manifest your individual take in your individual style with this short-term teaching contract here, this Substack subscriber there. In this way, autotheory must be seen as efflux of a context in which theorists with fair labor conditions like tenure encounter their dire lack of peer audience, and theorists without fair labor conditions hustle for crossover appeal to eke out a living.

Unsurprisingly, the institutional contraction of the waged production of theory pressurizes the circulability of theory, including its disseminations and vernacularizations, and its refresh as "relatable." Autotheory is equally at home as personal essay in open-access culture magazines as it is in university-press monographs as it is in memes and performances, poetry and reddits, or the bourgeoning fast-casual university press pamphlets like University of Minnesota's Forerunners and Stanford's Briefs.[19] Those accelerated university-press short books, along with open access journals, overnight cultural criticism, and administrative imperatives for "public humanities," comprise new highways for circulable scholarship, while circulation pressures issue from anti-academic ideology and defunding of higher education, from "culture wars" and populist rhetoric, and from university mission creep.[20] Innovations in the circulation of

19 Lauren Fournier celebrates its "transmedial" quality, from "personal essay to feminist meme and performance for the camera," which concords with the waning of medium we saw to constitute immediacy in "Video." See Fournier, *Autotheory as Feminist Practice*, 2.

20 Similar short series include Princeton's Shorts, Palgrave's Pivots, Cambridge's Elements, Duke's Practices, University of Tampa's Pith, and New York University's Avidly Reads. For an interesting outline of the little-books trend, see

theory betoken many good developments. At the same time, they propel the tendency of academic theory to empty out its own medium, to undo its own medial differences from commercial writing. It is good to make theory for the people. It is bad to portray the historical erosion of theory's conditions of production, including the reproduction of the class of professional intellectuals, as an endogenous style evolution of self-proclaimed "weak theory" and "amateur criticism."

Before moving on to less conspicuous modalities of immediacy theory, let us linger with very recent and prominent examples of autotheory, paying particular attention to its gushing form and unargumentative beat. In both of these award-garnering, soul-baring instances, representation and mediation wreck upon the profundity of corporeal pain and erotic pleasure. Rather than relay ideas with defamiliarizing velocity, these texts understand themselves to produce, above all, engrossing familiarity.

English professor Julietta Singh, the author of a scholarly book from Duke University Press as well as two books of autotheory, turns autotheory's signature pirouette in her recent book *No Archive Will Restore You*, hailing theoretical traditions to proclaim their insufficiency to life. A finalist for the Lambda Literary Award, *No Archive* introduces a young graduate student reading Edward Said quoting Antonio Gramsci, but what is made is not sense so much as ecstatic sensation:

> The starting-point of critical elaboration is the consciousness of what one really is, and is "knowing thyself" as a product of the historical processes to date, which has deposited in you an infinity of traces, without leaving an inventory . . . Therefore it is imperative at the outset to compile such an inventory.

Karen Steigman, "The Colloquy of Little Books," *Cultural Critique* 115 (Spring 2022), 186–201.

An infinite history of traces without an inventory! An endless collection of oneself that is impossible to gather . . . I had no concrete idea of what it meant, or what currency it had in my own life, but I knew how it *felt*. It felt as though the broken thing I was might be restored, and it felt like an embodied idea I would never stop desiring for myself and for the world.

The infinity of traces becomes a refrain, as she undertakes "a body archive" (a trope callback to Preciado's send-up of Derrida's *Archive Fever*) as "an assembly of history's traces deposited in me," filling her book with singular paragraphs floating in a sea of white space, disjunctive from one another.[21] There are racy musings that "couples who openly discuss their bowel movements have a higher relational success rate than couples who take shit as taboo," and sad effusions of unrepresentability around quotidian bodily pain:[22]

For all of the ways that I remain bound to pain, I can find almost nothing to say about its specificity. When I first tried to write about extreme physical pain, I discovered that I could only write in opaque poetic fragments. Pain seemed to belong more to poetry than to narrative prose. But even poetry, for all of its subtle rendering, fails to capture the *pain* of pain, its illegible core.[23]

Moans of pain are figured as especially "inarticulate traces," which repeat ineptly the infinite traces of historical processing and self-production, and the unfulfilled promises of uncarried acts, that accrete in "my impossible archive" and that entwine not in meaning but in guttural chorus, assembling "a body that

21 Julietta Singh, *No Archive Will Restore You* (Goleta, CA: Punctum Books, 2018), 29.

22 Ibid., 44.

23 Ibid., 61.

is in excess," as the book's last line has it.[24] Traces as the less than written, gasping sounds as inarticulacy, excessive bodies unavailable to prose, historical processes inimical to mediation—these are profoundly evocative shards of Singh's autotheory, and they burble with immediacy.

Aphoristic form props many of these texts thanks to its elliptical dance of vaporescence and glut, simultaneously pausing and flowing, at once crystal and aporia, snubbing and solicitous. They disrupt linearity, argumentative progression, and academic citation, boarding tiny theses absent plodding hallways. Pushing prose poems like other writers in the literary milieu, these genre melds are charming, accessible. We are drawn out of the realm of abstraction and solicited into a lyrical presence, a seductive proximity that subtracts the medium of theory's abstractions and generalizations, achieving immersion. Reclining into life-writing, recoiling from argumentation, such retreats attain great resonance and beauty even as they whittle away theory's distinct value, and recode theoretical knowing from revelatory to idiosyncratic. Immediatist theories posit a smooth continuum of body–experience–knowledge; bolster reflexive, passionate attachments as more legitimate than reason; refuse "symptomatic reading" in order to immanentize content. "It is what it is," immediacy theory incants.

The tautological maxims of contemporary culture are also enclosures of writing: autotheorists articulate, and their readers mirror, and then take the mic. Circularity and distributed multiplicity of speaking, rather than synthesis. The echolalic quality of speaking for oneself in turn elevates the timbre and tone and voice of the speaker—its sensuous intensity—above and beyond its sense. No wonder, then, that corporeality as the bed of the voice becomes a main motif in autotheory.

Wark's *Reverse Cowgirl*, published in 2020 with eminent theory press Semiotext(e), almost thematizes the aphoristic

24 Ibid., 80, 114.

structure from its very first page, with blackouts and blankness and dissociations (another Preciado callback) as the formal indices of terrible loss:

> He holds me and he tells me that my mother is dead.
>
> My mother is dead, he tells me. The world vibrates in a slow rhythm, waves of static alternating with waves of clear nothing. The black vinyl of the sofa, the gray wool of his trousers, my own flesh, the air, the walls all have a woozy complicity. There's a sucking sound but I don't hear anything. There is a subtraction, like a cut in a movie. For a moment I am not there at all.[25]

The production of gaps between the short paragraphs, the propulsive structure without knitting, assembles autobiography with decontextualized fragments and allusive quotes from cultural theorists like Sianne Ngai and Jean-François Lyotard, or other great aphoristic artists like Oscar Wilde or Maggie Nelson, and enhances it with vivid, sensuous bodily reflection. As the book progresses, the eroticized confessions and sometimes-lurid details proffer bodily disclosure as the real that perpetually sunders prose and logos:

> I was puny and weak and disinterested in the great contests of teenage masculinity. Could not even compete. Born with clubfoot, twice over, like I was two Iagos in one, although it was a disability that it wasn't too hard to mask. I could pass among the walkers, if not the runners. If I could pass as bipedal, maybe I could pass as bisexual? . . .
>
> This is not something logical but it is just how I feel about it: when one person is bigger than the other one, the big one fucks the little one. It does not matter their gender or age or inclination to be top or bottom, I just feel like the big human

25 McKenzie Wark, *Reverse Cowgirl* (Los Angeles: Semiotext(e), 2020), 11.

fucks and the small human is the one who is fucked. There. I
said it . . .

This, I felt then and still sometimes feel, is the great asymme-
try of human being: There are penetrators and the penetrated.
Either your body opens and encloses another; or your body
extends itself out of itself into another. One can be both of
course, alternately, or even at the same time. But basically,
there are the fuckers and the fucked. I wanted to be, and
became, one of the fucked. To become flesh . . .[26]

The climax of various coital how-tos and ecstatic rhapsodies
is an injunction to the reader to use the book object itself as sex
toy, to engage the printed matter not as sense or argument or
transportive mediation but as sensuous prosthetic immediacy:

Every book should have an image that passes through the whole
of it. So take this book and roll it into a tube. Hold the tube
in your hands. Pretend that the tube you made of this book is
my ass. Press your cock up against one end of it, and slowly slide
it right through. The book gives you its consent, in writing.

What, you don't have a cock? Everyone can have one. They
make very fine designer cock technology. It's the fashion now.
Better than the old flesh ones. You can choose what size and
color, and it's never limp. Either way, take your cock, press it
against one end of the ass that is this book. Slide it in, out, in,
out, until somebody cums. Maybe it's you, cumming cursive
into this book, your personal copy. Maybe it's you, wet from
rubbing the base of the dick against your clit. Sign a little of
your juice within its pages.[27]

Such frolicking provocative insurgence of sensuous stimulation
against linguistic or conceptual sense erects the theory text as

26 Ibid., 35, 40, 49.
27 Ibid., 61.

willing dildo. It is bold in its shedding of academic composure, compelling in its self-disclosure, and titillating in its seductive posture—although decidedly unsexy. These are acute and perhaps even vulnerable performances, insuring in advance that assessing them critically would amount to some kind of mean violation—and that seems indeed to be the very point: to be so effulgently bare and corporeally vivid as to preclude distance-taking or concept-making. Immediacy as the unambiguous transmission of affect from author to reader, autonomic responses imagined untainted by the symbolic.

In immediacy theory, ratiocinative mediations rarely enter the picture; affects and the body found an inexhaustible concreteness that demands empirical cataloging. Where older forms to which autotheory bears some resemblance, like *écriture féminine*, gen-erated uncertainty in their mix of fiction and fact and vectored their speculum toward invention rather than documentation, autotheory's phenomenological heft (experience, the self, the body, its beauty, its pain, its pleasure, its transformation) often explicitly counterposes theory's interest in discursive construc-tion. Drawing upon the tradition of phenomenology as riposte to philosophical inattention to the body, autotheory nestles in against theory's above-it-all posture. Critic Ralph Clare celebrates:

> It is autotheory's unique triumph to marry the truly personal, private, and/or confessional (the private details of life that Barthes, Derrida, and Kristeva shy away from) with critique, to insist against the poststructuralist reduction of self purely to a textuality that produces a distancing kind of impersonality by ultimately maintaining divisions between the public and private.[28]

Averse to distancing and impersonality, autotheory erects inti-macy and personality, attachment and charisma; the preserved

28 Ralph Clare, "Becoming Autotheory," *Arizona Quarterly* 76:1 (Spring 2020), 89.

private of incandescence then can be exposed and confessed in the snippets of fragmented text. Ahmed's much-adored text puts it plainly: "Theory can do more the closer it gets to the skin."[29] She continues,

> The personal is theoretical. Theory itself is often assumed to be abstract: something is more theoretical the more abstract it is. To abstract is to drag away, detach, pull away, or divert. We might then have to drag theory back, to bring theory back to life.

What is the thing from which theory must be dragged back today, the thing opposed to "the skin" and "the personal"? Apparently, mediation itself. But, if theory that does "more" authorizes itself in heretical departure from a conjured dominant, in the context of the hegemonic bid for immediacy we can read such moves as their own majority. Autotheory's skin-to-skin contact negates the mediating diversions of theory: its wild ideas unmoored from viscera, its transcendental striving riven from immanence, its tarrying with the negative and unlived experience.

In its substantialization of the flesh as anti-symbolic, in its trumping of conventional braininess with ethereal sensation, autotheory performs that very capture in the imaginary that characterizes contemporary psychic life and consonates with macroeconomic privatization and the reign of human capital. The epistemic sacralization of ineffable experience discredits those arcs of cognition and of action that capacitate affiliation beyond experience, thus delegitimating political solidarity. That there could be collectivizing, generalizing theories that any reader might find illuminating and activating is in advance forsworn by the insistent privatizations autotheory's proponents presume as virtues:

29 Sara Ahmed, *Living a Feminist Life* (Durham, NC: Duke University Press, 2017), 10.

Autotheory says too: *all* theory is in fact based in someone else's experience of their one particular body, though they have conveniently erased it from their theorizing and from their writing so as to seem like a disembodied brain, a neutral voice.[30]

Critic Arianne Zwartjes's particularization here exemplifies immediacy theory's hypostasization of an overly mediated theory it rejects: too impersonal, too abstract, too much the product of thinking as opposed to experiencing. Autotheory glides in this way as the explication of a longer history littered with critiques of universals and objectivity, and reproaching the very prospect of common goals, meaning across experiential divides, or signifiers sustaining solidarity. All too much representation, too little presence.

Jockeying for self-assured aura, immediacy theory nullifies concept formation. It neither makes arguments nor countenances counterarguments, for who among theorists can dispute another theorist's experience? Instead of advancing ideas, we are enjoined to pen our own disclosure (and, with luck, score a big trade publisher's advance). Now it is your turn.

autotheory as form, algorithmicized content

To everything, turn, turn, turn. Theory as mediation—as processing and sublating, as defamiliarizing and abstracting, as contextualizing and narrating—turns now away from its task, instead endorsing the cultural style it ought rightly to critique. In too late capitalism, critique resigns and futurity forecloses; only mesmerizing emissions present. The sublime and the singular solicit successive spreads, in a series that suspends synthesis, simulating nothing so much as the integers of digital computation.

30 Arianne Zwartjes, "Under the Skin: An Exploration of Autotheory," *Assay* 6:1 (Fall 2019), assayjournal.com.

Autotheory's vaporization of argument is merely the most stylized example of contemporary theory's immediacy style; with less flair but more reach, the current romance of empiricism negates the mediations of theory and fuses thought to the program language of circulatory platforms.

Numerous innovations and "turns" in the twenty-first century embrace objects on their own terrain, enjoining theorists to attachments and entanglements that close distance. As Harcourt so vividly avers, these intimacies require a rejection of the definitional trajectory from German idealism to materialist dialectics to the Frankfurt school and cultural studies, in which immediacy has always stood for an error to be corrected or fantasy to be traversed. Instead of critique and theoretical interpretation, immediacy theory propounds fluid interaction, the theorist imbibing the object, the object immersing the theorist. Abjuring abstractions, this empiricism favors inventories, iteration against mediation. As the ensuing lists discretize experience archipelagoes and push asymptotically toward infinite dispersals, they redirect theory as the emulation of algorithms.

This unwitting corroboration of the hegemonic episteme unifies a wave of turns in theory and method that might at first appear unrelated. The flat metaphysics of actor–network theory (ANT), object-oriented ontology, thing theory, posthumanism, and romantic ecological fusionism all directly aim to oust analyses of class relations with maps of distributed agency and to enmesh the knowing subject in hypercomplexity. The affective turn in literary study, anthropology, and political psychology de-emphasizes the subject (including the subject of interpretation and the subject of the unconscious), emphasizing autonomic response, bodily force, and pre- and trans-individuality, along with felt experience, irrational choice, and theaters of cruelty as all more real and intense than the administered world. Varieties of postcritique—in anthropology and theology, in art history and literature—enjoin critics to resign critical distance and symptomatic interpretation in favor of more phenomenological and

171

"amateur" concerns such as "surface reading" and identificatory "attachment." Posing itself as theory's other, the computational humanities—including data analytics, text mining, corpus mapping—use quantitative processing to join immediatist theory's dethroning of interpretative, qualitative inquiry: numbers are better than words. To each of these turns belong their own celebrities, book series, special issues, and symposia, and across them as well as beyond them, theory has unseated distance, decolonized reason, and subverted abstraction to arrive at realist entanglement with vibrant objects and their pulsating kinships. Each of these developments weld the theoretical to the technological by taking up, as Alexander Galloway incisively diagnoses, the selfsame epistemes of the software that powers Google, Monsanto, Equifax, and other super-corporations.[31]

The framework of algorithms—discrete quanta and their near-infinite serialization—quickens the many trends in contemporary theory that comport themselves as anti-mediation "realism." The movement of "speculative realism" has its origins in negating the distinction between the human and the nonhuman, unbinding the finitude that might divide philosophical apperception from worldly matter like rocks. Connectedness overcomes distance in the work of Levi Bryant and Graham Harman, among many others, where ontologies of vitality ensure continuity between humans and other citizens in "the democracy of objects." "Vitality" and "vibrant matter" are the proper core of philosophical attention for Jane Bennett, who borrows from travelogues and literary sources to deem her method "realism." Similarly, Karen Barad offers "agential realism" as a disputation of "representation": philosophers too often focus on epistemology at the expense of ontology, but truly enlightened theory cuts through the chaff of representation to revel in the real entanglings of "human *and* nonhuman, material *and* discursive, natural *and*

31 Alexander Galloway, "The Poverty of Philosophy: Realism and Post-Fordism," *Critical Inquiry* 39:2 (2013), 347–66.

cultural factors."[32] These insistent copulatives encode the continuity of immediacy, and their regnant theological guide (whom we have already encountered, Bruno Latour) deems the epistemology adequate to this "and-ing" horizontalism and vitalist immanence "a more realistic realism."[33] "Realism" is also what Stephen Best and Sharon Marcus call their program for "minimal critical agency" in the 2009 manifesto for surface reading, one of several rejections of "critique" in favor of a metaphysics of proximity, flatness, and intimacy.[34] The pursuant rapid-uptake anti-interpretative thrust of descriptivism, postcritique, weak theory, and amateur criticism, alongside computational analytics and cognitive criticism, share in this scientizing deflation of speculative interpretation, amounting to "the new critical modesty," which Jeff Williams pinpointed in an oft-cited piece for *The Chronicle of Higher Education* by underscoring that "realism" as reading practice punctures arrogance, resigns political purchase, and demurs to the immediately given.[35] In each of these domains—philosophy, theology, geology, literary and cultural study—"realism" presages an imperative to immersion, a renunciation of gaps and distance, a spiritualized negation of intercession, constellating as immediacy. Reality hunger indeed.

Denoting the epistemic posture of empiricism, nominalism, and positivism that registers proliferating agents (people, rocks, animals, plants, songs, books, languages) as they occasion not relations but exchange, realism of this sort esteems itself democratic: empiricist knowledge requires not conceptual literacy but sensory attunement. A fascination with folkways, amateurism,

32 Karen Barad, *Meeting the Universe Halfway: Quantum Physics and the Entanglement of Matter and Meaning* (Durham, NC: Duke University Press, 2007), 26.

33 Bruno Latour, *Pandora's Hope* (Cambridge, MA: Harvard University Press, 1999), 15.

34 Stephen Best and Sharon Marcus, "Surface Reading: An Introduction," *Representations* 108:1 (Fall 2009), 1–21.

35 Jeff Williams, "The New Modesty in Literary Criticism," *Chronicle of Higher Education*, January 9, 2015, B6–9.

imagined Indigenous epistemologies, and anti-abstraction propels ANT-style repudiations of higher-order concepts: when knowledge is immanentized, "amateur" and "weak" and "lay" become the buzzwords of retreats-qua-advances. And it is in this way that such a realism often signals indifference to the deinstitutionalization of higher education: flat ontology mimes the flattening of the academic profession, while weak theory rationalizes the loss of a living wage for theorists.

Across contemporary theory, realism and immanence, immersion and horizontality unseat reflection, transcendence, and the verticality of perspectival remove or causal analysis. These offer genuine redress for shortcomings—such as ignorance of the ecological in structuralism and poststructuralism alike. Yet in unshutting theory to ever more counter-rationalist topoi (affects, dogs, rocks, affects again), an aesthetic experience of fusion takes precedence over educing contradictions, critiquing ideology, or drawing lines in the sand. All is intensity, infinite concretude, oceanic feeling. The given and theory, one surging wave together, drowning the possibility of anchor or dam. As Lukács already foretold, "In the last analysis, all 'immanence' in imperialist bourgeois philosophy is aiming at the same target: to deduce from epistemology the 'everlastingness' of capitalist society."[36]

These enthusiasms and pressures for the immanent and empirical, the real emancipated from the cumbersome thickets of mediation and interpretation, stem from the thing-in-itself instant access of disintermediated circulation—and, while they rhyme with epistemology in the domain of the sciences, they strike a strange note in the arts. A recent luminary of literary and cultural studies smartly enacts an enterprise of empirical enumeration that evinces this dissonance. The decorated critic Rita Felski argues, in *Hooked*, on behalf of the complexity of aesthetic

36 Georg Lukács, "Nietzsche as Founder of Irrationalism in the Imperialist Period," in *The Destruction of Reason*, trans. Peter Palmer (London: Merlin Press, 1980 [1952]), available at marxists.org.

attachment and for complexity as the best conclusion at which theoretical inquiry can arrive. Her commitment is to "the irreducible nature of phenomena," her prescription for criticism is to attend to the complexity and variability of aesthetic experience: of "attachments to artworks ... considered for their own sake rather than as effects of a more fundamental reality," thereby "combatting the intellectualism of recent theory."[37] While Felski claims that her program "is not a matter of discarding thought in order to embrace a rapturous state of vibrating, throbbing, and wordless gaping," her method yields something "much messier" than analysis: a catalog of "messy realities" and long streams of unanswered, ungeneralizable, and even rhetorical questions.[38]

The mess here has a glint of theoretical prisming: ANT takes matters of aesthetic enjoyment, identification, and stirring as "different things coming together in ways that are often hard to pin down"; rather than rely on social analysis or historical causes or formal ekphrasis, it affirms "that our condition is one of ever-greater entanglement, of proliferating ties and multiplying tendencies."[39] The proper academic study of this condition is "acts of identifying," an empiricism that eschews concept formation. "Not interpreting," she writes, "but striving to pay attention" is the way to practice criticism—not intellection but sensory stimulation.[40]

Recasting sensibility as hyper-wired "receptivity" akin to algorithmic uptake, the critic is commissioned by vibrancy to make lists: lists of disciplines that can participate in naming, lists of actants to be named, lists of different media to whose specificity the attachment approach can remain largely indifferent; "actor-network theory's style of thinking, however, is additive, not subtractive."[41]

37 Rita Felski, *Hooked: Art and Attachment* (Chicago: University of Chicago Press, 2020), 24, 76.
38 Ibid., 11, 87, 98.
39 Ibid., 10.
40 Ibid., 119, 138.
41 Ibid., 52, 6.

Adding up to so many lists, this empiricist style regards art and literature not as ambiguities for interpretation but as self-identical items. Itemization presses in interdisciplinary initiatives, administrative imperatives, and public humanities programming that erect "aboutness" as the stuff of art: what matters is not the way aesthetic ideas solicit a different kind of thinking than ordinary, but only their discretizable core and direct message. Aboutness, according to the philosopher Stephen Yablo, effects the prepositionality that defines immediacy, "whatever it is that [items] are *on* or *of*."[42] Works "about" ourselves spring affect; works "about" the other stimulate empathic serotonin; works "about" animals and rocks propagate vibrant materialism. In mining aboutness, consumer and administrative initiatives often vitiate mediation, shortcutting adumbration to align aesthetic cultural production more clearly with sociology or history. Such alignments are predications of value, as literary scholar Kandice Chuh points out: "Aboutness is an instrumental analytic . . . a rubric like Asian American literature announces its subject matter as the Asian American rather than the literature," assimilating noncanonical literature into critical study while slighting its literariness.[43] Critic Merve Emre similarly studies how aboutness lodges the value of literary study in the twenty-first-century university, which increasingly abides not in literature departments but in "post-disciplinary" programs (medicine, environmental science, business ethics) that position literature as essentially, prepositionally topical—on, of, addressing or concerning subjects—rather than as conjuratively oblique.[44] Aboutness becomes the way that art and literature are admitted to conversations in public health or policy or design at the expense of their own mediacy; maybe *The Jungle*, Upton Sinclair's muckraking novel, has something to tell us about occupational safety

42 Stephen Yablo, *Aboutness* (Princeton, NJ: Princeton University Press, 2014), 1.

43 Kandice Chuh, "It's Not about Anything," *Social Text* 32 (2014), 130, 132.

44 Merve Emre, "Post-Disciplinary Reading and Literary Sociology," *M/M Print Plus* 3:4 (February 2019), modernismmodernity.org.

for food-industry workers or logistics for a greener supply chain, but that something will be in the facticity of its events, identities, and "real life" references, not in its figurative meaning-making. Extensive data informatics, cognitive processing, and linguistics research take "aboutness" as their core question, and the assimilation of aesthetic research to these other disciplines reveals just how much the administrative construct "the humanities" elides the internal division between mediation and the immediate; "the study of human experience" in anthropology, history, linguistics, and law differs from the unlived experience and unrealized possibilities produced by literature and art—but aboutness and empiricism redact that difference.

Everything is data. The discretized unit is immediately integrable, self-evident unto itself, and paramount for the quantum speed and scale of platform capitalism. Discretized data requires no interpretation, only accumulation. The withdrawal of argument and relinquishment of interpretation that animate intellectual empiricism belong as much to algorithmic culture as do the agglomerative listing and aphoristic enisling that supply contemporary theory's syntax. What is more, in their accumulative propulsion and fascination with the real, contemporary theories rouse a near-theological pursuit of imaginary infinity, so evident in recurrent motifs of eternal domination, irredeemable worlds, and nihilistic abandon. Galloway underscores how this infinity issues from flat ontology: "a system of objective essentialism" culminates in "an unmediated real, infinity."[45] Immediacy surprisingly conjoins solemn quantification and the exuberance of the uncountable; its algorithmic ethos enacts empiricism while also incarnating absolutism, the infinitization and sublime asymptotic horizon of all that accumulation.

45 Galloway, "Poverty of Philosophy," 356.

nihilism

In their fixation on the unanswerability and immutability of eternal forces, or primordially recessive unorganizable chaos, contemporary theory's many nihilisms have algorithmic underpinnings too. Extreme subtraction into nothing, a negation of the synthetic, affirmative, or normative, nihilism simultaneously aggrandizes theorists and alibizes their own inconsequentiality. Uniting queer anti-social hypotheses, afro- and gynopessimism, and primal negativities in idioms of deconstruction, psychoanalysis, biopolitics, and phenomenology, the tenets of contemporary nihilism are so pervasive as to be almost imperceptible: all "ends" are bad, all institutions are oppressive, human history is only the history of domination, values like freedom or responsibility are instruments of these forces of bad oppressive domination, and therefore the only minimally affirmable virtues are ephemerality, hybridity, destabilization, fugitivity. Abjuring positive formulations, nihilism offers subtraction, qualification, dissent, the radicalism of the unspecifiable—immediacy as the planarity of what evades synthesis. It aims at dissolution and dismantling, hypostasizing agency in destruction, freedom in formlessness, and a preferable Eden in anti-mediation.[46]

University of Minnesota's Forerunners text *A Billion Black Anthropocenes or None* announces in its title its intention to void the concept of the Anthropocene: either it must mean something

46 Some of these motifs are developed at greater length in Anna Kornbluh, *The Order of Forms: Realism, Formalism, and Social Space* (Chicago: University of Chicago Press, 2019), and "Extinct Critique," *South Atlantic Quarterly* 119:4 (October 2020), 767–77. See also Andreas Malm, *The Progress of This Storm: Nature and Society in a Warming World* (London: Verso, 2018); Timothy Brennan, *Wars of Position: The Cultural Politics of Left and Right* (New York: Columbia University Press, 2007); Mari Ruti, *Distillations: Theory, Ethics, Affect* (New York: Bloomsbury, 2018); Alex Woloch, *Or Orwell: Writing and Democratic Socialism* (Cambridge, MA: Harvard University Press, 2016).

inestimably diffuse, or it must mean nothing. The concept was constructed in 1980 by an international consortium of scientists to find a way to designate that the earth's material composition is being altered by contingent human activity, specifically the extraction and burning of fossil fuels by an elite ruling class. While the point of the term is to stratigraphically mark the present (we now live in the Anthropocene, a subset of the Holocene), academics diverge on exactly when the starting date should be. Many argue for the Great Acceleration, the dramatic increase in human productive activity, population, and fossil fuel consumption starting around 1950 that radically increased the levels of carbon in the atmosphere. Others argue for the Industrial Revolution, so something more like 1800, which even contemporary Victorian writers recognized as a transformation of the climate, and which is an undeniable point of increasing carbonization. Still others argue, rather differently, for 1619 or 1492, when points of contact between white Europeans and Indigenous populations of the Americas resulted in eventual disease, war, enslavement and therefore death of so many millions of people that carboniferous human activities significantly *decreased*. There is surely a political value to framing the energy regime of carbon modernity as inextricably tied to the political regimes of imperialism, settler colonialism, and slavery. But there is also a dilution of the very term "Anthropocene" when its transformations of the earth in the vein of anthropogenic climate change are expanded to include the opposite: atmospheric decarbonization. Calling attention to a decrease as equal to an increase eradicates the distinctiveness of increasing carbon concentrations and of formulating a specific name for that geologically significant process.

Ultimately, this militant anti-distinction is the contribution made by the book's author, human geographer Kathryn Yusoff, who rejects the coherence of the "Anthropocene" as a false division in what is really uninterrupted destruction since the dawn of time. "The Anthropocene is not reducible to anthropogenic climate change or to a carbon or capitalist imaginary," she writes,

diffusing the geological measure into the metaphysical measure of eternal anti-Blackness.[47] Beyond this repudiation of the historical content of the Anthropocene, Yusoff also indicts its form; the very project of concept-making and "description of the world" is discredited, she argues, by its resemblance to "property" and "captivity."[48] Through repeated assimilations of analytic distinction to violence, Yusoff replaces representation and conceptualization with the unrepresentable and unremediable. Refuse any historical specificity, technical content, or conceptual integrity to "the Anthropocene," since it is always and everywhere. No distinction, no causality, no carbon, and thus no culpability; only dematerialized ontology of billionite expanse. This absolutization, in all its algorithmic, flat infinity, all its exculpation of the actually guilty, all its negation without contradiction, effectuates immediacy as antitheory style.

The leveling of distinctions characteristic of immediacy theory often broaches a dissolutionist nihilism that absolutizes and dematerializes states, laws, and power relations, and abnegates alternative formations or alternative affordances of political-institutional forms. When that kind of argumentation prevails, its ambition is indistinction: harm-seeking laser vision sees particular injustices impugn the notion of justice; turtles all the way down. A brilliant and much-laureled example of this indistinction is the discourse of "university abolition" in the work of Stefano Harney and Fred Moten and their students/followers. Rather than distinguish between the institutional operations and effects of the university and the prison system, Harney and Moten recurrently assimilate the one to the other. In their essay "The University (Last Words)," for instance, they directly liken a research fellowship to one of the cruelest of carceral practices, solitary confinement:

47 Kathryn Yusoff, *A Billion Black Anthropocenes or None* (Minneapolis: University of Minnesota Press, 2018), 40.

48 Ibid., 10.

The university is a fortress whose various appearances—
refuge and refugee camp, writer's colony and colony—betray
its deep, various, nefarious functions . . . only in the university
can winning a fellowship mean access to solitude . . . a set of
fantasies, ranging from transparency to blackening, held in
relational solitary confinement that mistakes the restricted
(re)forms of the academy's general population for the revolu-
tionary force of a general intellectual metaeconomy.[49]

A lecture and teach-in on this essay takes the point even farther:
in the middle of the largest protest movement ever to transpire
in this country, a movement explicitly against police violence,
they observe "so much of our work is about how . . . the vast
majority of the policing that gets done in the university is done
by administrators and faculty and not by the police forces."[50]
And a manifesto authored by their students in their name fur-
ther blends the concerted right-wing campaign to defund higher
education into a radically flashy movement to "abolish" col-
lege. While there are countless critical pedagogy critiques and
studies of the school-to-prison-pipeline that would substantiate
more subtle versions of these imbrications, juxtaposed against
the fact that the University of Chicago and Temple University
have the largest private police forces in the country—and they
actually shoot people—such flattening associations actively
disarm the specific project of disarming and defunding campus
cops, by generalizing everything on campus into acts of policing.
Harney and Moten furthermore discard the vast differences
among institutions and outcomes in higher education in favor of
this monolith of domination, "the university," conveniently elid-
ing that the majority of university instruction happens in small

49 Stefano Harney and Fred Moten, "The University (Last Words)" (unpub-
lished talk), 4, available at academia.edu.

50 This widely circulated observation elasticizes "policing" to include, among
many other things, teaching. See "FUC 012 | Fred Moten & Stefano Harney—The
University (Last Words)," YouTube video, posted by FUC, July 9, 2020.

public places or that the enormous earnings gap between degree holders and those with less education continues to widen, and rankly allying with Republican efforts to tar higher education as an elite playground. Ecological theorist Andreas Malm decries this indistinction for the incapacity it begets; the point of such flattening is "to ruin as much analytic equipment as possible."[51] A vision that paints every human formation since the beginning of Western inscription with the same condemnatory brush can have as its only outcome the aggrandizing of the critic. In perpetrating these indistinctions, criticism forswears its task of cutting, instead rhapsodizing dismantling when it could be honing the mantle of emancipatory structuration. Such theologies of the negative foreshadow and refract activist practice in the present omnicrisis, where insurgencies repudiate value assertions, anarchic rhizomes reject organization, apathetic floods refuse voting, and visions of total destruction decline positive constructions.

In unhistorical dematerialized nihilism, horrors of the present are chained to horrors of the past in continuous current, overflowing the record of struggle for freedom and of contingent events with the oceans of domination. The identity of past and present ("It has always been this way") poses to capture the essence of the social order in its unchanging stone, a revelation of truth that endures unscathed. Similarly does the disposition away from change and toward essence involve a frequent ontologization of contingent social processes, so that "racialization" becomes "ontological anti-Blackness" and "patriarchy" becomes "the logic of misogyny."[52] There are frequently spiritual or theological overtones to these epics of "original sin," and their rhetorical and epistemological effect, as historian Matt Karp and

51 Malm, *Progress of This Storm*, 186.

52 Kate Manne, *Down Girl: The Logic of Misogyny* (Oxford: Oxford University Press, 2018).

others have observed, is the keenness of immutability.[53] By the light of the category of immediacy, we can see how this eternity of immanence, this ineluctable total everythingness, mirrors the motifs of timeless instantaneity and frictionless flow that organize the culture of circulation.

The appeal of these "poetheories" and nihilisms is undeniable, and inarguability is baked into their ethos. Therefore, it is crucial to appreciate the critiques and counterpositions offered by more materialist and dialectical thinkers of racialization, such as Angela Davis, Achille Mbembe, Olúfẹ́mi Táíwò, or Anthony Reed, who, in turn, find inspiration in the internationalist anti-imperialism of Frantz Fanon or Gayatri Spivak. Davis explicitly criticizes the "nationalism" and idealism of the paradigm of "anti-Blackness," because the "center on pain and injury . . . can create barriers to developing solidarity" and because "the importance of black people's histories in the Americas resides precisely in the fact that there has been an ongoing freedom struggle for many centuries, the centrality of black struggles is much more about freedom than it is about blackness."[54] Mbembe concurs that the "absolutization" operates in the realm of the ideal, reifying contingencies and eclipsing freedom and solidarity: "Afro-pessimism is also premised on the idea of a categorial antagonism that cannot be transcended." Drawing upon the work of Nigerian novelist Amos Tutuola, Mbembe argues for heterogeneity and contradiction as the contrasts to absolutism and nihilism:

> The most efficient logic of action is not flight and escape or fugitivity (but) clearing the pathways of composition. This is not about fugitivity; it is about the capacity to assemble and compose . . . it is a different way of inhabitation of the

53 Matthew Karp, "History as End," *Harper's Magazine*, July 2021, harpers.org.
54 Angela Davis, Gayatri Chakravorty Spivak, and Nikita Dhawan, "Planetary Utopias with Angela Davis, Gayatri Chakravorty Spivak and Nikita Dhawan," *Sexuality Policy Watch*, November 4, 2019, sxpolitics.org.

world . . . Freedom consists in the full inhabitation of the world, an embrace of its contradictions.[55]

Táíwò, in stark contrast to Yusoff's demolition, takes the concept of the Anthropocene as an opportunity to advocate for "constructive" reparations: since "the connection between climate crisis, slavery, and colonialism flows from distributions of wealth and vulnerability created by centuries of global politics and its ecological consequences, layered with more recent histories of pollution in the Global North and corporate fossil fuel interests," it is necessary for there to be centralized restitution that anticipates future suffering.[56] Reed powerfully argues that "the turn to theorizing (anti)Blackness as ontology, and the (re)turn to theorizing the inner life/subjective experience are two sides of one anticollective ultimately anti-utopian coin."[57] The obverse of immediacy's immutability and spiritualization is this embrace of construction, contradiction, contingency—of struggle and solidarity. Mediations are many-textured compositions that sustain inconsistencies and de-complete or de-immanentize, holding open the possibilities of practical connection in and through action to build.

The magnetism of immediacy theory, however, can repose in closing these possibilities. If nothing is changeable, if solidarity fails, if it is too late, the obligation to act dissipates. In its place arise valiant theories of the undesirability of action itself, along with entire lexicons for recriminating the instrumentalism and compromise of politics, and recasting politics as ontologization. An eloquent idiolect of this resignation is "antipolitics," a "beyond of politics" in which alterity and

55 Achille Mbembe and David Theo Goldberg, "In Conversation: Achille Mbembe and David Theo Goldberg on 'Critique of Black Reason,'" *Theory, Culture and Society*, March 7, 2018, theoryculturesociety.org.

56 Olúfẹ́mi Táíwò, "The Fight for Reparations Cannot Ignore Climate Change," *Boston Review*, January 10, 2022, bostonreview.net.

57 Anthony Reed, "The Black Situation: Notes on Black Critical Theory Now," *American Literary History* 34:1 (April 2022), 286.

negation disrupt and undo the ordinary order of things, including its ordinary prescriptions for organization and struggle.[58] Theory perpetually relativizes itself vis-à-vis practice and has historically wrestled with the problem of immediacy in questions about the imminence of revolution, the immanence of the general will, spontaneity, and party-planning—a swath of thinkers from Thomas Hobbes and Gustave Le Bon to Bruno Bauer and Karl Marx, from Sigmund Freud to Rosa Luxemburg and Vladimir Lenin, from Angela Davis to Michael Hardt and Antonio Negri, have recurrently asked whether the mass or class is identical to itself and on a trajectory of becoming conscious of itself, what intellectuals do to facilitate or impede mass action, and whether political theory is inherently descriptive and belated, or possibly projective and electrifying. But now, in the present theoretical landscape, the questions seem decided and the match seems won; antipolitics renounces the mediation of organization, antitheory renounces the mediation of theory, and immediacy autonomizes.

Assessing not only the known world but also available paths out of it as "inherently unfixable and beyond resuscitation, reform, or rescue" (as one self-proclaimed "insurgent" journal declares), contemporary antipolitics absolutizes a transhistorical, dematerialized ether of abjection while infinitely dispersing resistances that thwart amalgamation.[59] While an "anarchist sublime" has long piqued theory-savvy politics, in its latest iterations the algorithmic imprint is undeniable: again, that pattern of infinitization paired with a succession of singularities.[60] Immanence

58 An important twenty-first-century formulation of the terrain of antipolitics arises in Jacques Rancière, "Ten Theses on Politics" *Theory and Event* 5:3 (2001). "The beyond of politics" comes from Fred Moten and Stefano Harney, "The University and the Undercommons: Seven Theses," *Social Text* 22:2 (Summer 2004), 105.

59 "Burn It Down: Abolition, Insurgent Political Practice, and the Destruction of Decency," *Abolition: A Journal of Insurgent Politics*, April 22, 2018, abolition-journal.org.

60 Timothy Brennan so denominates the ideology of "fleeing, as so many left intellectuals did in those years (late 1970s and early 1980s) any politics seeking to

evacuates politics: "Power is no longer concentrated in one point in the world; it is the world itself, its flows and avenues," the Invisible Committee intones, and thus any action expedites flow.[61] Philosopher Roberto Esposito outlines the restless negativity of antipolitics vis-à-vis official exercises of power with his notion of the "impolitical": "Politics cannot be conceptualized in positive form but only on the basis of that which draws its contours at its outer margin and which determines it negatively, constituting both its ground and its reverse side."[62] Negativity as end in itself animates gender theorist Jack Halberstam's "anti-political project of unmaking."[63] And, most influentially, Harney and Moten conceive flight from collective power as "fugitivity":

> We owe it to each other to falsify the institution, to make politics incorrect, to give the lie to our own determination. We owe each other the indeterminate. We owe each other everything. An abdication of political responsibility? OK. Whatever. We're just anti-politically romantic about actually existing social life. We aren't responsible for politics. We are the general antagonism to politics looming outside every attempt to politicize, every imposition of self-governance, every sovereign decision and its degraded miniature, every emergent state and home sweet home.[64]

Immediacy style's liquidation of determination, its flows and dissolutionisms, leave readers awash in the circulatory system,

enter or make claims on the state." Timothy Brennan, *Wars of Position* (New York: Columbia University Press, 2006), 10.

61 The Invisible Committee, *The Coming Insurrection* (Cambridge, MA: Semiotext(e), 2009), 131.

62 Quoted in Bruno Bosteels, *The Actuality of Communism* (London: Verso, 2011), 79.

63 Jack Halberstam, "Unbuilding Gender," *Places*, October 2018, placesjournal.org.

64 Stefano Harney and Fred Moten, *The Undercommons: Fugitive Planning and Black Study* (New York: Minor Compositions, 2013), 20.

whose historic overweighting in the present precipitates the surging motif of exudent blur.

Antipolitics could hardly be more explicit, but the immediatizing impulsion of this arc of contemporary theorization is perhaps most stark in the recent developments of high-profile communization theory. Mediation signals, for such theorists, not only theory's deluded remove from experience, nor only generality's oppressive effacement of identity, but the capitalist dispensation itself, with immediacy its sanctified annulment:

> To speak of immediacy, with respect to the revolution, is merely a shorthand for the fact that the revolution abolishes the mediations of the modern world . . . the revolution cannot be a matter of finding new ways to mediate relations.[65]

The anonymous theory collective Endnotes forgoes any figurations of communization, apart from their repeated underscoring of "undoing" and ascription of the movement as immanent to capitalism itself: "If communization is presenting itself currently, it is in the palpable sense of an impasse in the dynamic of the class relation."[66] In claiming that "there can be no fixed theory of struggle . . . there can only be a phenomenology of the experience of revolt," Endnotes propounds "spontaneity" and phenomenological connection as embedded antidotes to distanced conceptualization.[67] Theories in this vein trumpet the "exhaustion of existing forms of organization that have tried to lead, dictate, or pre-empt struggles," critic Benjamin Noys summarizes, and they also resist specification or formalization, since struggles "contest(s) the tendency to affirm or adopt an alternative

65 "Spontaneity, Mediation, Rupture," *Endnotes* 3 (September 2013), endnotes.org.uk.

66 Endnotes, "What Are We to Do?," in *Communization and Its Discontents: Contestation, Critique, and Contemporary Struggles*, ed. Benjamin Noys (New York: Minor Compositions, 2011), 38.

67 "Spontaneity, Mediation, Rupture."

counter-identity (worker, militant, anarchist, activist, etc.)," and indeed assert that it is possible to "begin enacting communism now, within capitalism."[68] Théorie Communiste, a different anonymous group, also echoes these immediatist overtones in insisting that there is an instantaneity of communist struggle:

> The revolution is communization; it does not have communism as a project and result, but as its very content ... this is not a period of transition, it is the revolution: communization is only the communist production of communism ... capitalism is not abolished *for* communism but *through* communism.[69]

Philosopher Alberto Toscano helpfully diagnoses this immediatism in noting the reflexive antipolitics of "staking a claim to communism but refusing the politics of transition."[70] Enunciating revolutionary theory as the demarcation of the present's distance from the past (the old forms of mediated organizing don't apply) but, simultaneously, as the melting of the present's distance from the future (communism is not a project but a way of being in the moment), communization theory, Noys notes, "insists on immediacy." Against the mediations of argument and the mediacy of capitalist relations, against transition and antipolitics, immersive phenomenology and insurgent effusion arouse immediacy theory today.

68 Benjamin Noys, "The Fabric of Struggles," in Noys, *Communization and Its Discontents*, 14, 8.

69 Théorie Communiste, "Communization in the Present Tense," in Noys, *Communization and Its Discontents*, 58.

70 Alberto Toscano, "Now and Never," in Noys, *Communization and Its Discontents*, 90.

syntheses against immediacy

If critical theory lacquers itself to contemporary cultural style, declining anything beyond immediacy, whither generative projects? Theorists of cultural production—of ideas and images, of figuration and language—should be some of the people the very most qualified to make knowledge: ideas for living, speculations as to the possible, visions to hold in common. But lately, we have smeared argumentation as tyranny and decried the hubris of convoking collectivity, mounting our work instead as emanating and entangling. Naming and historicizing these habits, this book does depart. What comes after burning it all down, after indeterminacy and vibrant matter in the embers? Can't ideas animate us? Should not theory risk synthesis? Endorsing mediacy against immediacy is a proscribed move— but the wager of this chapter and of this book has been that theory and aesthetic production must be impelled by their own essential and definitive promise of *departure*: theory moves away from mere context, speculatively moving beyond reflexive cognition, propulsively moving against the merely extant; art and literature generate more than what is already given, speculatively proposing other worlds, other words, propulsively suspending ordinary ratiocination.

Theory negating mediation performs immediacy rather than interpreting it. Interpretation mediates by encountering phenomena and putting them into medium, like an articulated category that connects them to other phenomena or a historical narrative that helps explain how they came to appear. Interpretation of a dialectical sort pays attention to contradictions and negations, including the openings for thought to negate the circumstances of its own emergence, as well as the contradictory relations dissembled by that which solely appears. Dialectics attune to what is not immediate—to what a perceiving self doesn't first see

about itself, to what is contingent, to what is on the move, to what does not dawn. Immediacy style's reification of what merely appears, by contrast, stamps out contradiction. What you see is what you get. However much this self-identical manifestiveness feels warranted in these times, its voiding of contradiction eliminates the gap by which theory distinguishes between the actual and the possible. Without this gap, there can be no projects, no synthesis. Nothing other than the too late.

Theory must not guilelessly reproduce and reify what is immediately given; it must beguilingly bring into thinkability and perceptibility that which is not given. It is one thing for the dominant culture of a moment to fail the bar of immanent critique, reveling rather than revelatory—but it hits worse when theory also fails, and worst of all when that failure is celebrated. If there is a whiff of party-pooping in analyzing the form and content of immediacy theory today, this is only to recenter the contradiction between immediacy and theory. The construction of theory again as the metalevel seeing of how we see requires perceiving theory's own conjunction with the ruling ideas and class rule, while nonetheless activating the dialectic through which that conjunction can also host the coherent, synthetic demand for that rule's end. Theory can do more than fecundate immediacy, quicksanding all acts of knowing into the immanent blur. It can mediate us out of this place.

Conclusion

Never more than an arm's length away. Intimate, instant, improvised, the essential approach of the twenty-first century's signature art genre: the selfie. Paramount immediacy premiums like flash connection and intense charge converge in this every-man form perfected by topflight glitterati. Its genius-queen is Kim Kardashian, an image vendeuse whose marquee art press book *Selfish* formalized the casual mode for the Z Gallerie coffee-table set. On 448 glossy pages weighing 2.09 pounds, selling out numerous Rizzoli print runs in 2015, Kardashian purveys her face, her eyes, her cleavage, and, most famously, her butt, through a patented posture of nigh-impossible torque that also delivers face and "sideboob." Few words distract from the images, and those that do are only intermittent phrases, vapid and redundant: "So many memories." "I love that I took this."

Consume the objectified guilt-free, because this canny artist owns her curves, and she's letting you look, in case you didn't get who was in charge from the knowingness of the title's pseudoirony. Behold the belle unillusioned, as the maestro honestly acknowledges the labor of maquillage experts, preempting disdain of contrivance. Numerous #NoMakeup #NoFilter images also affix the collection's interest in exposure that aggrandizes; there's simply no avenue by which the spectator can resist the magnet of truth and beauty. Fixed to the gloss, scrolling the monotonous abundance, privy to self-deprecating disclosure, numbly engrossed in the sheer effusion of images without momentum, we unite with the bare spectacle as well as with the

aspirational art: anyone can be highly personal with Kim, and anyone can self-publish their own *Selfish*.

As the first book of selfies—what one critic deemed "a new kind of autobiography," while another called it "a nail in the coffin for artistic photography"—*Selfish* puts pressure on the medium of photography and of the artbook, as well as on art criticism: it is everything, to everybody, and nobody can dress it down because it has already called itself selfish.[1] The nature of the selfie as genre strips the medium of photography: its perspective can only ever be close; its framing can only ever be distorted by the conventional wide-angle phone lens and off-centering; its subject and artist collapse into one; its content a face, perhaps an ass; its composition pasted to Kim's four-rule formula ("Hold your phone high; know your angle; know your lighting; and no duckface!"). The book as a conceit performs ironic disdain for art, while its contents empty out aesthetic distinction: its images familiarly reel (the majority had attracted literally millions of likes on Kardashian's Instagram before any book deal); there is nothing new to see here, just a repackaging of what has already been seen so often that its fame consists only in being famous. Sexual titillation is little match for deadening agglomeration. In these fullnesses without discrimination, in cheeks without contrast, in the blur of all flesh, in the burlesque mordancy melding pure profit motive to winking exposé of misogynist image obsession, *Selfish* snapshots the genre of our time in all its immediatizing immersion.

Radically more than an arm's length away, the extreme vantage that has become the signature of Canadian gold miner and factory-worker-turned-artist Edward Burtynsky obverts the myriad reductions of photography in Kardashian's successful, compelling antiart. In five-by-eight-foot high-gloss "manufactured landscapes" that almost never depict human subjects, at

1 Jonathan Jones, "Kim Kardashian's *Selfish*," *Guardian*, May 5, 2015, theguardian.com.

a supersize utterly resistant to iPhone circulation—the opposite of selfies in every dimension—Burtynsky's works study systems and industries like oil drilling, automobile superhighways, copper mining, and waste processing, striving to encompass the banal infrastructure of catastrophic slow violence. Where selfie machines are in everyone's pocket, the tech substrate of Burtynsky's art is rarer: helicopters, drones, the industrial sites themselves, photo-paper writers rather than enlargers. While selfies frequently look directly into the camera, positioning the spectator to hold the subject's gaze, panoramas often cannot direct the spectator's focus: there is so much land and nowhere to land; it's impossible to know your angle. Selfies exude the authentic charisma of their agent's presence, but these scapes expose the produced presence of even nature itself, man-made industrial strength. The destruction in production is their theme, and the problem of perspective adequate to such a dialectic propels their form, from allusions to Jackson Pollock and Paul Klee to $7,200-an-hour helicopter costs to unprecedented print size. Critics constantly label these immensities "sublime," though that's surely misappraisal: they are highly composed and highly studied, making pattern and order their subjects, always evoking the underlying logic of capitalist extraction in its all-too-cognizable concretude. And they are beautiful: pleasurably coordinating the sensuous appreciation of daring construction, of all that could be built if we dared toward more. Immediacy stylizes the spirit of circulation in instantaneity and realness, but Burtynsky's works mediate the supply chains and resource development that materialize the platforms of the circulation economy. As he himself notes, "In our ephemeral information age, people think we've left behind the stone, bronze and iron ages . . . But they're all still going on—we use tonnes of this stuff every day. You just have to look."[2] His looking therefore encompasses

2 Oliver Wainwright, "Edward Burtynsky on His Ravaged Earth Shots: 'We've Reached Peak Everything,'" *Guardian*, September 15, 2015, theguardian.com.

projects like *Quarries*, *Mines*, *Oil*, and more, relaminating the culture of on-demand flow to the pits of its engineered waste, while hypothesizing that all this terraforming could work for different ends.

A concrete body of personal pizzazz in an authentic situation. A material network in a bustling system at a real site. *Selfish* offers closeness, a whole art book composed of repeating saturative close-up in our habitual corporeal range. Distance, on the contrary, zooms out from ordinary phenomenal perception and banal experience, to levels only possible in the imagination and with advanced tech. We don't—most of us—get to perceptually encounter the orbit of human degradation of the earth or capitalist extraction of resources; we don't see from on high afar. Burtynsky's large formats and sweeping perspectives tender us something more than ourselves, and something other than one-to-one correspondence. Selfies, as Kardashian makes them, are wholes unto themselves, deep gaze, lush corporeality without background, on-demand immediacy. Scapes as Burtynsky makes them are enormous and complex, but unwhole—magnitude deployed to decomplete, immensity that relativizes itself with the allusion to all that is unimaged and unimagined. Glimpsing the order of industry or energy or labor, making patterns perceptible, Burtynsky's images activate the symbolic, the realm of the social and the systematic. They use the image not to mirror but to precipitate otherness, inviting us to traverse obscure zones and to construct for the good. Mediation depends upon this thirdness beyond body and the image, the medium of interaction without prescribed outcomes, relation without guarantees.

Immediacy, or, The Style of Too Late Capitalism opened with the contemporary artworld's vitiation of medium in immersive spectacle, engaged practice, and nonfungibility, and it concludes with this contrast between two recent corpuses of photography to refocus on the capacity of the mere image for avowing rather than negating its own mediations. The extreme opposition of Kardashian cleavage and Burtynsky chasms is itself an act

of frictive intercession, an acknowledgment of drag amid the flow of hegemonic style. The very point of proposing a totalizing category like immediacy is to delimit the dominant formation so that alternatives come into the light. Mediation shadows this book as the negative space of immediacy's disallowed and disavowed, the outmoded and the uncool. Crushing mediation into direct messaging, authentic affect, and emanative intensity seems like a savvy choice in devastatingly urgent times: everything is a burning catastrophe; there's no time for art; magnetize connection with confession and exposure, right quick! But since this logic of getting down to business fuses to the circulatory imperatives of disintermediation—the very tendencies which have accelerated ecocide and immiseration—there must be other sources for aesthetic value in our time. Imaginative indirectness, speculative adumbration, collective collocation, and extraordinary, counterintuitive ideas are also tools for survival.

Culture is dialectical: everyday practices and conventional meaning secure existing relations of production in place, superglue for what sucks—yet, everyday practices also bear out efforts of everyday people to improve the conditions in which they live, imparting the knowledge that social life is fabricated and could be differently so; it doesn't have to be this way. In artworks and aesthetic cultural production like literature or TV, formal composition discloses this fabrication. Sometimes the dialectic animates individual works, and sometimes it rustles in the contrast of dominant styles with emergent or residual alternative tendencies. The style of immediacy often stamps out this possibility of the dialectic intrinsic to individual artworks, but in cultural production as a whole, this hegemonic movement nonetheless abuts some countertendencies.

To schematize those possibilities, let's try "scale," "impersonality," and "hold"—respectively in tension with the premiums on immanence, presence, and flow we have seen to dominate recent aesthetic output. Scale extrapolates that which is readily present into relation with something of a different order, transcending

the concretude of the body and the individual for an alternate level.[3] Impersonality acknowledges conflicts and seeks possible middle grounds, deflecting the absorptions of auto-emanative charisma with a collectivizing, dislocated perspective—one which needn't be as exclusive as helicopter cameras, since fictional omniscience and theoretical abstraction cost but little. Hold clogs circulation, keeping some reserve from exchange, or slowing down processing, or impeding flow, making palpable the work of relation.

Scale, impersonality, hold: these are some minimal contours of mediations that merit a new day in the sun. For enhancing circulation, immediacy stylizes essences that automanifest, language that concretizes, images that denude, streams that surge, and dissolutionisms that blur. The ensuing continuities, intensities, and expresses cradle the allure of that style. By contrast, a style of a different sort, less bent on negating mediation, would offer production that must be undertaken, possibilities that require relay, discontinuities in coordination, long- rather than short-cuts when adumbration and even artifice better suit the matter, order processing without same-day-delivery guarantee. In quest of that other style, this mediation against immediacy, this book synthesizes at saucy scale, speaks impersonally without "I," and composes prose that holds off intuition and holds out interpretation. Beyond this object lesson, this conclusion showcases some peripheral twenty-first-century cultural production that pursues mediation against the immediacy dominant. Residual, emergent, extra.

"Writing" took up literature and the field of letters as prime indicators of the contemporary undoing of representation.

3 Of these three terms, "scale" has been an object of inquiry in some recent critical work. See, for example, James English and Ted Underwood, "Shifting Scales between Literature and Social Science," *Modern Language Quarterly* 77:3 (2016), 277–95; Caroline Levine, "The Enormity Effect," *Genre* 50:1 (2017), 59–75; Deborah Coen, *Climate in Motion* (Chicago: University of Chicago Press, 2018); Benjamin Morgan, "Scale in *Tess* in Scale," *Novel* 52:1 (2019), 44–63.

Fiction composed in the third person (as it has been for the majority of the history of the novel) makes a kind of thinking that individuals do not experience in their everyday lives: parallel access to other people's minds; structures of other times, other places, other sensibilities; and integrated generalities or convoked commons. Free indirect discourse, a marvelous affordance of language only available in written form, mixes perspectives of characters with narrators with implied readers and hypostasized social consensus; it is a type of mediation of ideas that always raises the question, as Roland Barthes and others have observed, "Who is speaking?"[4] Unattributed words and ideas belong to no one and therefore to a kind of everyone— that's what makes them free. Collective intellection of this type is one of fiction's magical properties. A capacity to represent ideas that exceed persons, to evoke signifiers, to construct generality in contrast to the manifested personal. For immediacy writing, as we have espied in so many instances, there's a voice and nothing more, an infinite succession of ones; your story is something to own; now it is your turn. For literary mediation, the unanswerable question "Who is speaking?" extrudes beyond proprietary subjectivity or charismatic voice to a wide-eyed, roving, unlived experience. Each of us are finite, but that doesn't mean legitimate massings can only grope after infinity, under the sign of algorithmic theology; a collectivity that avows its own structuring remains finite while transcending the register of the one.

Free indirect discourse and its requisite omniscience construct disembodied, impersonal, impossible perspectives that radically depart from our phenomenal, embodied, banal experience. The immediacy style of autofiction and anti-representation directly

4 To develop this account of freedom, objectivity, and impersonality in free indirect discourse, please see Anna Kornbluh, "Freeing Impersonality: The Objective Subject in Psychoanalysis and *Sense & Sensibility*," in *Knots: Post-Lacanian Psychoanalysis, Literature and Film*, ed. Jean Michel Rabate (London: Routledge, 2020), 35–54.

repudiates this constructive departure, historically demarcating the twenty-first-century novel. Immediacy deletes fictionality: everything is real, everything is uncut, "fictional writing has no value." Pronouns: "I," "me," "mine." It thus negatively imprints the capacities of fiction we can contrarily esteem: holding impersonality at scale, pronouns "who," "they," "we." A wild imagining of nonhabitual, extraordinary cognition. A daring conjuring of provisional collectives. A speculative making of more than is already here. There is nothing given. None of us get to think in the third person. If we want to know what other people think, we have to ask them, and fantasize and project, and misunderstand. If we want to know about places and times we've never been, we have to research and read and interpret. Connection is a process. Fiction's divergence from the immediate operates that process in its making. Antifictions in the now insist that there's no time for art, no budget for inauthenticity, no capacity for possibility—and at their very most compelling they sell this diminution as strategy for life in the futureless hellscape: it's too late for mediation. Here's a starkness otherwise: without thick representation, mental exertion, and symbolic functions, we doom our common efforts to intervene.

The ferocity of antifictionality and fervor of personalism in the contemporary literary field bring into relief the genuinely conspicuous commitment to objective narration in the work of a few contemporary Black writers who have enjoyed acclaim that underscores Black themes, but that often underattends to their marginal form. Colson Whitehead, Brandon Taylor, and Diana Evans produce free indirect discourse to evoke ideas beyond the personal, capable of historical and institutional and ideological expanse, and all three do so in conjunction with finely figurative social realism rather dissimilar to the empiricist realisms we canvassed in "Writing" and "Antitheory."

Whitehead's entire outstanding oeuvre to date consists of eight novels, not one of which is told in the first person. Most

of the novels are conspicuously historical fiction ranging over the nineteenth century, the 1950s and '60s, and the 1980s—*The Nickel Boys, Harlem Shuffle, John Henry Days, The Underground Railroad, The Intuitionist, Sag Harbor*—that unseat the presentism of autofictions while strategically threading resonances and continuities between various pasts (industrial, infrastructural, institutional) and the present of systemic inequality. At stake in these novels is the importance of long narrative as such, which must be deliberately composed. Experience is neither immanent to itself nor evident to itself, and its determinants can only be conceptualized in weaving connections rather than presuming evanescence. This objective narration visits settings in the past, crafts Black characters in the round accorded by that penetrating and contextualizing omniscience, and plots psychic depth on the axis of social breadth, in realist signature. Lush details and lurid textures ferried in lyrical, figurative prose confound rapid reading and problematize superficial vision. What is to be known takes time—historical time but also reflective time, mediating meditation. In turn the quality of that knowing tends toward the accretive and collectivizing, integrating historical expanse and capacitating commonalities with free indirect discourse. A present tense of generalizing observations links the stylized past settings to the all-too-burning contemporary of reading; as *Harlem Shuffle* puts it explicitly, of the 1960s and so also of 2020: "With the riots, what was the point? Everything keeps on the way it is, so all the protests were for nothing."[5] But this pessimism soon finds a riposte in the collective projects formalized by free indirect discourse, uniting the protagonist's suffering to the broader world:

At times it seemed the grief was powerful enough to shut down the world, cut off the juice, stop the earth from spinning. It was not. The world proceeded in its mealy fashion, the

5 Colson Whitehead, *Harlem Shuffle* (New York: Doubleday, 2021), 306.

lights stayed on, the earth continued to spin and its seasons ravaged and renewed in turn.[6]

Over its course, the plot links a Black furniture salesman to white real estate developers, with jewel heists and car details recurring; so many solidities of the officially crooked economy. These temporal and perspectival and plotted forms of connectivity cradle the motifs that require interpretative work to interanimate. Here is a long sequence in which the setting sparks musings on the lives of others in political and economic context:

The Big Apple Diner faced a row of four-story brownstones that had been built by the same developer at the end of the previous century. Identical doglegged stoops, leaf brackets and keystones, wood cornices, one after the other from one corner to the next. From across the street, the houses had distinguished themselves from one another over time through the plantings out front, the decorations behind the front-door glass, and window treatments—the accumulated decisions of the residents and modifications by the owners. One misguided soul had painted one of the exteriors a mealy peach color and now it stuck out, the rotten one in the barrel. A single blue-print—funded by speculators, executed by immigrant construction gangs—had summoned this divergent bounty.

Carney imagined beyond the facades; he was looking for something. Inside, the brownstones had remained one-family homes, or been cut up into individual apartments, and their rooms were marked by different choices in terms of furniture, paint color, what had been thrown on the walls, function. Then there were the invisible marks left by the lives within, those durable hauntings. In this room, the oldest son was born on a lumpy canopy bed by the window; in that parlor the old bachelor had proposed to his mail-order bride; here the third

6 Ibid., 311

floor had been the stage, variously, for slow-to-boil divorces and suicide schemes and suicide attempts.[7]

These lines bolt perceptions of the built form to speculations on lives unlived, the repetition of suicide to the bounty of materials. The book asks us to shuffle between exterior and interior, past and present, Harlem then and Harlem now, the hole in the ground as the World Trade Center construction commenced and the void where it stood. The seemingly static details of setting become the vehicles of history in motion, but these connections demand the work of fastening their leaf brackets and keystones. Nothing is self-evident; metaphors don't autoactualize. In this work of figuring, reading, interpreting, the immanent presence of immediacy time is nicked and the inundant identity of immediacy meaning is intercepted.

Setting, architecture, urban texture: the social space of sentiment, the infrastructure of intimacy that does not individuate charismatic singletons so much as illustrate common ties—this is a faculty of fiction Whitehead shares with Diana Evans, whose *Ordinary People* makes apparently concrete references that transmute into figures of social determination, helping to abstractly intimate broad social relations. The Crystal Palace first occurs as an ordinary geographic detail, but, in the course of the narration, the book de-realizes this figure. Plasticizing the signifier "crystal palace" into both imperial jubilee and diasporic despair, the architecture of the past and the infrastructure of the present, the novel is able to evoke a *longue durée* of historical sociality that contextualizes the domestic scenes it relays. Its first sentence tempers that evidently intimate phenomenality with the length of epochs and the weight of the great exhibition: "To celebrate Obama's election, the Wiley brothers threw a party at their house in Crystal Palace."[8] As such, the text starts with bodies in

7 Ibid., 123.
8 Diana Evans, *Ordinary People* (New York: Liveright, 2018), 1.

motion in the strong, palpable present of a vibrant London neighborhood, but it quickly activates a semantic multiplicity to excise that immediacy with historical structuration. Among the party attendees are two couples; young, middle class, Black; a social volume of four different focalizations; six different pairs; many flavors of banal distress. The narration follows the couples home, where the palace remains in view. As the intricacies of the marital relations spool, long excurses on the central figure ensure that ordinary setting is defamiliarized as extraordinary social structuration coordinating ordinary people:

> No matter where you were . . . it was possible to see the Crystal Palace tower, soaring over the landscape, appearing and disappearing between the buildings . . . a reminder of that long-ago glass kingdom, which was rebuilt on the south side of the Thames after its arduous horse-drawn journey.[9]

The tower is thus positioned as the inverse panopticon of perpetual London, a derealized physics that also disavows the technicalities of historical time. Visible from the bedroom window, the palace illuminates one of the couples in their post-party aborted tryst:

> Passion, at its truest and most fierce, does not liaise with toothpaste. It does not wait around for toning and exfoliation . . . No, there would be no love tonight . . . From the wide stretch of land at the top of Westwood Hill, the Crystal tower loomed and shone red . . . The palace was no longer standing. It had burnt to the ground in 1936, after a long and steady decline.[10]

And that is the end of the first chapter, circling back to where the first sentence began, but in the dematerialization of that referent,

9 Ibid., 10.
10 Ibid., 157.

in the shimmering metaphorization of its glass concretion. Acknowledging that the palace itself burned in 1936, but not acknowledging its figurative transposition of "tower" from the original palace towers, demolished in 1941 to remove a landmark for war pilots, to the television transmitter tower that is currently the fourth-tallest structure in London, the narration erects a continuous structuration of intimacy by imperialism, of privacy by the state, of personality by mediation. In so doing, the derealized figure partakes in the great realist tradition of dislocating and defamiliarizing existing spaces—think Thomas Hardy's Wessex, T. S. Eliot's provinces, Anthony Trollope's Barsetshire— taking London and anchoring it with an omnivisible tower, a prism for the global totalities concentrated in and determining the local affects. Antiphenomenal narration recurs continuously to lengthy descriptions of the palace materials, palace history, and palace spectacles, excising the personal and immediate concretude of embodied experience. At the same time, the novel accrues manifold reflections to the recurrent image of the palace by working through everyday life, cooking and cleaning, child-care and career, celebrations and tears by its lights. Through this motile figure and systematic gaze, through this deliberate omni-science and taste for Hegelian determination, realism works here as the warp and woof of abstract synthesis.

Brandon Taylor's *Real Life* tells a story of intimacy in institu-tions—of a young, poor, queer Black man's new and tumultuous sexual relationship with a PhD cohort-mate turned lover—but it does not tell this story intimately. Rather, it uses third-person perspective to impersonalize vivid yens and acute pain, it uses narrative ellipsis to abstract away from crescendos of inter-personal conflict or personal suffering, and it evokes a scientist's study of particulate matter and sensuous data, an objective microscopy of smells and birds, weather, and wasps. The novel also constructs a staggeringly lyrical, metaphorical, figurative linguistic texture, an intricacy that beautifully confounds expres-sivism and refuses prosaic immersion. Sentence by sentence, the

reader is not asked to identify one to one with the emanating individual on the page, but to conceptualize the interlocking social forces that contour the story and systematize individuals. One of the avenues of this request is the precept of figuration, which compounds meaning across thematic levels: images of birds flit from the very first paragraph ("Overhead, gulls drifted easy as anything") to the penultimate scene, in which the protagonist invites his new lover to the roof of his apartment building ("When I feel like everything is closing in, I go to the roof of my building . . . the sense of inverted scope, so high above the world, where everything flattens and becomes smaller. So high up—birdlike—that Wallace feels as if he is floating"), vitrifying objects of biological research to devices of novelistic point of view, freedom to fragility, in lustrous layer.[11] Birds wing through the novel as dialectical figures of "real life," now scope-empowered, now treacherously out on a limb:

> There were birds that had been thrown from their nests, skin translucent and blue like fresh ice from a vending machine, their pink mouths flung wide. Delicate little clothes of skin and feather, bones so light that in another life they might have floated away into the sky, riding on currents of warm air, but now splashed in mud and being disassembled by ants.[12]

Economic inequalities, academic hierarchies, empiricist epistemes, and individualized perception become thinkable in the third person, that bird mode which constitutively defies the immediately observable. Conceptual vectors of queerness, race, class, and the mobility truths and lies of the university thwart any effort to congeal this story as the private magnetism of an isolated sufferer; the entrenched habit of correlating Black art to Black artists' biographies is similarly destabilized by *Real Life*'s

11 Brandon Taylor, *Real Life* (New York: Riverhead Books, 2020), 3, 318.
12 Ibid., 196.

refusal to personalize. From its title to its campus novel mantle, from its systematic free indirect discourse to its concluding summit in bird's eye perspective, this is a book concerned to purvey genericness and uncommon commonality—even if its biggest formulation of that collective is shared incredulity toward the attainability, representability, or desirability of "real life."

Fictional consciousness, a volume outside of embodied knowledge, has an analogue in the mediating, sweeping, disidentificatory point of view possible in televisuality (albeit voided in most contemporary streaming content). In "Video," we saw the moving-image arts of immediacy prioritize the stream: colonoscopy cinematography, fluid nongenre, looping nonplot, intimate confessions, and gushing irruptions. So, what are anti-stream aesthetics? Our opening opposition within art photography exposes some trajectories that the moving image camera also tracks: projecting out of the confessional perspective into cinematography that encompasses environments and collectives and manifold locales; defocusing the human subject in search of customer relations other than imaginary identification or specular desire; composing such breadth that the spectator stills, holding uncertain where to look or what to think. These principles, arguably, shape two recent shows that do not go with the flow of stream aesthetics: OWN's *Queen Sugar* and HBO's *Succession*. Both air on residual network schedules, both sidestep stream style's looping and surging to follow instead a deliberately old-fashioned, highly plotted ensemble realism, and both train their gaze, shot by shot, on the capitalist firm form.

Queen Sugar, created by film director Ava DuVernay and produced by Oprah Winfrey for her proprietary cable network OWN, eyes Louisiana as a dock of Black life in the United States, coordinating Los Angeles, Mississippi, and the I-10 corridor with heirloom plantations and the wild beauty of the free territory of New Orleans. Sugar is the commodity at the center, an 800-acre sugarcane farm in question when its freeholder dies, and the

business of milling and selling beyond the grunt of growing. Integration of industries metaphorizes racial incorporation but also economic monopolization: the Black family that tries to branch out to milling threatens the exploitative hold of the white mill over Black farmers; scaling up to get ahead.

Sugar is also a cipher commodity for the empire of capitalist modernity, from the triangle trade's extension of territory and production of race, to hyperconsumption (the average American intakes seventy-seven pounds per year) and public health crises, to the $4 billion in annual subsidies from the US government that make the country fifth in its global production.[13] Its reign as premise for the show coordinates all these vectors of economic production and solicits interpretation. Unlike the charismatic individual core of typical confessional streaming shows, many are the characters spun through *Queen Sugar*: a patriarch's three children, their own lovers and partners and children, their many social acquaintances and professional rivals and white antagonists in the bedroom, boardroom, and courtroom. Diversity of class status and professional location among a majority-Black cast creates a cross section of life rather than a niche. Within this diversity, from affluent L.A. to destitute LA, looms omnipresent police and surveillance, a consistent backdrop of extrajudicial violence and citizen protest inflecting the more domestic slights.

Focusing all this systematicity and expanse, the camerawork is conspicuously cinematic: lavish composition, arresting color, surprising marginal focal points (a tree, a glint of jewelry, a decaying shed), and sweeping establishing shots put the visual storytelling first. And the pacing is slow to match the sweltering humidity, achieving a calm at odds with the careening plots of TV made to be tweeted. *Queen Sugar* asks for distributed attention to different scales of oppression and different navigations of trauma, and for a contemplative eye on the quiet everyday. Six

13 Justin Walton, "The 5 Countries That Produce the Most Sugar," Investopedia, June 27, 2022, investopedia.com.

seasons deep and still going, its request has been granted. Realism articulates histories of social relations with intensities of intimate encounters, always posing the question of how the norm is its own extreme. In its committed production of connections across time, space, class, temperament, and industry, and in its multiple plots, sticky atmosphere, and creator's documentary mien, the show erects video that contrasts stream style with scale, impersonality, and hold.

HBO's *Succession* similarly spins a family business story, with even more possible heirs and side plots, and similarly blends scopic realism with cinematic camerawork. Impersonality lodges: not a single one of the characters stands as a point of identification; empathy is not the spectatorial mode. Indeed, "not a single one" is something of a formal principle for the show, which rarely shoots individuals in close-up, offers no protagonist, and most commonly stages scenes as large-group affairs—board meetings around desks, family gatherings around tables. The camera works to encompass so many centers of gravity, usually focusing on the spaces and even furniture of interrelation (couches, consoles, vehicles), with a prevalence of panning shots rather than cuts or reverse shots that would atomize the relations. The camera's mainly medium distance undermines the fluidities we have seen to define stream aesthetics (all the more distinctive because the show's creator, Jesse Armstrong, made his career with front-facing extremity in *Peep Show*). Frequent handheld equipment palpates the visual scope with sweeping movement, but there is no immanentization here; a partially removed perspective surveys the group as subject, polymorphous and unsolicitous, keying the spectator to the social structure of the firm form and the unstable alliances among lonely jesters.

Workplaces were the main milieu of prestige TV, and this holdover form mediates the company as the abiding structure, more important than any character or even any family tie, thus objectivating the publicly traded corporation and its impersonal shareholder accumulation. That the firm in question, Waystar

Royco, is a media company à la Fox but also enfolding news, entertainment, tourism, amusements, and real estate orients the show toward the business of mediation and the economic interests of industrial integration. Contrasting the sensationalist sensorium of the chyron, *Succession*'s composition prefers a persistent gray palette and unspectacular realist angles.

While the camera and plotting effectuate scale and impersonality, the moment-to-moment texture of the show achieves hold through dialogue that torques ordinary language 180 degrees, always igniting clichés and dislodging expectations, often inlaying puns and parapraxes: "I'm losing juice." "What-fucking-ever." "Little Lord Fuckleroy." "You know who drinks milk? Kittens and perverts." "That would be the straight-leg chino way of putting it." "I'm just really happy in my headspace." "Nothing is a line. Everything everywhere is always moving forever." Amid all these unpredictable pearls, stones stud the talking, clouding translucent meaning; entire scenes revolve around the halting and sliding of scarcely verbal utterances: "yeah," "uh," "yeah?" "uh?" "so," "yeah, yeah." The caliber of these tiny estrangements fires the shows humor; the thickening and obstructing of these language games accentuates mediation. What is more, the dialogue vehiculates a Shakespearean quality of highly plotted construction wrought by seasoned stage actors Brian Cox and Sarah Snook (along with veteran playwrights in the writers' room), the small boardroom/dining room/waiting room sets, suspending high television alongside the older medium of the theater. Rather than the dramedic goo of so much streaming content, *Succession* holds open the gap between its hilarious jousts and its terrific stabs.

Through its impersonality and scale, the show's great gambit is its underlining of what holds in place across acts: stasis is high. Over four seasons, there are various deals to acquire competitor media companies, from legacy Pulitzer outfits to startup streaming networks, which repeatedly fail, the integrations insufficient to the unstable circulation market. For three full seasons, billionaire patriarch Logan Roy never dethrones; no

successor unproblematically ascends; the form of the plutocratic firm maintains. In the final season, the equally plausible and equally implausible claims to power by the would-be successors and paths to partnerships with would-be acquirers or acquirees propel suspense while stabilizing the firm form. Money does not smell, and the rectilinear corporation, affixed by the medium-distance, midline-composed shots, presses on. No matter who's on top, business is business. For achieving this idea, the show invites different engagement than identification and crafts itself differently from expressivism: distantiation and form-thinking are its aesthetic principles. Immediacy absorbs and flows, but mediation rouses and lurches, ostentating medium, keying the arbitrary and formalized processes of successions.

In both of these shows, the camera's commitment to context and collectivity zips away from immediacy's intimacy and confessionalism, while the themes and settings center the changing fortunes of capitalist production and capitalist circulation. Kardashian is to Burtynsky as *Fleabag* is to *Queen Sugar*; skin and gaze parried by infrastructure and establishing swoops. The style of impersonal and scaled exploration of production remediates the manifestiveness, expressiveness, and emanativeness that artists of the self, confessional posers, and antifictional authors hock as authentic, showing instead how these desirable elements of present culture are conditioned by economic imperatives to circulate. Arts of mediation make apparent this relationship between media technology and capitalist valorization, just as they also interlace forms of relation like the family with the corporation, or romance with the police, or mentorship with patriarchy.

Photography, televisuality, and novels of this peripheral sort illustrate the richness of representation beyond expression, the liberations available via objectivity, publicness, and mediacy. Twinklings in contemporary theory also provide some fodder for sustaining this opposition between crushing mediation (the selfie as spontaneous, front-facing confession as vulnerable,

autofiction as authentic) and constructing it in collective and compositive truss. In studying the tendencies of autotheory and the algorithmically ordained topics of entanglement and immutability in "Antitheory," we registered the resignation of the mediating office of theory: no abstraction, no distance, no generalization, no future—no scale, no impersonality, no hold. Attacking mediation itself, these trends construe representation as alienation, imagining a real lost when the symbolic interjects. Any challenge to this pervasive antitheory in the present must therefore embrace the mediating function of the symbolic while committing to the work of construction beyond emanation.

Some trajectories in recent theory, broadly conceived, give grounds for hope here: conspicuously project-based theorizing, constructive philosophy, and categorical theorizing. Each of these initiatives enact theory as the production of concepts that capacitate action and still other productions. These energies of synthesis aim at something different than antitheory's expressivity and extremity; they aim at shifting registers, scaling knowledge, impersonalizing by objectivating from the immersion of affects back to the realm of the symbolic, and holding circulation at bay, prizing the slow or vertiginous making of new constructions.

Project-based theorizing is a practice-driven set of ideas rooted in the exigencies of omnicrisis but unrepentantly scaling up to the level of thought the situation demands and boldly formulating positive representations as spurs to action. A "should" activates a future-thinking, a break with the immanence of immediacy's present toward the well-being and flourishing of the majority. Works like *A Planet to Win* (Kate Aronoff, Alyssa Battistoni, Daniel Aldana Cohen, and Thea Riofrancos) and *Feminism for the 99%* (Cinzia Arruzza, Tithi Bhattacharya, and Nancy Fraser) and *How to Blow Up a Pipeline* (Andreas Malm) offer pragmatic policy white papers on what is to be done to address and ameliorate profound suffering and widespread inequality, including the uneven distribution of ecological threats.

In great contrast to the aggrandizing first-person singular that dominates the field of writing, these books wield the first-person plural and are often collaboratively authored: we know this much is true; we agree it would be better to do things differently. And the substantive content of that difference is affirmatively elaborated at length, operating at the general level: the masses of people and their social institutions, up to and including the state, must implement transformative solutions like decarbonization, universal care, and vibrant cities that prioritize people over profit, liberate sexuality, and combat racist imperialism with democratic internationalism. Big eyes conceived these big ideas, and a choral "we" intones them. And while they are enormous in scale—new paths for the state, the planet, the species—they are doable and essential. Provocations in these theories work not as invitations to masturbate with the material object of the book, not as incitements to individual intensities, but as exhortations to assent to collective visions and take collective responsibility. This is not the distributed interconnectedness of entanglement theory, promulgating the fancy that epistemic preferences will redress ecocide. It is, instead, the embrace of mass agency to expel the hyperconsuming majority and propel the state toward the uniform large-scale lines in the sand. Like: no more carbon dioxide, no more hyperconsumption, yes to the right to water, yes to the right to seek refuge. These are theories that begin from concrete, urgent problems, experienceable at the level of the body and affects, but which understand the trajectory of argumentation to pull away from that level. Theory articulates the local and global even as it disarticulates the thinkable from the merely perceptible—and it formulates novel ideas to inspire reasoned agreement.

Hands-on what-is-to-be-done white papers put theory's projective faculties to work as blueprints, a tactical and interventive quality that some traditions of critique might regard as too instrumental. It is therefore exciting to see, alongside these initiatives in social science, a complementary murmur in philosophy:

211

a mediation of the abstraction "justice" to root policy programs. Olúfẹ́mi Táíwò, a leading theorist of the ethical, political, and epistemic challenges posed by climate crisis, practices theory as synthesis. His integrations articulate common notions like "security" and uncommon initiatives like "reparations" as bedrocks for justice. How should we think of security? Not as the property of the terror-fueled surveillance agency, but as fundamentally inhering in "basic material needs such as food, water, shelter, healthcare and protection from violence" and therefore "one of freedom's most important building blocks."[14] How should we think of reparations? Not as penalty for past injustice, but as "a worldmaking project," steered by a "constructive view . . . geared more toward collective needs than toward accumulation."[15] Collectively minded, future-oriented, and valorizing "construction" as that capacity of theory which is also a capacity of praxis, this philosophy intercedes through rather than despite its own generalizing ambit.

Theory's mediations may be most operative in those fields where the theory takes for its object the mediations produced by art and aesthetic culture; for it is here that thinking with mediation requires appreciating the kinds of para-theoretical ideas made possible by aesthetic representation, and thus that theory activates the contrasts and convergences between its own project of idea architecture and the plans of the arts. Interpretation of cultural production through mediated forms like literature and video is a different kind of work than the analysis of phenomena like ecocide, capitalism, and the state; it presumes, rather, that the boundedness of artforms is necessary for representing and theorizing the immediacies of social life. A question of something like sublation attends this estimation though: if mediations like those art practices are essential—and not, as the style of

14 Olúfẹ́mi Táíwò, "Who Gets to Feel Secure?," *Aeon*, October 30, 2020, aeon.co.

15 Olúfẹ́mi Táíwò, *Reconsidering Reparations* (Oxford: Oxford University Press, 2022), 20, 5.

immediacy imagines, dispensable—then what is the theoretical exercise that can hold the scale of that essentiality? How can theorists of aesthetic mediation follow the divagations of design in particular instances while still hewing a path toward something general? We can find one answer in the commonality across the work of three twenty-first-century cultural theorists: Caroline Levine, Sianne Ngai, and Fredric Jameson. Engaging the problems of representation and dynamics of figuration with all the patience and strangeness they compel, these theorists commit to *categorical* thought, the composition of categories that work for and through scale, impersonality, and hold. They offer interpretations of aesthetics to propound syntheses that can, in turn, capacitate new understandings and other kinds of critical theorizing.

Levine's signature work in this vein is her book *Forms: Whole Rhythm Hierarchy Network* (2015), which proposes that the category of form as it is articulated in literary study also illuminates social phenomena, and reciprocally that the skills of formalist analysis are generative beyond the study of literature. Formalists attune to wholes, to rhythms, to hierarchies, and to networks, resulting in practical knowledge about what these forms afford and what they hinder, or about distributed agency and therefore sites of strategic action, or about how social power arises not just from the operation of a hierarchy when CEOs are compensated more highly than hourly workers, but from the interaction of that hierarchy with rhythms like the 24/7 working day and its different opportunities for composing wholes like unions. The goal of Levine's book is for formalists to esteem their academic skills as socially useful, and for pattern recognition to ignite social transformation.

Ngai's books *Our Aesthetic Categories*: *Zany, Cute, Interesting* (2012) and *Theory of the Gimmick* (2020) share the premise that the processing of aesthetics—in her case, aesthetic judgment (the practices and frames through which we assess the value of a work of art in accordance with a social imaginary of other's

parallel assessments)—is also the processing of social relations. Judgment that something is "cute" is a portal to fathoming "how aesthetic experience has been transformed by the hypercommodified, information-saturated, performance-driven conditions of late capitalism"; judgment that something is a gimmick disequilibrates the valorization process, bringing into collective appraisal the contradictions of overwork and overconsumption. The more we understand that everyday, seemingly superficial appraisals like "Yeah, this article is interesting" are actually vertices where we enact the value paradigms of an extractive exploitative society, the more we may be able to turn those social perceptions of style into muscle memories of claims for universality and practices of justification. Such syntheses hew a path for praxis that radically detours from the self-emanation we've seen apotheosized by Bernard Harcourt and onanized by autotheorists. Rather than the echolalia of selves in succession, aesthetic judgments chorally coordinate social consensus and social struggle, including the struggle over production and circulation, but they make these stretches and revelations in highly mediated ways.

Both of these theories overtly formulate new ways of classifying experience and tethering it to social literacy. This is quite far from autotheory's lyric rendering of experience that defies predicate, or from entanglement and nihilist dissolutions of all classifications and distinctions. Both also elevate the mediated character of aesthetic judgments or formalist interpretation to the stratum of political and social tactics. Rather than prescribing what is to be done, in the urgent and lucid way of collectivist social theories like *A Planet to Win*, they illustrate *how* it is to be done: by way of the constructed analyses and deliberative judgments and shared signifiers that constitute intellectual mediations so that a group may agree on a course of action. Ideas guide us.

Categorical thinking links up with the other countertendencies to antitheory we've outlined—namely scaled policy programs and constructive philosophizing—in the work of Fredric

Jameson. Over the course of his extraordinarily generative career, Jameson has produced countless concepts designed to help other people produce still more interpretations and ideas—concepts like "the political unconscious," "postmodernism," "a singular modernity," "utopia exists," and the emancipatory impetus of dialectics. At the same time as he has devised concepts through readings of mediated culture like novels, films, art, and architecture, he has also deployed them for social blueprints—for constructions that will support collective flourishing. He scandalized literary and political theorists alike with the speculative propositions that Walmart and the military enact integrated social infrastructure of the kind necessary for better states, and that these forms are appropriable for utopian ends.[16] But such wagers are the merging of dialectical cultural criticism with collective political programming, and they are not wrong. They also can only happen in a symbolic medium that sustains collective imagining and capacitates deliberate composition—which is precisely the medium refused by antitheory immediacies. Jameson's mediations come into being through his consistent style: his dialectical sentences, his promiscuous semicolons, his "well-nigh" flourishes, his gallant tone, his exuberant yet engineered articulation that has unwavered for sixty years. *Immediacy, or, The Style of Too Late Capitalism* owes its infrastructure to Jameson's vesting brilliance; theory owes us not just titillation but building materials.

The work of this book has been to propose the category of immediacy as a support for the interpretation of aesthetics and politics, inviting readers to the cause of thickening mediation. Immediacy's consolations and appeals are many, redounding all the more the worse things get. Though it sells itself as the answer to the horrors of what presses here and now, its redactions and extremities adhere too fervently to those conditions. Too late capitalism

16 Fredric Jameson, *An American Utopia* (London: Verso, 2016).

speeds toward ecocidal destruction, foreclosing the future in the interest of the instantaneous pulsing present of access, fulfilment, flow. The immersive presence, smooth fluidity, and transparent relay of contemporary cultural aesthetics congeal this wretched system, when they could oust it.

> Immediacy is instant; mediation dilates.
> Immediacy is urgent; mediation displaces.
> Immediacy flows; mediation bars.
> Immediacy confesses; mediation intermixes.
> Immediacy laps; mediation relates.

Drawing these conspicuous oppositions is an exercise in educing contradiction, including friction-freighting categories. There will be readers to whom immediacy remains balm, and those for whom the exhortation to mediate clangs of false opening. But perhaps a final contrast will inspire: immediacy is all about circulation. Mediation might, then, be conceived as production, though that production which distinguishes itself as for its own sake, means in themselves: making relations, making something different happen, making shit not the worst.

Productivist cultural style isn't an economic resolution to the crisis of capitalist production like universal basic income, or abolition of the value form, or renewed Keynesian state capitalism where progressive taxation fuels general social welfare spending. But it just might prove pivotal to political resolution—both pluck and project—bringing into thinkability ideas of collective flourishing and common abundance despite the ecocide. The deluge is here. Whether any dams may be built depends upon fomenting mass political will—and the aesthetics of immediacy will not suffice for that. Autoemanation, flow, blur—these are not the modalities of knowledge or representation that work to produce deliberate signifiers, shared ideas, structured relations, nor are they lines in the sand of the drought zone. It is up to actions to produce the necessary mediations, and from there cultural

style may follow, but actions themselves require mediation—for recognizable sustained effect rather than just undecidable entanglement, symbolic efficacy beyond imaginary feint, it takes conspicuously knitted chains of cause and effect, signifiers resounding, and collaborations exercising collective sovereignty.

The style of immediacy precludes art, literature, video, and theory from convoking collectives and from catalyzing representation itself as a medium of collectivity. Mediations are composites of language, composites of images, compositions of meaning, composed ideas—that produce something more than immediate experience. It is this putting into medium and generating of the middle that actually responds to crisis, instead of perpetuating its intrinsic immersions and extremes. As this conclusion has highlighted, residual, emergent, and extra forms of cultural production activate rather than evacuate mediation. And still more promising than these fomentive imaginings in aesthetics are the brave stoppers in the circulation economy: labor acting militantly in unprecedented ways, from Amazon and Starbucks to educators in West Virginia and Chicago, to academics at Rutgers, Temple, Illinois, and even Columbia and Harvard, to culture workers in the Writers Guild, at the Guggenheim, the Museum of Contemporary Art in Los Angeles, the New Museum, *New Yorker*, *New York Times*, Pittsburgh Post-Gazette, Duke University Press, and Verso Books. Their fights are all the harder because our dominant culture so negates mediations, but even so, these struggles build a base for renewed representations, for another cultural style. The omnicrisis will not autosettle. The old world is dying, but immediacy poorly midwives the new world's struggle to be born. It is not too late for us to build things less worse. Mediation is not a luxury. Let's get it on.

Index